The Seduction
of Miss Evelyn Hazen

Jane Van Ryan

Library of Congress Cataloging in Publication Data

Van Ryan, Jane
 The Seduction of Miss Evelyn Hazen / Jane Van Ryan
 p. cm.

ISBN: 0-9785637-0-0

Cover design by Chuck Cook

Printed in the United States of America

GlenEcho
PUBLISHERS

Glen Echo, Maryland

For Lucille

Prologue

In January 1989, Suzanne Barkes had a good job, her own home in the pleasant and established Bellemeade neighborhood of Louisville, Kentucky, and she had just met a man who intrigued her. He was Dr. Alvin D. Gilbert, a prominent chiropractor and eligible widower who was 15 years older than she. Early in their five-year relationship, Gilbert dated other women; but when he presented her with an engagement ring at Christmas in 1991, he made his intentions quite clear. His wanted to get married and purchase a "country home" with Barkes in nearby Bardstown, Ky., where they would grow old together.

In June or July of 1992, Barkes was given the opportunity to volunteer for an early separation from her job as a production supervisor at Philip Morris, where she had worked for more than 17 years. Believing that she would be married within six months, she took the buy-out and put her own home on the market. Barkes sold her house in July 1993, and moved into Gilbert's home.

Soon thereafter, the relationship began to sour. Barkes began to suspect that Gilbert was seeing other women. In fact, during a motor-home vacation with Gilbert, one of his former lovers had shown up quite unexpectedly, claiming that she was supposed to have a date with him that evening. Barkes said the woman's sudden appearance was so shocking to her that she nearly collapsed. Although Gilbert denied that he had planned a date with the interloper, Barkes was unconvinced. "I never felt I could trust him after that," she said. "I felt sure he was seeing other women."

In June 1994, Barkes moved out of Gilbert's house and the wedding was called off. On the advice of friends and colleagues, she hired a lawyer and filed suit for breach of promise to marry against Gilbert. Barkes and her attorney wanted a jury to award her compensation for her loss of her home and job.

The right to sue for breach of promise to marry can be traced back to Fifteenth Century England, where the courts viewed marriage

largely as a property transaction. At that time, the injured party, almost always a woman, had to prove deception in order to receive monetary compensation. The deception requirement was eliminated in the Seventeenth Century.

When English settlers landed on the shores of North America, they brought the British system of justice with them. The breach of promise to marry action was one of many accepted legal doctrines that was adopted by the American colonies and became part of common law. In fact, according to one legal scholar, it was significantly more popular in the New World than in England. Women in particular relied upon breach of promise to marry as a means to seek justice, or quite possibly revenge, against men who had left them standing at the altar.

At the time, women had few rights under the law, could not vote, and had very few opportunities for gainful employment. The breach of promise to marry action provided a legal remedy to recover lost property, regain one's sense of pride, and seek compensation for emotional distress.

Barkes's attorney argued that the break between her client and Gilbert had been costly to the plaintiff. She contended that at the relatively young age of 46, Barkes had left her job and forfeited her salary only because she had been promised marriage and financial security. Gilbert's attorney countered with the argument that Barkes had retired from her job voluntarily, and therefore, should not be awarded compensation from Gilbert.

As the case moved through the courts, the civil matter between Barkes and Gilbert touched off a debate on the validity of the breach of promise to marry cause of action, and prompted a review of the case law that had been cited in similar disputes—the landmark 1937 *Scharringhaus v. Hazen* case.

In *Scharringhaus v. Hazen*, Evelyn Hazen, the raven-haired, statuesque daughter of a wealthy Southern aristocrat, sued her handsome and well-heeled former fiancé Ralph Scharringhaus. She accused him of seduction, deceit and breach of promise to marry. He claimed that she had engaged in lewd conduct, was not fit to be his wife, and had masterminded a conspiracy to murder him.

Rarely had such well bred and glamorous people sparred so openly about their private relationship in a court of law. And rarely had the stakes been so high. Hazen was seeking $100,000 in damages, which was a huge sum in 1934, the year in which the case went to court. At the time, America was submerged in The Great Depression. Millions of people were unemployed. Thousands of families were migrating across the country in search of a new start only to find hunger and despair in the Dust Bowl.

The salacious testimony elicited in the *Scharringhaus v. Hazen* case fed the more prurient interests of the American public and became a favorite topic of reporters and gossip columnists around the country. It also led to a court decision that helped to establish guidelines for breach of promise to marry cases throughout the United States. In order for judges and juries to find in favor of the plaintiff and to award monetary compensation, the Court decided that:

> ...[I]t is proper to consider anxiety of mind produced by the breach; loss of time and expenses incurred in preparation for the marriage; advantages which might have accrued to plaintiff from the marriage; the loss of a permanent home and advantageous establishment; plaintiff's loss of employment in consequence of the engagement or loss of health in consequence of the breach; the length of the engagement; the depth of plaintiff's devotion to defendant; defendant's conduct and treatment of plaintiff in his whole intercourse with her; injury to plaintiff's reputation or future prospects of marriage; plaintiff's loss of other opportunities of marriage by reason of her engagement to defendant; plaintiff's lack of independent means; her altered social condition in relation to her home and family, due to defendant's conduct; and the fact that she was living unhappily at the time of the alleged promise.

Gilbert's attorneys asserted that Barkes could not meet the test established by *Scharringhaus v. Hazen* and argued that the breach of promise to marry action had become antiquated. With the lower

courts split on the issue, the case was propelled into Kentucky's highest court.

When the Kentucky Supreme Court reviewed *Gilbert v. Barkes* in 1997, it handed down a ruling that dealt a mortal blow to *Scharringhaus v. Hazen* and modernized the definition of marriage. In the majority opinion, Chief Justice Robert L. Stephens wrote, "Today, the concept of marriage is generally no longer perceived as an economic transaction. Rather [it] is regarded as a union of two persons borne out of love and affection, rather than a device by which property is exchanged." Furthermore, he noted that "...[W]omen today possess far more economic, legal and political rights than did their predecessors. Accordingly, we must examine the Utility of the [Breach of Promise to Marry] BPM action in the context of the present day, not in the era in which it was created...Accordingly, the action for Breach of Promise to Marry is no longer a valid cause of action before the courts of the Commonwealth."

The Court's decision not only eliminated breach of promise to marry as a legal remedy, but it also signaled that the position of women in Kentucky, and by extension throughout America, had changed forever. The ruling implied that the courts no longer should view women as the fairer sex that is deserving of special protections or assume that women are continuing to be financially dependent on men. It also undermined a huge body of case law, including *Scharringhaus v. Hazen*, by labeling it old-fashioned, sexist, and paternalistic. Stephens noted that the court was unaware of any cases in which men had filed breach of promise to marry suits against women and pointed out that more than half of the states had legislatively or judicially abolished the action.

"We believe the cause of action for breach of promise to marry has become an anachronism that has out-lived its usefulness and should be removed from the common law of the Commonwealth," Stephens wrote.

As a result of Stephens' decision, Barkes lost her case against Gilbert on two counts. The Court determined that *Scharringhaus v. Hazen* was too old-fashioned to be relevant, and that Barkes's complaint had not met the criteria necessary to be successful. She did

not prove that a wedding date had been set; she failed to show that she had lost money by making wedding arrangements, such as purchasing a wedding dress or renting a facility for a reception; and it was not clear that Gilbert was guilty of reckless disregard when the engagement ended. Simply put, Barkes had loved and lost, and had no legal recourse.

There is little doubt that many court observers would say that the Kentucky Supreme Court's decision to eliminate the breach of promise to marry action was long overdue. But Evelyn Hazen, the woman whose suit became the litmus test for successful breach of promise to marry cases in the Twentieth Century, would have disagreed quite strongly.

Chapter 1

I first heard Evelyn Hazen's name in the winter of 1989, when my cousin Lucille LaBonte came to visit from Tennessee.

"You've got to write a book about Miss Hazen," Lucille said to me in her thick, southern drawl.

Her black eyes narrowed slightly, adding intensity to her steady gaze. Her mouth, always bearing a smear of red lipstick, was pursed, waiting for my reply. Deep vertical lines surrounded her lips, signaling that she had worn this expression frequently during the past 70 years. She waited, almost too patiently, for my reply.

I studied Lucille for a moment. Heavy rings, some bearing diamonds, adorned her thick, knotty fingers. The red polish on her nails was cracked and chipped. Her face, white and deeply lined, with a little too much rouge on her high cheekbones, was framed by short, coarse black hair. As I gazed at her and at the strength and resolve chiseled into her features, I was reminded of a photograph I had seen of a distant relative, perhaps her grandmother as a young woman. She was dressed in deerskin and her black hair was parted down the middle and braided into two long plaits that hung across her shoulders. Lucille had inherited her Cherokee eyes and cheekbones.

Lucille learned her powers of influence through her work as a paralegal in a law firm owned by Judge Howard Bozeman, one of Knoxville's most prominent attorneys. Her understanding of the law, knowledge of court procedures, and her ability to understand and minister to people endeared her to many of the firm's clients, including Evelyn Montgomery Hazen.

"We've got to tell Miss Hazen's story," Lucille continued.

"I want to help you," I replied, "but I've never written a book." As a former television journalist, I was used to writing very brief news stories that were designed to fill a few seconds of airtime, not hundreds of pages filling a book.

"I trust you," Lucille said. "You can do it."

Lucille began telling me about Evelyn Hazen, who had died a few months before and had named Lucille the executrix of her estate as well as a trustee. As the one person that Hazen had trusted at the end of her life, Lucille had become responsible for handling her affairs after her death.

At the time of her death, Hazen owned several houses including some rather run-down rental properties. She also had inherited her family's home, a mansion built before the Civil War on the highest promontory in Knoxville. The manse with its panoramic view of the city to the north and the Tennessee River to the south was of strategic importance to both the Confederate and Union forces during the war, particularly during the Siege of Knoxville.

Hazen's Last Will and Testament required that her "residence and the antique furnishings, pictures and other memorabilia located therein" be restored and maintained "as an historical site…[and] open to the public at reasonable and appropriate times." The will also specified that if Lucille could not comply for any reason, the house should "be razed and the land and contents of the Hazen residence…sold at public or private sale or otherwise disposed of…."

Lucille was looking for ways to raise money to make repairs to the house and to establish the Hazen museum. A book about Hazen might help, she told me, although I had no idea at that moment why anyone would want to read about her.

On the day of her visit, Lucille and John Coker, an antiques appraiser, had driven from Knoxville to my home in Maryland where they had planned to spend the night before continuing on to New York. In Lucille's car, they were carrying a small, satinwood, slant-top table with a hand-carved piecrust edging from Hazen's estate. They were taking it to antique experts in New York City who had agreed to examine it. If their suspicions were correct and the table had been made in America by a traveling furniture-maker in the Eighteenth Century, it could have been worth more than $1 million.

With that much money, Lucille could pay the taxes on Hazen's estate to avoid sacrificing the house or any of the remaining scores of potentially valuable items that were in her home. Lucille explained

2

that Hazen was the last of her lineage and had received all of the antiques owned by both her mother's and her father's families.

Lucille and Coker were not successful in certifying the origins of the satinwood table in New York. Disappointed, they returned to Knoxville where Lucille searched for other ways to raise the funds necessary to preserve Hazen's mansion and antiques.

At Lucille's insistence, I agreed to travel to Knoxville and spend a day in Hazen's home where I could learn more about her. So, a few months later on a breezy April morning, I met Lucille at her duplex in the eastern section of Knoxville and together we drove west through the Holston Hills area of Knoxville to the house, which was known as the Mabry-Hazen estate.

It was not what I had expected. After hearing Lucille's narrative about the prosperity of the Mabry and Hazen families, I had assumed that the house would resemble Tara before the war, gleaming white on a wide expanse of lawn. Instead, it was a decaying two-story frame structure sagging under the weight of neglect. Years of rain and wind had eroded the paint to a dingy gray hue. Part of the roof had rotted and caved in, leaving a wet, gaping hole. Shutters were hanging at odd angles from broken hinges. Pigeons roosted in the rusty gutters. Massive trees, many with huge broken limbs, towered overhead and shaded the ground so deeply that the grass refused to grow.

Lucille stopped the car on what appeared to be the remnants of a circular driveway, and we walked toward the broad front porch. The air was strangely still and silent. The sounds from the traffic and the city below could not penetrate the green, tangled fortress wall of overgrown brush that surrounded the hilltop. The present was not able to intrude upon this relic of the past.

We stepped onto the porch that stretched the length of the house, taking care to avoid stepping in holes, and entered through the front door. A single light bulb hung from a long cord in the wide foyer, barely illuminating the faded roses decorating the grimy, water-stained wallpaper. The air was dank and musty, heavy with the odor of mildew and urine. A staircase curved upward to an archway housing a tall Palladium window, which allowed a narrow

shaft of sunlight to slice through the darkness and cast a wedge of white light on the stairs. The brightness was a stark contrast to the bleakness that permeated the house.

Lucille led me through a dark hallway and gave me a tour. Very little had changed since Hazen's death. The gloomy oil portraits of her long-deceased ancestors hung on the walls. Victorian furniture with its original horsehair upholstery waited to accept guests in the parlor. The square, claw-footed piano in the music room was poised to entertain. Decades-old Persian carpets covered the wide plank floors. Hazen's silver-handled mirror still lay on her dressing table just where she had left it. A weathered trunk at the end of a four-poster bed held what appeared to be a bride's trousseau, including gowns that would have been considered quite stylish in the 1920s.

Lucille opened a drawer in a heavy walnut bureau and produced several photographs of Hazen. As a young child, she was photographed sitting in the grass playing with a litter of kittens. The full skirt of her dress flowed in waves of taffeta on the ground, and her dark curls cascaded over her shoulders.

"Miss Hazen loved animals," Lucille said, "and she was very timid and shy as a child. She knew how to play the violin and was asked occasionally to play it in church. She said she wouldn't perform alone but would play with other children, so she could stand behind them and not be seen by the congregation."

In a photograph taken when she was about sixteen, Hazen's bobbed hair waved away from a widow's peak and around her temples, adding emphasis to her large eyes and softening the straight line of her nose and her perfect chin. Her face was full and youthful; her mouth was soft and vulnerable.

"She went to a private school for young women and earned enough credits to attend the University of Tennessee at the age of fourteen," Lucille said. "She told me once that she was one of the youngest students to ever graduate from the University. She also was chosen as queen of this and that, because she was voted the most beautiful girl on the campus."

In later photographs taken when she was in her late teens and twenties, there was a decided change in Hazen's appearance and

4

demeanor. She looked tense and strained. In a black-and-white photograph Hazen is seated next to a military officer on a park bench. His expression is confident, even slightly arrogant. She is frowning and appears angry. Her arms are folded across her chest in a defensive position.

Lucille said that Hazen's behavior prior to her death at age 88 had become increasingly unpredictable and erratic. Paranoid and reclusive, she carried a loaded .32 caliber Colt revolver with her constantly, even when she was merely walking from one room to another. With a crutch under one arm and her pocketbook dangling from the other, Hazen brandished the firearm in her free hand as she stomped heavily through the house. On at least one occasion, she shot at or over the head of one of her renters when she mistook her for a thief.

Although Hazen constituted a serious threat, Lucille was obliged to visit her frequently, so she devised a system to avoid being shot. Lucille always parked directly in front of the house so Hazen could see and recognize her car. Then she would climb the steps to the porch, call out to Hazen, and knock on the front door, while standing off to the side with her back against the wall. It was too risky to stand directly in front of the door.

Hazen would not allow most visitors to go beyond the foyer. But Lucille, who had Hazen's power of attorney, had earned her trust and was afforded the right to go throughout the house, including to the tiny, closet-sized alcove that held Hazen's bed. Hazen refused to sleep in her bedroom because she believed it was haunted. So at night, she retired to a narrow youth bed that was piled high with newspapers, magazines, men's wool socks, money, bank deposit books, letters, bills and empty candy boxes.

"She never went to bed until three o'clock in the morning, and then she slept until eight or nine in the morning. Some nights I'm not sure she slept at all," Lucille said.

Hazen's descent from a young woman of privilege to a gun-toting recluse was striking. Surely time alone was not responsible for her paranoia and self-imposed isolation.

Lucille handed me a newspaper clipping from the mid-1930s, showing Hazen wearing a cloche hat and a heavy wool coat

indicating that the photograph was taken during the dead of winter. She appeared anxious and weary. Her face was thin, tense and haggard, and her eyebrows were drawn up in sharp peaks. The news article next the photo provided sketchy details about a court case in which Hazen had sued a former lover.

"She didn't talk about the court case very often," Lucille said, "but since her death, I've found articles like this one showing that the trial was covered by newspapers all over the country."

With Lucille's help, I arranged interviews with the few people who had known Evelyn Hazen. According to their combined recollections, it became clear that the court case against her former lover had had a profound impact on her.

Sarah Jane Grabeel, who worked for Hazen and served as her companion for several years, told me that as a college student Hazen "got to going with" a boyfriend named Ralph Scharringhaus and apparently expected to marry him, but that he also had the attention of a young married woman. Recalling Hazen's response to Scharringhaus's duplicity, Grabeel said, "They had a pretty good law suit."

Dannie Mellen Payne, one of Hazen's oldest friends, said Hazen was offered $50,000 to drop the suit, but she refused because she wanted vindication.

Pleas Lindsay, who worked as a security guard and stayed in the house with Hazen a few nights shortly before she died, said she talked about the suit with him only once, and it led to an argument. "[She] would only say…[that Scharringhaus] slithered across the floor like a snake, [and] begged not to go to jail."

Now, I thought, I have something to write about.

1913-1932

Chapter 2

In the summer of 1913, Edward Scharringhaus was eagerly anticipating the First Exposition of Conservation in Knoxville, Tennessee. As one of its primary organizers, he hoped that the national event scheduled for October would lure thousands of visitors to the city and give him and other local businessmen the opportunity to showcase Knoxville as one of the most progressive cities in the South.

Scharringhaus and his fellow members of the Rotary Club had plenty of reasons to be proud of Knoxville. Located in the lush Tennessee Valley, the city was surrounded by fertile soil, navigable waterways, and abundant natural resources, including mountain timber, zinc and marble. It also was a major hub of commerce, boasting an expanding economy, successful industries including a steamboat manufacturing plant, hundreds of miles of macadam roads stretching out to nearby towns, and two railroad stations. Prosperous Gay Street, which ran through the center of Knoxville's business district, was the site of one of the first skyscrapers in the South. The Burwell Building, which was completed in 1907, had filled quickly with businessmen and lawyers, many of whom provided services to the city's prosperous wholesale merchants.

Knoxville was an ideal location for wholesalers, also called jobbers. With a port on the wide Tennessee River at the foot of Gay Street, the jobbers could ship goods over approximately 2,200 miles of waterways on steamboats and flat-bottom boats that carried cargo west to the Mississippi and south over the treacherous mussel shoals to Decatur, Ala. On land, a network of rail lines stretched to the South and Northeast. The trains also provided ease of travel to passengers. Accommodations on the Southern Railroad lines were said to be among the best in the world, with meals in the dining cars served on fine china and silver. During the early Twentieth Century, at least 30 passenger trains traveled on East Tennessee railroad lines each day. The trip from North Carolina, through the Great Smoky Mountains

and along the French Broad River just east of Knoxville was called "the most wildly beautiful bit of railway journeying in America."

A jobber himself, Scharringhaus was one of the owners of Gillespie, Shields & Co., a wholesale clothing company. From his glass storefront on Gay Street, he and his business partners could observe how modern innovations had changed Knoxville and infused the business community with a sense of optimism. The street bustled with the cacophony of early automobiles, horse-drawn carts and carriages, and the electrically powered streetcars that lurched along on steel tracks embedded in the pavement. The sidewalks were filled with throngs of shoppers moving along in a proud procession.

Knoxville's prosperity had helped Scharringhaus become a very wealthy man. At the time, he lived with his wife and young son at Whittle Springs, made famous by the luxurious hotel, spa and swimming pool. A few years later, he moved his family to a large brick home with lush gardens on Knoxville's west side near the Cherokee Country Club. At regular intervals, he traveled to New York City on buying excursions to purchase the finest and most stylish suits, collars and hats available for his customers as well as for himself.

Scharringhaus's well-heeled clientele had grown accustomed to having access to the same clothing and hats as the sophisticated city dwellers of the Northeast. The wives and daughters of the businessmen in town, particularly those who belonged to various women's social clubs, went on regular shopping trips to the most expensive stores in New York City and were seen around Knoxville in the elegant broad-brimmed, feathered hats and exquisitely tailored dresses that were considered high-style at the time. Their strong interest in the fashions of the day prompted one of the local newspapers to publish a regular column that showed what women were wearing on Madison Avenue.

Around the corner from Gillespie, Shields & Co. on nearby Market Street stood the wholesale grocery business Hazen, Trent, Harrell and Company. A neat, red brick structure with its back to the wide expanse of railroad tracks, the building contained supplies of foodstuffs that were delivered to the grocery warehouse by railcar

and distributed throughout the Southeast. Nearly every day, the loading dock accepted shipments of basic commodities including flour, cornmeal, and sugar as well as produce from the deep South, candy, coffee, and finely cured, aromatic tobacco. The candy and tobacco were kept in a safe that helped to keep them protected from Knoxville's hot, humid summers.

Rush Strong Hazen, one of the firm's partners, had started his career as a traveling salesman riding on horseback throughout East Tennessee. His hard work and dedication paid off. By the early 1900s, he had become one of the wealthiest and most prominent businessmen in Knoxville.

Hazen was respected not only for his business acumen, but also as a man of great personal integrity and excellent judgment. He was highly regarded as a leader in his industry and was asked to serve as the vice president of the National Wholesale Grocers Association. He also was a member of the board of directors for the conservation exposition, and in 1916 he helped to found the Morris Plan Bank in Knoxville, rising to become its president and later the chairman of the board. Hazen also was a member of the city council where he was admired by his colleagues for his independent spirit, charity, and frankness.

His wife Alice Evelyn Mabry Hazen was a Southern lady more accustomed to the social proprieties of the Old South than the modern ways of the early Twentieth Century. In tintypes, she was pictured in Victorian dresses with whale-bone bodices and stiff bustles, with her thick, dark hair carefully braided and arranged on the top of her head. Her expression was stern, and typical of the unsmiling portraiture that was common at that time when it took several seconds for the camera to capture each image.

Mrs. Hazen descended from a wealthy family with significant land holdings. She was the daughter of Joseph Alexander Mabry III, whose father Joseph Alexander Mabry II was a landowner with more than 2,000 acres in East Tennessee, one-time publisher of the *Knoxville Whig* newspaper, and the president of the Knoxville and Kentucky Railroad prior to the Civil War. When the war began, the elder Mabry became an ardent supporter of the Southern cause and

personally offered to equip and clothe an entire regiment. His actions earned him the honorary title of "General."

According to a story passed down through the family, General Mabry frequently rode his horse over the countryside, inspecting his farms or going to the southern boundary of his land to visit the Indian camps. On one visit, the Indian chief invited him to stay for supper, which consisted of a wild pig—hair and all—cooking in a kettle over a fire. General Mabry knew that he had to accept the chief's invitation to avoid jeopardizing his peaceful relationship with the Indians, so he spooned a little broth into his bowl. But the chief insisted that he eat a hearty meal and filled up his bowl with the greasy gruel. Since Mabry was an intelligent and diplomatic man surrounded by savages, he ate it.

After the South lost the war, General Mabry experienced financial difficulties and was forced to reduce his land holdings and sell his blooded horses. The railroad went into receivership and was sold. Then in 1882, he and his son Joseph A. Mabry III were killed in a shootout on Gay Street.

The Mabry family claimed Thomas O'Conner had assassinated them. They said General Mabry and young Joseph had gone to New York City on business and had entrusted O'Conner with managing a separate business arrangement in Tennessee. When they returned to their office in downtown Knoxville, they discovered that O'Conner had double-crossed them and caused General Mabry to suffer a financial loss. The Mabrys felt they had no option but to seek an indictment against O'Conner. But O'Conner was ready for them. When General Mabry headed toward his attorney's office to initiate legal action, O'Conner and an accomplice fired shots at him from their hiding place in the doorway of a local business. General Mabry was struck and died instantly. Hearing the commotion, young Joe Mabry rushed into the street and also was shot. Just before he died, he managed to shoot and kill O'Conner, but his accomplice got away.

One family member attributed the murders to the deep-seated anger and resentment that existed between the Southerners and the Carpetbaggers after the Civil War. As she explained it, "O'Conner had 'cooperated' with the 'Yankees' for some time, no doubt for

considerable profit." She noted that "...jealously and spite toward wealthy, aristocratic persons" such as the Mabrys were common practices among the "newcomers" to the South after the war.

Mark Twain, in a series of articles published in his book *Life on the Mississippi*, told a slightly different version of the story based on a news report. According to the report, General Mabry had hastened his own death by threatening to kill O'Conner over the transfer of some property, saying that he would shoot him the next time he saw him. But O'Conner, who was the president of the Mechanics' National Bank and reported to be the richest man in Tennessee, took action first. Armed with two shotguns, he hid in the entrance of the bank and shot General Mabry twice as he walked down Gay Street. Then, after young Joe retaliated by shooting O'Conner in the chest with a pistol, he fired again with a second shotgun and struck Joe Mabry in the side. Joe fell, tried to get up, and then died. According to an article, the shootings reportedly occurred a few months after the Mabrys had killed two other people and had been acquitted of the crime.

The article added that there were thousands of people on Gay Street when the shooting began. At least two people were injured by flying buckshot, and a few others had their clothing pierced.

The Mabrys acknowledged that several versions of the story had been published over the years, but they insisted theirs was accurate.

Rush Hazen and Alice Evelyn Mabry Hazen lived in an antebellum home built by General Mabry, her grandfather, in 1858 on the promontory of Mabry Hill. With its canopy of trees and large floor-to-ceiling windows, the white, two-story Italianate mansion was a prime example of the grace and style of Victorian architecture. The wide veranda, studded with tall columns, surrounded the house on three sides. In the foyer, a wide staircase swept upward to a sitting area illuminated by a tall arched window made of leaded glass. The bedrooms were ample, light and airy, and decorated with pink and blue wallpaper bearing tiny flowers.

In the evenings when Rush Hazen returned home from the warehouse, the Hazens' dined on meals that had been prepared by their cook and served on imported china. After dinner they went into

the music room to play the piano or read. Outside, the stable boy cared for the horses and dogs at the nearby stables.

It was in this place, firmly embedded in the customs of the Old South and overlooking the Tennessee River, that Rush and Alice Evelyn Hazen reared three daughters, the youngest of which was Evelyn Montgomery Hazen. Evelyn was born many years after her sisters, and by all accounts was her father's favorite.

In the fall of 1913 when Knoxville was preparing for the opening of the exposition, Evelyn was attending her last year at a private school for young women. A bright child with an aptitude for languages, she excelled at French and English grammar and easily passed all of her courses. She was an avid reader and often perched with a book in the crook of the massive magnolia tree a few steps away from the house, with her dog at her feet. Evelyn had all of the educational opportunities that her family's considerable wealth could provide, including travel overseas. By the age of 13, she already had traveled to Europe with her headmistress and youthful classmates. Years later, she claimed that during that trip she had met the Queen of England.

On November 8, 1913, Evelyn celebrated her 14th birthday with her adoring father and protective mother. Her youthful face and full mouth were filled with anticipation as she opened her presents under the watchful eye of her parents. Evelyn was strikingly beautiful, with porcelain skin, green eyes, and an abundance of dark hair that waved around her fair face. She was a like a precious jewel, an emerald exuding an uncommon glow. And her parents guarded this rare gem jealously by enveloping her in the safety, security and serenity of their hilltop enclave. Evelyn had never been allowed to venture away from home without a proper escort. She neither had boy friends nor any knowledge of men's ways. In fact, her entire understanding of the world was limited to her school studies, the lessons she had been taught by her mother, and the Bible stories taught at the First Presbyterian Church.

Simply put, Evelyn was a lady. She had been reared in a proper and controlled environment where formal Victorian manners and customs were the norm. Her lack of experience with the outside world

left her timid, shy and very vulnerable, a naïve young woman who was totally unprepared for the harsh realities of the world.

Evelyn's protected childhood came to an end when she entered the University of Tennessee in the fall of 1914 and began attending classes with students who were a few years older than she. To become accustomed to student life at the university, Evelyn went to various functions and parties with a group of young men and women. She hoped to be part of the crowd and remain in the background as an observer, a relatively anonymous member of the student body. But her beauty got her noticed throughout the campus community. Evelyn said she frequently was "picked as the one for Cadet Colonel, Queen of this, that, and the other, and such similar college stuff," but she "was almost too scared to appear after the elections and was entirely unaware of the 'great honor.' Some one else could have had it," she said, "and I would have been pleased to death to be out of the limelight."

The Sigma Alpha Epsilon (S.A.E.) fraternity took a particular interest in Evelyn. Her cousin Fleming Hazen was a member of S.A.E. and was a very popular student on the "Hill," as the campus was called. He and his fraternity brothers considered Evelyn a "little sister" of the fraternity and gave her a nickname.

"I hated most of them because they teased me so terribly," Evelyn wrote years later. "That began the nickname of 'Little Tim,' which stuck, much to my timid embarrassment…[I]t built up in me a protective armor to hide how timid and sensitive I really was."

One of the S.A.E.s was Ralph Scharringhaus, the only child of prosperous businessman Edward Scharringhaus. At the time, Ralph was dating Georgia May Ferris, who was one of Evelyn's closest friends and a Chi Omega sorority sister. Based on Ralph's behavior, it was clear to Evelyn that he had an intense crush on Georgia May.

As the fall term progressed, the star of the U.T. football team and S.A.E. brother Russ Lindsay began to shower his attentions on Evelyn. He took her to school every morning, walked her to class, and stopped to talk with her in the bookstore. By being so obvious in his

love for her, Russ had made Evelyn more conspicuous than ever, a fact that prompted another round of teasing from the fraternity boys. Although Evelyn was thrilled that Russ was interested in her, she hated being the target of "those crazy S.A.E.s" who had elevated the tenor of their annoying banter and had even "yelped their smarty remarks at Russ."

Evelyn was totally unprepared to defend herself against the teasing of the fraternity brothers. She described herself as a "sensitive, dependent young girl" who "was not capable of looking out for herself and was therefore, pretty easy prey for a person who apparently looked out for her and gave her a much needed feeling of security."

It was about that time that she became acquainted with Ralph Scharringhaus. Evelyn had seen him in class and at dances but did not know him very well. She considered him just another one of those pesky S.A.E.s. But her perceptions of him changed markedly in the spring of 1916 when she, Ralph, and eight or ten friends put on a series of plays by the U.T. Players at Staub's Theatre. Evelyn had flatly refused to act in any of the plays, choosing instead to work backstage. Then, just three weeks before one of the plays was scheduled to debut, one of the players had to drop out. The club members convinced Evelyn to take her part, which happened to be the role of Ralph's wife.

Despite being afraid of performing before an audience, Evelyn forced herself to rehearse the part and go through with it. Usually, her father or Russ Lindsay would pick her up after each rehearsal and take her home, but eventually Ralph offered to give her rides. "Fish," as his fraternity brothers called him, was pleasant and charming, and Evelyn began to think of him as a good friend. She saw no harm in accepting his offer to take her home, even though it irritated Russ.

That spring, Ralph was dating Evelyn's friend Margaret Madden, so she was very surprised when Ralph called her during the summer and invited her to go out on dates. Evelyn said she "enjoyed seeing him, but never thought much about the possibility of his being very much interested" in her, and she refrained from encouraging him to call her or take her to the movies or to the local drug stores for a soda.

When they returned to the university in the fall, Ralph asked her if she would be willing to take some classes together. Evelyn brushed off the request, failing to take it seriously because he was continuing to date Margaret. But Ralph continued to contact her. First, he offered to help her with her math problems; and later he asked Evelyn to help him write letters to Margaret, who had left U.T. and entered Columbia University in New York.

Under the guise of writing letters, Ralph began to spend several afternoons a week with Evelyn. She was struck by his quiet and serious demeanor, and by the fact that unlike his fraternity brothers, Ralph never teased her.

"…[H]e was always the perfect example of a sweet boy and a perfect gentleman, and I began to think that he was the nicest, most sincere person I had ever seen," she said. "Naturally, thinking so highly of him, as a lot of people have all along, I had great confidence in what he said and would have defended him if any uncomplimentary remarks had been made about him. He has always appeared the sweet, simple boy who is almost worshipful in his attitude, not only toward me but toward nearly everybody he had come into contact with, older people especially."

Evelyn also discovered that Ralph could be excellent company. Along with his best friend Clifford Penland and Cliff's girlfriend Eleanor Akin, Ralph and Evelyn rode around together in the afternoons, as many college students did in those days, "eating the ghastly conglomerations of food that kids are given to and squabbling and patching up our little jealous spats." Cliff and Eleanor developed "quite a 'case'" for one another, and Ralph and Evelyn grew closer with each passing day.

Russ was growing increasingly irritated with the amount of time that Evelyn was spending with Ralph, and he had good reason to complain. Although she acknowledged that she and Russ had "a sort of 'engagement,'" she told Russ that he could not monopolize her entirely because she also wanted to spend time with Ralph. Russ and Ralph argued bitterly and started avoiding each other at the S.A.E. fraternity house.

Throughout the 1916-17 school year, Ralph left notes almost daily for Evelyn at the university bookstore. The manager of the bookstore Lula Jones, called "Jonesy" by the students, was complicit in helping Ralph win Evelyn's affections.

"All that note writing, daily meetings at school, and increasing number of afternoon and evening dates with Ralph built up more than a friendly interest in him," Evelyn admitted. And his tolerant and even superior attitude toward Russ's bad temper won points with her.

As she put it, Ralph's "never-failing quiet, unruffled exterior contrasted very favorably with Russ's more sincere and honest temper. Both are extremes, but Ralph's role was cleverer, more polished and studied, and more pleasant, especially when Ralph went so far as to tell me to make allowances for Russ...Thus he craftily turned me against Russ slowly and at the same time got me to feeling closer to him, even dependent on him, I suppose," she said.

"By the spring of 1917 I thought I was really in love in Ralph," she recalled, "and at the same time I thought of him as my best friend and a sort of protecting shield against teasing and Russ's undeniably bad temper. Sometime during that spring he asked me to marry him as soon as possible, after he had finished school and got a start in business. I agreed...."

To Evelyn, Ralph's proposal and her concurrence constituted a real engagement.

Chapter 3

In the early spring, East Tennessee is breathtakingly beautiful. Under the canopy of the towering oaks and hickories, the diminutive dogwood trees form pink and white clouds that waft gently in the misty, deep shadows of the forest. The rolling terrain along the Tennessee River takes on the Technicolor hues of the emerald green foliage, the dark charcoal of the shale outcroppings, and the rusty red clay of the earth. Luminous, the Tennessee Valley envelops the senses, embraces the soul in the folds of its lush hillsides, and promises fruitful abundance in the coming summer season.

It was in this verdant and fertile season that Evelyn and Ralph swore their love for each other. They seemed perfectly matched. They were young, intelligent, and reared by parents who had prestige, position, and money. Their lives were uncomplicated by financial worries. For them, life was as simple as it was prosperous.

In the early years of the Twentieth Century, all of America was enjoying flourishing and peaceful times. Economically, the country was a powerhouse. The United States had become a major exporter of oil, cotton, and wheat, and was leading the world in the production of coal and steel. With a population of nearly 100 million, the nation also had the influence and the physical might to be a major player in international affairs. Yet, the government had no formal alliances with overseas countries. Protected by oceans on the east and west, and still upbeat from a victory in a 100-day war with Spain in 1898, the nation was focusing inward.

When Archduke Ferdinand was assassinated in June 1914 and Austria-Hungary declared war on Serbia a month later, President Woodrow Wilson adopted a policy of neutrality and sought to protect the United States from becoming involved in the conflict. Americans mourned the loss of life caused by the sinking of the Lusitania in May 1915 by a German U-boat and read about the growing bloodshed in Europe in the newspapers. But they were not

willing to enter a war that did not have a direct impact on the homeland. Recognizing the public's reluctance to engage, President Woodrow Wilson won re-election in 1916 with a campaign slogan that summarized the popular opinion of the voters: "He Kept Us Out of the War."

In early 1917, two events convinced the United States that it could no longer stand on the sidelines. Germany announced a new submarine offensive, and the British government intercepted a telegram to the German foreign minister in Mexico City. The telegram instructed the minister to convince Mexico to support Germany if conflict broke out between Germany and the United States. In return, the minister was told that he could offer to help Mexico reclaim the territory that it lost to the United States in 1848—land that eventually became Texas, Arizona and New Mexico.

The proposed alliance between Germany and Mexico was the final straw. When the British government shared the telegram with President Wilson, he broke off diplomatic relations with Germany, and on April 2, 1917, he asked the U.S. Congress for permission to declare war. A few months later, the United States also declared war on Austria-Hungary.

America's entrance into The Great War had an immediate impact throughout the country. Thousands of young men enlisted in the armed services, including Russ Lindsay. His departure for military training in Maryville, Tenn., gave Ralph the opportunity to get rid of his rival once and for all.

In hushed tones and with great sincerity, Ralph told Evelyn she should end her involvement with Russ for her own good. Russ had a disease, he said, that would injure Evelyn and any children that she might have. Evelyn, who was too embarrassed to ask any questions, took Ralph's word for it and was grateful that he had warned her. She also was resentful that Russ might have been willing to subject her to his horrible illness, whatever it was.

Although Russ traveled from his military training camp to Knoxville nearly every weekend, Evelyn refused to see him. "I was

scared of Russ and 'his terrible disease,'" she recalled later, "and steered as clear of him as possible although I still did not want to hurt his feelings; of course I did not really understand what it was all about and did not believe that Russ was wholly poisonous, just selfish and inconsiderate of me in contrast to Ralph's wonderful unselfishness."

Evelyn's fear over Russ's alleged condition made it obvious to Ralph that Evelyn knew virtually nothing about sex. Ralph told her that he was amazed at her ignorance on the subject and was grateful for the opportunity to be the one to explain sexual relations between a man and woman to "his sweet little girl."

"...[W]hat he said to me to explain the why and wherefore of life and all its complexities could have been published in a little booklet for young girls to read for their delicate enlightenment," Evelyn recalled. "...[H]e did not tell me all this at one time and then rush into material proof of it in a manner that would have frightened me or aroused suspicion of his motives. Instead he brought up the subject very casually several times, adding that my mother probably had not discussed those things with me because she was mid-Victorian and shy perhaps."

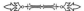

A few weeks later, Ralph answered his nation's call for able-bodied men and like Russ was sent to training camp. First he went to Fort Oglethorpe in Georgia, and later to the U.S. National Army Cantonment at Camp Jackson, South Carolina. Created in early June 1917, Camp Jackson was one of 16 that were constructed hastily to support the U.S. war effort. In a period of only three months, a plot of vacant ground with its scrub oaks and pines was transformed into an army training center with 10,000 men, hundreds of buildings, and a trolley line.

Ralph arrived at the camp before his quarters were ready, so he and his fellow officers stayed in a local hotel. Although they were expected to report to camp every day, they had little to do. They often slept late in the mornings, walked around the city of Columbia in the afternoons, and listened to music in the hotel lobby in the evenings.

Although the accommodations were comfortable, his military uniform was not. The heavy wool jacket with its stiff upright collar, shoulder tabs and patch pockets tended to trap heat close to the body. Likewise, the thick pants, russet marching boots, and leather leggings held tight with buckles were not made with the South Carolina summer in mind. Only the military haircut made sense to Ralph; it was shorn very short on the sides for convenience and comfort, but longer on the top, where his brown hair was wavy and thick.

Ralph cut a handsome figure in his officer's uniform. The Montana peaked campaign hat lent his youthful face and brown eyes a look of strength and resolve, and flattered his perfect Teutonic features. The jacket accented his broad shoulders and added authority to his erect posture and gait. A slight tilting of the head and a bit of a swagger in each step emphasized his apparent self-confidence.

In late August 1917, Ralph sat in the lobby of the Jefferson Hotel and wrote one of his daily letters to Evelyn. His eyes focused intently on his task, ignoring the other officers who milled around, smoked, and talked about the war.

"Someone is playing 'Poor Butterfly' on the piano and it makes me awfully lonesome for you," he penned. "Now it's 'I Ain't Got Nobody.' I wish they wouldn't play it. I guess you think I am silly but I love you Little Tim and when I hear certain pieces of music it makes me realize that I can't see you for a long while."

On August 29, Ralph was told that his temporary barracks had been completed and that he was supposed to report to camp the next morning to prepare for the arrival of the enlisted men a week later. In another letter to Evelyn, he noted that the camp stood in stark contrast to the lush forests and meadows of East Tennessee. It was, as one of his fellow officers commented, like the Sahara Desert. Camp Jackson comprised four square miles of two-story barracks on top of a hill covered in ankle-deep sand.

"I think there is about one tall pine tree to the square mile so we won't have enough shade to make things damp," Ralph wrote. "I guess we will eat breathe & sleep in sand...It's going to be hot as blazes out there. Today has been fierce," he lamented.

During his first leave from Camp Jackson, Ralph asked Evelyn whether she would consider leaving school, marrying him, and returning with him to Columbia.

"We discussed it pro and con for awhile," she said, "and finally decided that it would be very sweet and wonderful, even if he was not making a very large salary and I would not be able to finish my last year at school. Late one afternoon we stopped by the Court House, and he went in to get a marriage license, he said. He soon came back to the car and said that bureau was closed for the day and that we could not get one right then."

That evening Ralph drove to Evelyn's home to see her. Although he was unhappy about being unable to get a marriage license, he convinced her that the license and a wedding were unnecessary formalities for people who truly loved each other. As she explained:

…[H]e told me that a few words made little difference anyway, that he loved me so much that nothing could change him in a million years, that he wanted me to prove to him that I loved him that much too, and that if I would give myself to him because we really loved each other so undyingly and so on and on, we would be married in the sight of God in a sort of secret marriage, and that there was nothing wrong in it…[H]e was crushed and amazed that I would think for a moment that he would allow me to do anything wrong, much less ask me to, and the equally often repeated opiate that ten ceremonies could not make him feel any more bound to me than he did already and that I showed I had no confidence in him if I suspected him of any disloyalty or deceit. He certainly pulled the meek, saintly, religious piety act and got away with it beautifully then and later too.

Believing in him from every point of view as I did and being confronted with the statement that I would do as he asked if I wanted to prove that I loved him as he did me, I gave in to his wishes. That first experience was ghastly, for I was frightened to death at the reality which turned out to

be painful, totally lacking in any gentleness that he had hinted at before, and suddenly very repulsive.

…It remains beyond my comprehension that he could ever have expected me to enter into a relationship that he himself had painted as beautifully sacred when he proved it anything else by his own practices, and which from the very beginning hung over me as a sword on a hair…I believed his talk about the beauty of such love, etc., and was shocked into a horrible awakening after it was too late to go back to what I was…a passive, trustful victim, doing what I myself had not interest or curiosity in simply because he had persuaded me that I would convince him I did not love him if I refused…[T]hat one experience was enough to bind me to the conviction that I must have a marriage ceremony to right it and give me peace of mind….

The next day, Ralph returned to South Carolina, leaving a distraught and disillusioned Evelyn behind.

Chapter 4

In the fall of 1917, Evelyn and Ralph continued to be separated by the war that raged throughout Europe. Evelyn lived at home with her family and took college classes. Ralph stayed at Camp Jackson where he helped to prepare new recruits for battle. Russ Lindsay, who served with the Thirtieth "Old Hickory" Division, so named for President Andrew Jackson, was sent to Camp Sevier and eventually was shipped out to fight in France as part of the American Expeditionary Force.

Evelyn traveled out-of-state to visit Ralph only once. Since she was considered too young to make the trip alone, did not know Ralph's father or mother, and had no one to take her to South Carolina, traveling to Camp Jackson was nearly impossible. Her only trip to see Ralph occurred when Dr. and Mrs. Wait invited Evelyn to accompany them to Asheville, North Carolina, where Ralph and his friend Charles Wait, who also was serving at Camp Jackson, joined them.

"Fortunately for me," she said, "there was no opportunity for Ralph to get by with what he seemed to take for granted were his 'marriage rights,' and I enjoyed the stay in Asheville with that group of congenial friends whose presence gave me protection and a temporary loss of the feeling of apprehension that was fast developing when I was with Ralph alone."

Evelyn was desperately unhappy. She was a ruined woman in love with a man who, in her view, had taken advantage of her youth and naiveté to seduce her. She deeply regretted their sexual liaison, feared its potential impact on her spotless reputation, and was hurt by Ralph's disregard for her wellbeing. Evelyn also was completely isolated. She had no one to talk to about her relationship with Ralph. Evelyn was convinced that she could never talk with her mother about sex; her sisters, who were much older, had married and left the family's home years earlier and were not available; and she could not

bring herself to tell the story of her seduction to her father. She felt that she had to bear the burden alone.

Ralph, relegated to a gritty training camp miles away from home, seemed to draw strength from Evelyn and from their intimate relationship. As he put it:

> I came back to camp a hundred percent more efficient just because of having been with you and talked to you. I was somewhat discouraged as you know and I was wondering if perhaps after all now that I had been thrown out on my own look where I must rise or fall according to my merits, I was a failure. You put me back on my feet again and filled me full of that fighting spirit which makes any man hard to down. Do you see what I am driving at? I had something to fight for, someone believed in me and don't you see I couldn't disappoint her. A man even with mediocre ability will go far if he has this feeling.
>
> Evelyn you are my ideal. Not that I think you are perfect. No one is. But you are the one person in whose eyes I don't wish to be a failure. If to others I seem a success and to you a failure then I have failed.
>
> I suppose every man feels this way about one woman. With me you are that one woman. I know that I love you because otherwise you would not awake everything that is good within me. I think we are congenial and I hope you think so. In fact you are the only girl that I am congenial with. The more I am with you the more I want to be with you. I like to talk seriously with you because you understand. I believe you know me better than anyone has ever known me and since I was home the last time I feel that I know you better than ever before. You are pretty and attractive but that isn't the reason I love you. It's because we are congenial and I feel like confiding things in you that I don't care to tell other people. You are the biggest thing in my life Evelyn and I need you. Don't fail me.

Ralph spent the remainder of his military service at Camp Jackson and wrote to Evelyn nearly every day. He was so lovesick, his commanding officer recommended that he marry Evelyn immediately. But Ralph decided that he could not support Evelyn properly on a lieutenant's salary. He did manage to purchase some rather expensive clothing, however, which he kept in his footlocker.

"I got a bill from Ross & Le Coultre yesterday for $103.00," he wrote in July 1918. "I am ruined financially but have some good clothes. After we get married [I] don't think I will have to buy any more clothes. I resented of my extravagance when I got back to camp but it was too late then."

Evelyn graduated from U.T. in the spring of 1918. During the summer she filled her days by volunteering with the Red Cross, and in the fall, she accepted a job as a substitute teacher in the Knoxville school system. She took the job because she felt that she should not continue to be financially dependent on her father, and she believed that Ralph could not support her on his military salary. At the beginning of the second semester, Evelyn accepted a full-time teaching position. Although she did not particularly like teaching, she figured that she could bear it until Ralph returned to Knoxville and they were married.

"You might as well get all fixed for when I get home next time there is going to be a wedding and you are going to be saying, 'I do,'" Ralph wrote to her. "Seriously dear I love you very much, so much more than I can tell you and I am going to marry you."

Each time Ralph came home on leave, he looked for ways to spend time with Evelyn alone. Often he was successful.

"Now don't you go regretting what happened while I was at home," he said in one letter. "The time I spent with you was absolutely perfect. I was never so happy. I didn't know I could feel the way you made me. It seems that I never knew what real happiness was until I found that you cared. I am almost afraid that it is a wonderful dream & I shall wake up. My entire existence is wrapped

up around you and you are the most wonderful thing that has ever come into my life."

With the signing of the Armistice on November 11, 1918, World War I ended. The doughboys climbed out of their muddy trenches in Europe. They cheered, laughed, and then cried for their fallen comrades. Eventually they came home.

Some of them brought the Spanish Flu with them. More lethal than the war, the flu killed an estimated 20 million to 40 million people in the pandemic of 1918-1919. The disease, named for a severe outbreak in Spain in May 1918, seem to travel along supply routes and on troop carriers. During the war, it festered in the fetid and unsanitary conditions of the trenches.

The first cases in the United States were reported before the war ended in a Kansas military training camp in the spring of 1918. Unlike previous influenza viruses, which seemed to target children and the elderly, this strain was most virulent in adults aged 20 to 40. Many of those who perished developed pneumonia, turned blue with cyanosis, and suffocated in their own blood. For many, death came rapidly, often within a few hours of the first symptoms.

The flu swept across the world in waves. It would strike hard and then ebb away, leaving an aura of calm in its wake only to return again with a vengeance. Many of the returning soldiers had lived through combat only to become infected on their return to the United States. One Illinois soldier recalled taking the train from the East Coast into America's heartland and becoming too ill to make it home. He got off the train in Louisville, Ky., rented a hotel room, and climbed into bed, wondering whether he would ever see the flat stretches of his home state's farmland again. Somehow, after several days of suffering, he survived to tell his story.

In a futile attempt to slow the spread of the disease, public health officials in major cities passed out gauze masks and imposed guidelines on the size and duration of public gatherings. Shopkeepers were asked not to hold sales, and funerals were limited to 15 minutes. They also questioned the wisdom of living in humid areas, such as

Knoxville, Tenn., where they feared that airborne water vapor might feed the growth of the virus.

By the time the pandemic burned itself out, an estimated 675,000 Americans had died, ten times the number of U.S. soldiers who had been killed in World War I.

<p style="text-align:center">❖━━━❖</p>

Ralph was lucky. He had avoided combat and the flu, and had served his country admirably. A few weeks after the war ended, he received his discharge papers and returned to Knoxville, where went back to college and earned his degree in 1919.

Evelyn had expected that they would be married as soon as he returned, but Ralph delayed their wedding, saying that they would be better off financially if he finished school first. Evelyn was taken aback by the postponement, but accepted Ralph's explanation and reluctantly agreed to wait a little longer.

"…[H]e was sure he was pursuing the right course," Evelyn said. "…I felt mean about seeming to try to force him to do something that he felt indicated a lack of interest in his success and a determination to make him take on responsibilities that he said he could not assume at the time because he was not 'in a position to.'"

<p style="text-align:center">❖━━━❖</p>

After graduating from college, Ralph went into business with his father at Gillespie, Shields & Company. He traveled with his father and Mr. Rodgers, the firm's textile judge, to New York City on buying trips, and held what Evelyn called "a position of importance" in the company. When his father suffered a severe nervous breakdown, Ralph assumed his role in the firm and became the general manager and buyer. Although he was young and inexperienced, he became responsible for the day-to-day management and operations of the business.

Despite his promotion at work, Ralph continued to put off the wedding. He told Evelyn that he had "to get his feet on the ground in business" before they could afford to have a home of their own. Ralph reminded her that they already had a "secret marriage," and

reproached her for wanting to formalize their relationship when she knew that they would face "an embarrassing struggle for existence." He told her they should wait "just another year when business would surely be better."

Although Evelyn was terribly disappointed, she knew that Ralph had reason to be concerned about his finances. In 1920-1921, the U.S economy plunged into one of the steepest downturns of the Twentieth Century. With business and industry no longer propped up by the wartime demand for goods and services, consumer prices dropped by more than 50 percent, unemployment climbed to 12 percent, and the nation's output plummeted. In Knoxville, Ralph and the other local jobbers tightened their belts and prayed for the economy to recover.

Confronted by an unwilling groom and a shaky economy, Evelyn had little choice but to wait a while longer for her wedding. The delay had no impact on Ralph's continuing demands for sex. He continued to insist that marriage was not a prerequisite. She gave into him frequently. To deny him would indicate to Ralph that she did not love him as much as he loved her.

"...[H]is interest in sexual relations steadily increased as I steadily withdrew more and more into a shell of fear, worry, and complete unhappiness," Evelyn wrote. When she tried to make him understand how she felt about continuing their physical relations outside of the bonds of marriage, "he pretended not to understand and went doggedly on with one of those smiling, complacent exteriors that can so perfectly ignore what it wishes to ignore and thereby exasperate its victim to a feeling of unpleasantness to say the least...It is a solemn truth that Ralph seemed to think of nothing but some sort of physical contact, running the scale from ardent caresses to greater liberties, which he arrogantly assumed were his right and that I should have nothing to say against them."

Evelyn described Ralph as an "avid extremist" in his lovemaking. Although he told her that he expected her "cooperation," she learned quickly that her active participation was not necessary. He reached climax very rapidly, usually within a few seconds. Evelyn said she

never encouraged or condoned their sexual relations and never truly cooperated with Ralph, but he never realized it.

"…[H]e gave himself over to such nauseating physical abandonment that he was conscious of nothing but himself and what he was experiencing within himself. I meant little or nothing to him, either when he was in a sexual mood or when he wasn't; any one else would have done just as well as far as any consciousness on his part went," she said. "…[S]uch abandon and total lack of consideration for me was physically, as well as mentally, painful and thoroughly unpleasant."

While she waited for the economy to improve, Evelyn continued to teach school and support herself financially. She also watched enviously as her and Ralph's mutual friends got married, bought homes, and started families. Occasionally their friends would ask when she and Ralph planned to marry. Evelyn was offended by their impudence and embarrassed because she did not know how to answer their questions. She became increasingly defensive and irritated at their attempts to "ferret out" details of her and Ralph's personal affairs. She said she considered their questions "impertinent interference."

Evelyn struggled to keep up the appearance that she and Ralph were a happy, loving couple when in reality she was miserable. Her unhappiness was becoming apparent. Occasionally she made snippy remarks to Ralph in public. Their friends noticed and disapproved of the change in her behavior and accused her of being mean to "poor Ralph." They believed that she was responsible for the delay in her and Ralph's wedding. As Evelyn explained it:

> My "meanness" was simply the visible evidence of a miserable hurt that was almost unendurable, and their attitude and talk, as well as Ralph's smug deceit, was no less than cruelty. Ralph…apparently enjoyed seeing me get the blame for our failure to marry and semi-joking threats of our friends if I did not marry him soon. What could I do to show them that it was not my fault—without exposing

him and my situation—except say that he seemed content enough, as I did time after time; but they did not believe me of course in the face of his smug smirks and meek silence. I even told them to ask him occasionally instead of always pouncing on me, but they took that as only a way to pass the subject off lightly.

In other words, Ralph watched casually while I floundered hopelessly in a trap out of which he made no move or said no word to help me, and my reaction to the feeling of strain and apprehension changed my disposition so noticeably that I was accused of being "more hateful than ever to poor Ralph," who still maintained his characteristic and most successful silence and surface sweetness.

If you could have seen him just once with me alone, I would not have to try to get across to you what a difference there was in his attitude when with me and when with a crowd of those who upheld him. With me he either was absorbed in the sexual or was sulky and silently angry if I had asked or insisted that he let me alone for the time being. I cannot stress too strongly his paradoxical attitude that I should not object to the "the only thing that marriage meant" (his own words) when he continued to postpone giving me a marriage that meant anything at all. He finally got it into a vicious circle—he would not set a definite date for our marriage, but in the meantime expected me to act as if we were married (as he said he felt he was and "just cannot understand why you do not feel as I do").

When I would not think and act as he did, that was his alibi for not marrying me, for, according to his reasoning, I would be no different afterwards—again a decision and a judgment of me in his arbitrary manner with no basis whatever. In other words, if I lived up to his terms, he might give me the ceremony and home that he continued to promise; but if I could not see fit to continue a situation that was the cause of my unhappiness and the irritability that

irked him so much, he decided that was a basis for his saying he figured I did not want to marry any one!

What he thought I wanted is a mystery to me, if he did not know after all the hours I spent trying to get my feelings through his thick skull. His impossible probation, as I term it, was that I must go on, doing just as he wanted and being thoroughly pleasant and having things just as he expected them, if I expected him to be obligated to live up to his promises. If I did not, he was thereby automatically freed from obligation, regardless of the hell he had made me endure in the past....

None of their friends was aware of Evelyn's dilemma because in public Ralph seemed to be the perfect gentleman. He also appeared to have plenty of money. He took Evelyn out frequently to the movies or to dinner, bought expensive clothes and cars, belonged to several clubs including the Cherokee Country Club, and took several trips each year. Despite complaining to Evelyn about the state of his business affairs, Ralph bought about $30,000 worth of stock in Gillespie, Shield & Company and paid for it from his profits.

Evelyn thought this investment and his profligate spending were odd in the face of his protestations of poverty and asked him about it. Ralph turned on her and accused her of wanting him to "slave" away at his store and never enjoy leisure activities with his friends.

"I cannot understand why you suspect me of ulterior motives when you know I am doing everything for our future happiness and success," he said. "You don't want to make a failure at marriage and a home just because you would not let me get on my feet before attempting heavy responsibilities, do you?"

Evelyn said that Ralph was a master at making her feel petty and selfish. She did not press him further. Only years later did she learn that he was making $4,800 a year, which was significantly more than the salaries that most of their friends were earning. At that time, the average non-farm annual wage in the United States was about $1,400.

In the summer of 1920, Evelyn caught typhoid fever and was ill for eight or nine weeks. She was seriously ill for about four weeks and had two nurses who cared for her around the clock. When her condition began to improve, her medical care was reduced to one nurse, who arrived early in the morning and left in the afternoon.

Ralph sent her flowers and called every day to inquire about her recovery. When she started to improve, he begged Mrs. Hazen to let him stay with Evelyn after the nurse left. Although Mrs. Hazen disapproved of it, saying that it was "too familiar," she eventually relented and allowed Ralph to read to Evelyn or talk with her for short periods of time.

One day, though, Ralph noticed that Evelyn seemed to be feeling better and was sitting up longer than usual. He asked to kiss her, which seemed harmless enough, but then he signaled that he wanted to do more. Evelyn was frightened; she was afraid that someone would walk in and find them. She told him he "was wild to risk such a thing" and that she did not want to have sex "for various reasons of a personal nature." But Ralph was determined.

"The truth is I was afraid to refuse and have him keep on and on about it until some one might have come in and been suspicious at least," Evelyn said. "I decided that the quicker over the better, but I was scared to death it would make me ill—the fright from it really did—but he didn't seem to consider how I would feel—kept saying I wouldn't feel any worse, for it never affected me much anyway. There was really no arguing around him, and nothing short of deliberate anger and curtness ever stopped him."

Evelyn became convinced that Ralph simply could not control his urges. Sex seemed to be the driving force in his life. To counter his advances, she tried to shrink away from him and use "sharp words" to dissuade him from being "inexhaustible" in his demands.

"That should have been enough for any decent person," she thought. She was wrong.

Chapter 5

In the early years of their engagement, Ralph expected Evelyn to give him what he called the "commonplace things of marriage" and to do "the very minimum one could ask." But on three or four occasions in 1921-1923, he initiated some additional sexual activities that Evelyn described as utterly repulsive and ghastly.

Ralph launched his new campaign with inoffensive baby talk and delicate terms that masked his true intentions. His talk of the "beauty and wonder of sex and love" cleverly concealed his objectives as he cooed gently in Evelyn's ear. She had no idea what he was talking about, but she finally concluded that his use of symbolic terms was a cover up for the "viciousness of his attempted perversions."

The first attempt occurred in Evelyn's living room after her mother, father and uncle, who lived with them, had gone to their rooms for the night. Evelyn was wearing a short skirt and was seated in a low chair, both of which were fashionable at the time. She and Ralph were talking when he walked over to her, presumably to kiss her. Suddenly, he slipped to his knees in front of her and began to kiss her knees and legs.

Evelyn was horrified. She pulled away from him and told him to stop. She had discouraged Ralph from touching her in a "too familiar way," and was not about to allow him to take such liberties with her body.

Ralph told her that he loved her so much that he had always wanted to "kiss [her] all over." Evelyn told him he was crazy, but he insisted that he was not any different than any other man. "You're the different from ordinary one," he said.

Still on his knees, he said, "There is absolutely nothing wrong in my wanting to kiss you. It proves how much I love you when I show you that I think one part of your body is just as beautiful and sweet as

another…You don't mind when I kiss your lips or hands," he continued, "I don't see why you would mind if I kiss everything.

"The fact that you're squeamish about touching me," he added, "except rather casually shows that you don't love me as much as I love you."

A stunned Evelyn stared back at him. She could not imagine that a decent, clean person would do such a thing. She had no knowledge of sexual acts other than intercourse, so to her the very idea of oral sex was sordid and perverse. "I simply will not allow it!" she said. "And I can't imagine how you could encourage me to do such a thing!"

Ralph, crestfallen at her refusal, said, "Evelyn, I am crushed and amazed that you would think for a moment that I, of all people, would encourage you to engage in improper behavior." Then he added, "You owe it to me because it means so much to me, even if it doesn't mean anything to you."

Evelyn stood her ground. "No!" she said. "It is out of the question."

But Ralph was not to be denied. Finally, he nearly begged her to allow him to do as wished and tried to sugar-coat his request. "Let me kiss (a symbolic term) just once," she recalled him saying.

Evelyn could not fathom why he would want to kiss her in such a manner, but she finally gave in. "Get it over with immediately just the once, if you must do it or die," she told him.

But she was totally unprepared for his so-called kiss. To her, it was vile and horrible, and not at all like a simple kiss on the body. She shrank back and tried to pull away from him, but Ralph grabbed her tightly as he used his lips and tongue to probe her.

Evelyn gasped, and gathering strength from her outrage and horror, she shoved him backward onto the floor. His head narrowly missed the sharp edge of a chair.

"Ralph, you are beside yourself!" she hissed at him, trying hard to avoid making a commotion that could be heard by her family. "It's ghastly that you would allow yourself to do things that you will be ashamed of later!"

Picking himself up off the floor, he said, "I don't see what you did that for. You certainly are getting to be quick-tempered."

Evelyn shot back, "Quick-tempered indeed. You certainly are getting to be indecent, and I will not stand for it."

Ralph, aroused and disheveled, ran a hand through his hair and tried to regain his composure. He glanced at Evelyn and came to the realization that she was not going to back down. Changing his tone, he said, "Evelyn, you're just very, very delicate-minded and fastidious and…although I adore you for being so sweet, I cannot help wanting to do those things. To me they are perfectly natural expressions of my love."

Evelyn was aghast. "Do you really mean to sit there and tell me truthfully that such filthy performances are actually taken for granted by married men and women?"

"They certainly are," he responded, "and people really in love see nothing dirty in it, as I do not. You are just as sweet in one spot as another to me and I'm just sorry you do not look at it the same way."

Ralph nearly had Evelyn thinking that she was "evil-minded" and had rushed to judgment against his behavior, but she was determined to hold him at bay. "I am sorry if you feel that you are being deprived of anything that you think I ought to do for you [now] or after we are really married, but I want you to know right now that you should never expect any such as that from me at any time and that our marriage simply cannot involve it, for I cannot stand it," she said. "Do you mean to tell me that our married friends do such things?"

"Yes, of course, if they want to," he said. "There's no harm in it. I would venture to say none of them would think it dirty and repulsive to see or touch each other anywhere."

The very idea of her married friends engaging in oral sex was reprehensible to her, and made her reconsider whether they deserved her respect. She admitted that she began to wonder what they did in the privacy of their own bedrooms. At suppers or parties, she would gaze around the room and ask herself, "Do you do such things as Ralph says you do and wants to do himself?

"I decided Bill McClure did not, for he looked too clean, but I thought Asbury Wright might very likely, for he looked so much a like a dirty, little hairy bear or baboon! Then I decided after all Ralph might be right, for he looked the meekest and cleanest of them all!

However, I figuratively shrugged my shoulders and made up my mind once for all that I would never allow Ralph to do such as that, no matter how cheated he would feel, and that ended it."

A few weeks later, though, Ralph tried to perform fellatio on her again. In a soothing voice, he used baby talk in an attempt cajole her into giving in to his desires.

"…[H]e got so stirred up he was almost pitiful from one point of view, and I was distressed that showed so little self-control and told him so in the kindest way I could," Evelyn said. "He brought up the subject always by asking me to let him 'kiss everything or (symbolic term) just once' and cloaking it all over by cooey baby-talk about 'tiss' instead of 'kiss' and a few other similar inanities."

Then one night Ralph tried to get Evelyn to "tiss" him. He pulled her head down toward his groin, and she slapped him. "…[H]is trying to make of me, as well as of himself, a degenerate creature who would use his lips for such a purpose was the last straw, and I jerked my head back and slapped his head nearly off.…"

Evelyn said the slap seemed to wake Ralph from what she called his semi-conscious, sex-absorbed state. She felt completely justified in striking him. As she put it, it was as though she had thrown ice water into the face of a drunk.

Ralph's preoccupation with sex was a constant worry for Evelyn. Whenever he became aroused, he seemed unable to think of anything but his own sexual gratification. She became so concerned about his inability to control his physical desires that she decided to speak with a doctor about him.

"Dr. Acuff said Ralph sounded like a victim of sex mania," she said, "and he certainly has acted like a maniac on numerous occasions when he has seemed really not to be able to act anywhere near as normal as a normal human being would, even under great tenseness and excitement; he did not seem to know or care how he looked to me or how little semblance of self-respect and dignity he was leaving himself."

Ralph's ever-increasing sexual appetite also raised Evelyn's anxiety about continuing to have sex outside the bonds of marriage. With great trepidation, she worked up the nerve to tell him that she

did not want to engage in any form of sex until they were married. A wedding ceremony, she said, would remove her apprehension and fear about intercourse.

Evelyn's decision made Ralph angry, and he responded to her "no more sex" decree by accusing her of being uncooperative and "prissy like her mother." He also informed her that he would not accept her ultimatum. She owed him sex, he claimed, and it was not fair for her to withhold it.

The callousness of his remarks brought her to tears. In fact, Evelyn said she cried "a good-sized lake full of tears" over Ralph's domineering attitude. But he would not be moved. So Evelyn sought other ways to find relief from his frequent sexual demands. On several occasions, when she saw signs that he was becoming aroused, she would begin a conversation about some trivial matter in hopes of distracting him. At other times, she took a more direct approach by asking him about the potential consequences of intercourse. Once she asked him what they would do if she became pregnant. He ridiculed her fear and called it "absurd" because he was using protection.

"...[H]e said if something did happen to me, he knew a doctor in Chattanooga who 'will get you out of it'...what was the occasion for his knowing such a doctor, I wonder?" Evelyn asked.

The very notion that normal people, particularly friends of hers, willingly engaged in sexual intercourse and fellatio soured Evelyn's opinion of the world. As she put it, it gave her "a pretty bad impression of humanity in general, when I thought of it at all, and, I feel sure, made me harder and less inclined to see the best in people, consciously and subconsciously." She said she developed a hard-boiled attitude, particularly when their mutual friends teased her about not being married. She snapped at them, and in doing so, inadvertently encouraged them to sympathize with "poor Ralph." Without knowing it at the time, she was playing directly into Ralph's hands.

Although she appeared self-assured and confident in public, Evelyn was completely overcome by self-doubt. Because she was ignorant of the sexual activities between a husband and wife, Ralph had been somewhat successful in convincing her that she was "overly

prudish." As a result, she wondered whether she was being unreasonable to expect him to withhold his only means of physically expressing his love for her. Still, for a period of several weeks, she refused his advances.

Eventually, Ralph caved in and agreed to forego sex. But he scored points with her by saying that a lesser man would not have been so "high-minded and holy" to make such a self-sacrifice. In fact, he implied that a lesser man would have walked out on her and left her to fare for herself. The very thought of Ralph leaving her was frightening to Evelyn. Since she now had carnal knowledge, she feared that she would not be acceptable to any other man.

With Evelyn refusing to engage in sexual relations, Ralph began to look for other ways to release his sexual tension. As a last resort, he turned to masturbation and tried to persuade Evelyn to assist him. His desire for self-abuse was her fault, he contended, because she was so opposed to sex in general. "It ought to suit you, for you hate to involve yourself so," he said.

Evelyn told him he was being crude and utterly unrefined, and was making her feel terrible. But her comments had little impact. He persisted, and then raised the stakes by once again encouraging her to use her mouth and tongue to satisfy him.

"When he began his wheedling and cooing to try to persuade me to allow him to make a pervert of himself and to become one myself, he would say, 'Honey, please tiss J——,' and other equally nauseating expressions of baby-talk mixed with symbolic viciousness. I told him I thought such talk was little short of blasphemy, certainly blasphemy of the sanctity of self-respect and one's feelings of decency; then he would begin that amazed, hurt line about not being able to understand why I thought he would want, much less permit, me to do anything wrong and why I allowed myself to see the sordid in such things when he had told me there was none..."

Ralph said to her, "Evelyn, why do you always seem to want to make me out awful and worse than anybody else...You always say

that I do not care about you except for the physical, and that makes me feel so terrible that physical things are then impossible…What do you want? What do you think I am?" he asked.

Evelyn said that she could not answer the last question because she did not know what Ralph was. But the other question was easy to answer. She wanted one thing: she wanted Ralph to fulfill his promise to marry her.

Chapter 6

Evelyn tried to convince herself that Ralph's voracious appetite for physical satisfaction was a temporary problem, an obsession that would subside over time. But Ralph continued to harp on it, insisting there was nothing wrong with sex because it was the logical expression of their love and devotion. And he reminded her that by refusing to have sex she was signaling that she did not love him as much as he loved her.

Evelyn weighed his arguments and his behavior in her mind, going over them again and again. There was little evidence, she decided, to indicate that he was a cold-blooded cad or a conniving thief who would steal her heart and lead her down the path to ruin. Despite his focus on physical love, he seemed earnest and caring, and nearly crazy with love for her. Whenever he traveled on business trips to New York, he wrote to her in aching detail about how much he missed her and wanted to be with her.

Evelyn reversed her earlier decision. She decided that she would have to give into him occasionally to prevent his breaking their engagement. At Ralph's urging, Evelyn also agreed to go on three weekend trips with him. She thought that "trying to please him…would be an incentive for his hastening" the date for their wedding.

During these trips, Evelyn noticed that Ralph was developing a predictable pattern for entering and leaving the hotels. He would drive up to the entrance, leave her in the car while he went inside to register, usually under the name of "Mr. Yates," using the name of an old Army buddy, and then send the bellboy to the car for Evelyn and the luggage. When they checked out of the hotel, he would ask the bellboy to take the luggage and to accompany Evelyn to the lobby, while he retrieved the car from the garage. As a result, Ralph and Evelyn were never seen together in the lobby, where a chance visitor from Knoxville might see them masquerading as husband and wife.

Aside from the fact that Ralph would pressure her for sex, there were times when Evelyn truly enjoyed their excursions. The trips gave the young couple the opportunity to talk about their plans for the future and the travels they would make together after they were married, including summer vacations and his business trips to New York. Ralph also showered her with little presents, including magazines and candy.

Although she was impressed by his thoughtfulness, his generosity raised a question in Evelyn's mind: How could Ralph afford even small extravagances when he claimed to be struggling in business? If he could afford to buy her presents, Evelyn figured that they should be able to live on his salary. But when she mentioned this to him, he told her that she did not understand household finances. The money he spent on theatres, flowers, candy and magazines was a pittance in comparison to the cost of supporting a wife and a home, he said. Just wait awhile longer, he crooned to her in a soothing and fatherly voice, until he "got on his feet financially."

Emboldened by Evelyn's decision to engage in sex from time to time, Ralph began to search for additional opportunities to maneuver her into a bedroom. One warm summer day, when Ralph and Evelyn took her friend Ruth Mills from Knoxville to Spring City, Tenn., to visit a friend, Ralph suggested that they take a different route on their return trip and stop in Chattanooga for dinner before driving home that evening. After they dropped off Ruth, Evelyn and Ralph drove to the Patten Hotel. When they arrived, Ralph got out of the car and left Evelyn alone in the passenger seat. Although they had no plans to spend the night at the hotel, Evelyn did not ask him why; she thought that would have been rude. Instead, she waited patiently, figuring that since it was too early for dinner, they would ride around town awhile and come back to the dining room later.

When Ralph returned to the car, he said, "Let's go in and freshen up a little now, and then go out until dinner time."

Ralph accompanied Evelyn into the hotel and onto the elevator. Assuming that he was piloting her to the ladies' lounge, Evelyn got off the elevator with him and then discovered that "Mr. Yates" had gotten them a private room.

"…[I]t was too late to do anything but go on, as the wife he had represented me to be would have done, or make a scene by refusing, which would have been the worst thing I could have done," Evelyn said.

"Much to his displeasure I remained in the room only about thirty minutes, permitting only once what he would not take 'no' about and that for only a moment, instead of the several times he probably had in mind when he came to the hotel. He could have murdered me, as usual, because I thwarted his plan, after permitting once what I realized I had to to keep him endurable at all, for otherwise the rest of the day and evening would have been very unpleasant. I then proceeded to fix my hair, powder my nose, etc., and insisted on leaving the room and riding in town until dinner time."

Reluctantly, Evelyn admitted to herself that giving in to Ralph from time to time did not have the desired effect. Sex was still uppermost in his mind. She noticed that he was easily aroused by the mere hint of a sexual subject. Worse yet, he had begun to order and read books that were "advertised luridly in first one magazine and another." He tried to get Evelyn to read them but she said could not "wade through the stuff." Ralph also bought experimental birth control aids, claiming that he heard about them in New York from a business acquaintance. Evelyn flatly refused to experiment with what she called these "pseudo-scientific" items.

Ralph's buying trips to New York seemed to feed his interest in all things sexual. Indeed, it was on the streets of Manhattan where he was exposed to the modern lifestyle of the Big City and the risqué entertainment that had grown in popularity in the early 1920s. The cosmopolitan attitudes and the nightlife of New York were quite a contrast to his life in Knoxville.

Ralph seemed to enjoy the titillating shows that were all the rage in New York in those years. In a letter he sent Evelyn in 1923, Ralph described his reaction to seeing the Follies for the first time:

> I went to the Follies last night, and I wish you could have been with me except certain parts of the show bordered on the indecent. Am glad Billy Sunday [the traveling evangelist who campaigned for Prohibition] wasn't there. I sat on the third row and believe me it was no

place for a Presbyterian deacon. I'll admit it got me down and I haven't gotten over the effects of it yet.

I have seen about all there is to see of the Folly girls and it didn't help me any. There were also some very clever comedians among them Mr. Gallagher, Mr. Shean and Will Rogers. The latter in his monologue said that he was tired of the men using him as an excuse to come to see the girls. He said a man in the follies was just about as important as the intermission—just there to give the girls time to change their dresses or rather rearrange their clothing and put it where it would do the most good.

Seeing the Follies seemed to inflame Ralph's sexual passion for Evelyn. He wrote:

I would give anything if I could see you tonight and hold you tight in my arms and just love you and love you and love you. I try not to be wild but what's the use. I can't beat down the feeling that is me. I will love you placidly (is that the word) a part of the time but you must make up your mind that I will also be as wild as an Indian some times and right now is one of them. Guess you are glad I am in New York but some how I feel that if I could be with you, you would like it. Is that conceit? Please say it is not and when you write tell me if you like for me to love you real wild even at the risk of being eaten up. I love you darling more than I can tell you in a letter and I simply wish to be with you and feel those red lips that are so warm and sweet.

Love, Ralph

P.S. Better not save this letter.

P.S. This sheet has been censored and rewritten.

P.S. Think I will lay off of the oysters.

Ralph wrote letters to Evelyn every time he left town on business, and he usually complained bitterly about being separated from her. But, in a move that was perplexing to her, he also insisted upon going on a vacation lasting a few weeks each year without her.

46

During several summers, he went to Blowing Rock, N.C., to find respite from the Knoxville heat and humidity and to play golf and tennis. In his letters, he said he was dreaming of the day when they would be married and could take vacations together.

Evelyn told him that she was terribly lonely when he traveled and asked him to forego his extended vacations. She said he responded "in a very peevish, accusing way, 'You certainly are selfish not to want me to have a little rest. I can't work all year and not get away in the heat of the summer, for I am not as strong as you are.'"

Once again, Ralph had succeeded in making her feel petty and unappreciative. Years later Evelyn learned that Ralph had not gone to Blowing Rock simply for rest and relaxation. Starting as early as 1921, he spent much of his time at the resort enjoying the company of what the local boys called the "summer girls."

Chapter 7

During the early years of the Twentieth Century, Bible-thumping evangelicals crisscrossed the continent preaching about the evils of demon rum. Liquor, they postulated, was responsible for many of society's ills, including the dissolution of families, poverty, and crime. These preachers claimed that drunkenness was a mortal sin and alcohol had to be outlawed.

Their campaign against liquor grew stronger at the end of World War I, when a tide of immigrants flooded into the United States. These newcomers to America initially moved into the cities and then fanned out across the country, bringing their peculiar habits and their appetites for drink with them. Suspicious Americans, who had prayed for the safety of their sons and husbands in the war and endured the pestilence of the flu, discovered that the Germans were fond of beer; the Irish liked their whiskey; and the Italians imbibed in wine. The fact that they all were predominately Roman Catholic added to the under-current of distrust and religious discrimination that rarely was discussed openly but that was an accepted fact of life.

The potent combination of religion, distrust, and politics prompted the U.S. Congress to take action against alcohol, but not until several states had passed laws of their own. In fact, 33 states including Tennessee already had outlawed alcohol by the time the Eighteenth Amendment to the U.S. Constitution was ratified on January 19, 1919. The amendment prohibited the "manufacture, sale, or transportation of intoxicating liquors...for beverage purposes." Since many interpreted the amendment to cover whiskey and other distilled spirits only, it did not adequately address the Germans' and Italians' use of beer and wine. Therefore, the U.S. Congress passed the Volstead Act, named for Congressman Andrew J. Volstead of Minnesota, which applied Prohibition to any beverage containing more than one-half of one percent of alcohol.

The evangelicals and the other anti-alcohol forces were triumphant. Billy Sunday, who preached that America should be "so dry, she can't spit," proclaimed the end of the tyranny of liquor.

"The reign of tears is over," Sunday said. "The slums will soon be a memory. We will turn our prisons into factories and our jails into storehouses and corncribs. Men will walk upright now, women will smile and children will laugh. Hell will be forever for rent."

During the first few months after Prohibition went into effect on January 19, 1920, it successfully combated the evils it was designed to defeat. Fewer deaths were attributed to alcohol, there were fewer hospitalizations for alcohol poisoning, and homicide rates in major cities were beginning to decline. But the early successes of Prohibition were quickly outweighed by the long-term outcome.

By 1922, finding ways to defy Prohibition was becoming a national pastime. The consumption of liquor began a meteoric climb. Speakeasies opened in out-of-the-way locations in cities and towns across the United States, where the lure of liquor encouraged risk-taking behavior. Gangs, including the Mob, were formed to control and market the illegal liquor trade. Grain alcohol, sold legally for industrial use, was poured into bathtubs to concoct "bathtub gin."

The so-called Noble Experiment became a great travesty that did exactly what it was set up to defeat. Rather than discourage alcohol consumption, it encouraged it. Rather than prevent the destruction of families, it pushed them ever closer to the brink.

As alcohol rose in popularity, the very fabric of society changed. Women began to drink and smoke with the men. The strictures of the Victorian Age were reduced to rubble, chivalry eroded, and propriety vanished. Fed by Vaudeville shows that traversed the country stopping in every small town with a theatre, the bawdy humor that had developed a following in New York was transported to Middle America. The so-called Age of Innocence was replaced by the Roaring Twenties, a decade of decadence and self-indulgence.

These new ways of thinking and behaving crept stealthily into Knoxville and altered the temperament of the times. Fanned by huge income tax cuts in the 1920s, easy credit, and cheap prices for everything from food to automobiles to radios, Knoxville's young

social elite danced at the Cherokee Country Club, played golf and tennis, and relished the devil-may-care freedom of the times. Their ready access to money and booze loosened their tongues and the bindings of their formerly staunch moral code. And although these young southern socialites were perfectly proper in public, behind closed doors they sent morality scurrying for cover.

Evelyn, still the young Southern belle, was dismayed by their new attitudes. As a teetotaler, she had no interest in drinking, gambling, smoking or their off-color humor, and she was easily embarrassed by rudeness. Attending private dinners or parties with Ralph's friends became a thoroughly unpleasant exercise for her.

During the sweltering heat of the Tennessee Valley summers, some of Ralph's social set occasionally would hold a weekend "house party" at a cottage in the Smoky Mountains where the cool mountain breezes and mountain streams offered a welcome respite from the heat of Gay Street. Since these affairs generally were attended by couples, Evelyn usually accompanied Ralph.

One summer in the early 1920s, Asbury and Margaret Wright invited Ralph, Evelyn and a group of friends to their cottage on White's Creek for a weekend house party. Everyone except Evelyn drank, smoked, and as she put it, "acted the fool rather generally." The Wrights were put out with Evelyn because she did not participate in their antics. In fact, Asbury Wright commented that he hoped Ralph would drop Evelyn and start dating someone who was "a better sport when it comes to drinking and hearing a dirty joke without looking pained." At one point, Margaret grew angry with Evelyn after she had witnessed Margaret's "startling change from [the] role of charming hostess...to plain rudeness" when she joined in the drinking, smoking and gambling.

A few days later, someone gave Evelyn the credit for spreading gossip about the party. Evelyn, who swore that she had not uttered a single comment about it, asked Ralph to tell Asbury that she was not responsible for the rumors, but he made no apparent effort to set the record straight. In his usual silent manner, he listened to Evelyn but took no action to defend her.

As a result, the Wrights and Hugh and Elizabeth Goforth became openly hostile to Evelyn and told her that they intended to drive a wedge between her and Ralph. In their view, poor little Ralph had gotten himself into a relationship with a shrew who was trying to ruin their reputations by telling tales all over town. When Asbury Wright confronted Evelyn directly, Ralph did not go to her aid. He just stood there, with a little smile on his face.

Evelyn came to the painful conclusion that Ralph was more loyal to his social clique than to her. Her friends told her that "Ralph must have acted the way he did in order 'to keep in with' the crowd he thought would make him appear more prominent."

The idea that Ralph was a social climber troubled Evelyn greatly. Yet, the evidence was unmistakable. As she put it, Ralph "always defended his newer associates by saying, 'They know that you don't like to drink and smoke or hear risqué stories, so you can't expect them to like you.'"

By the time of the house party, Ralph had purchased an engagement ring for Evelyn. She was thrilled initially, but was puzzled by his casual suggestion that she should wear it on her right hand and tell her friends that it had been a birthday present.

Soon afterward, she accompanied Ralph and parents on a Sunday afternoon drive. Mrs. Scharringhaus asked to see the ring. Evelyn removed it from her finger and handed it to her. Mrs. Scharringhaus examined the ring, gave it back to her, and asked her about the engagement.

The question was disconcerting to Evelyn because she did not know the Scharringhauses very well and she was a little intimidated by them. Ralph's mother, who had suffered from tuberculosis, was ill much of the time and was considered an invalid. His father, who was highly regarded in Knoxville for his fiercely aggressive and successful approach to business, was not very approachable.

After they briefly discussed the engagement, Mrs. Scharringhaus asked, "Evelyn, does Ralph always expect to find things just as he wants them and is disagreeable when he doesn't?"

Evelyn was surprised by the question, but answered, "Yes, I believe he does, but I am afraid I am not a very good person to live up to that expectation, for I cannot read his mind ahead of time very often."

"I've tried to break him of that habit his entire life," Mrs. Scharringhaus replied, "but I haven't been very successful."

Mr. Scharringhaus glared at her but said nothing. Ralph, who was driving, stared straight ahead.

In the early spring of 1924, Evelyn noticed that Ralph's ardent affection for her had begun to cool. In fact, she described him as "lukewarm—a startling contrast to his attitude in 1917 and that of any other year, on occasions when he wanted what marriage meant to him without the marriage itself." Evelyn grew worried, and pressed him harder than ever for a marriage ceremony. Ralph agreed to marry her in October.

In the hope that her ordeal—her "impossible probation"—finally was drawing to a close, Evelyn happily picked out clothing for her trousseau and talked with her friend Ruth Mills about the bridesmaids' gowns. Then in June she heard that Ralph's aunt Mrs. Tate had told friends that Ralph's parents did not like her.

Evelyn was crushed. She asked Ralph to find out whether this tidbit of gossip was true, but he passed it off casually and told her that his mother had not talked about her and Ralph to anyone. That explanation was not enough to quell her concerns:

> I told Ralph how I dreaded having to endure his family's dislike...and asked him if he thought it would be better to postpone our wedding date until the spring of 1925 so that I might be able to fathom the difficulty and correct it. I thought it would be easier to do so before we were married than after, when they might become set against me, just because we had seen fit to be married over their veto, so to speak. I thought at this time that a few months longer might mean a lifetime of benefit to every one

concerned, and I was desperately anxious to have everything as propitious and happy as possible.

I knew Ralph would be of no help where his family was concerned even after our marriage, for his silences and the attitude that he could say more than he was going to, made things more difficult and mystifying than anything else he could have said or done. Although I was terribly worried, of course, about the existing situation between us, I felt that so much had already happened that the betterment of domestic conditions would more than warrant the short delay in righting the moral conditions.

Ralph agreed to the delay and at Evelyn's urging, set a new date of March 1925. "I told him that if I could not change things by then, I would feel I had done all I could and would then go on and marry him without their enthusiastic approval," she explained.

But Evelyn saw no attempt by Ralph to schedule a meeting with her and his family. Instead, he simply would not talk about it. He was not belligerent or argumentative, nor did he actually refuse. Rather, Evelyn described him as "sitting smugly by not saying a word," as though he were holding his own private, silent protest against her pleas for help.

During the fall and winter of 1924-1925, Evelyn noted that Ralph "broadened his impenetrable, insolent silences on many subjects to include the subject of our marriage and his family's attitude." And, as usual, Ralph offered her no assistance against the hurtful comments of their friends, who blamed Evelyn for delaying their wedding plans. On the contrary, Ralph "more or less defended" them, she said.

Ralph continued to vacation in North Carolina, and despite his apparent reluctance to discuss their marriage, he still wrote love letters to Evelyn nearly every day. From Blowing Rock in 1924, he wrote:

Honey I love you better than everything in this world and the longer I am away from you the more I love you. You are my sweet Baby and the only girl there is as far as I am concerned…you surely know that I am crazy to see you and can hardly wait to hold you in my arms again. I love you and I love you and then love you some more. I can't begin to tell you how much you mean to me. After this I know we will have to take our vacations together. We can spend our real honeymoon in March and then have our second honeymoon a little later in the summer. In fact it will be one continuous honeymoon won't it sweet child. I wish you were here tonight Honey for I am as lonesome as I can be. I only hope you are missing and wanting me as much as I am you. I am wild for you angel and when I get you again I am never going to let you go. Will you be satisfied Honey?

…There is a big kiss for the sweetest Baby in the world.

Yours,
Ralph.

Evelyn was eagerly anticipating their March wedding, and was planning to resign from her teaching position. At the time, married women were not allowed to teach in the Knoxville schools. When the first term of the school year ended in January 1925, Evelyn said to Ralph, "I certainly am glad I am not going to have to go back to school next term."

Ralph replied, "Why, aren't you going to teach again next term?"

Evelyn was stunned. Wide-eyed, she whimpered, "I hadn't thought so, Ralph. Do you want me to?"

Ralph, avoiding looking her in the eye, said without emotion, "I think you ought to decide about that yourself."

Evelyn felt as if the wind had been knocked out of her. Unable to speak, she searched Ralph's face for any sign that he understood the significance of his words. A week later, when the time came for

Evelyn to resign from school, she tried to bring up the subject again. Ralph put it off with a "noncommittal silence" that took the place of his earlier explanations of not having enough money.

From that point on, Ralph never brought up the subject of marriage. Whenever Evelyn mentioned it, or suggested that they publicly announce their engagement, he told her they should delay "for a little while."

"He gave no reason for this opinion, as he never did for any of his superior ideas, but was so positive about it he knew I would not venture to argue with him and bring on a disagreeable scene for him to blame me for," Evelyn wrote. "I also urged him to talk with my father about our marriage before I should have to mention it myself—if for nothing else but a matter of courtesy. But he put that off too...nothing was ever a definite refusal with him. He simply evaded both a refusal and a definite agreement by exaggerating inconsequential details, which he assumed, over my head, were quite sufficient reasons for what he wanted to do and I was a fool if I didn't think so."

Evelyn was completely mystified by Ralph's reluctance to get married in March. She believed that a man who had held himself up as honorable, gentle, and as a deacon in his church would uphold his promise. The month of March came and went, and Evelyn continued to wait, forlornly, for her reticent groom.

Chapter 8

"Wouldn't it be nice if both of us could go to New York City at the same time this summer?" Ralph asked in June in 1926.

Evelyn frowned as she considered the idea. Always worried about her finances, she was concerned that the trip might be too expensive for her schoolteacher's salary. Since her graduation from college, she had made a point of paying all of her own bills except for repairs to her automobile, which had been subsidized by her father. She studied Ralph's face and silently wondered whether his appetite for physical pleasure would reassert itself the moment they were alone together. "No," she said finally, "I can't go."

But when Ralph mentioned it again a few days later, offered to pay her expenses, and help her come up with a plausible story to tell her family, she changed her mind. Maybe Ralph had had a change of heart, she thought. Perhaps he would be willing to get married during the trip and "eliminate the necessity for a more…expensive wedding" in Knoxville. Convinced that getting married was part of Ralph's plan, Evelyn waited with great anticipation for him to make the travel arrangements.

When they arrived in New York, Evelyn went to her hotel room in the Waldorf and Ralph went to the Astor. For a day or two, they remained in their private rooms and enjoyed their time together touring, shopping, and going to shows in the city. Then Ralph suggested that Evelyn move into the Astor with him.

His arguments were persuasive and Evelyn acceded, deciding that if he did not surprise her with a wedding the very next day that she would force a conversation about it. Ralph checked out of his single room and reregistered in a larger room as Mr. and Mrs. Yates, in keeping with his usual routine.

After they moved Evelyn's luggage to the Astor, they had lunch and took a walk along lower Broadway. When they spotted St. Paul's Chapel, they went inside to look around. Evelyn knew there was a

memorial tablet in the chapel to General Robert Montgomery, one of her ancestors, and they walked over to see it.

"Wouldn't this be a wonderful place for us to be married?" she hinted. "Here, near the tablet and in this historic place. What a romantic and interesting place for our wedding."

"Yes," Ralph answered, "but I think that I would prefer the Little Church Around the Corner."

Evelyn eyed him cautiously, and did not mention their wedding again that day for fear that she might make him angry by rushing him. That night they went to dinner and a theatre, and spent the night together.

Although she dreaded being alone with Ralph, she felt she had to endure his sexual demands and not put too much pressure on him. As she put it:

> ...[I] had learned from sad experience just about how much I could and could not say to him without throwing him into one of his silent, stubborn spells when he would do nothing I asked...[I wished I] could just hit on some incentive that would make him willing to carry out his promise—even if just to please me...My only chance was to 'catch him off-guard,' I might say, by occasionally doing what he wanted in the hope that he would in return do what I wanted...
>
> Mine may have been a groundless philosophy, but I had to evolve it alone—by the trial and error method as the psychologists say—while I was so apprehensive I didn't know what to do for fear I would make a wrong move that would destroy what little progress I thought I had made. I was still believing that an essential decency would urge him to do as he should. His profession of so much religion also helped to fool me, but I am inclined to think now that religious people—even preachers—use their religion sometimes for things never intended by the Lord. I am convinced that there is a vast chasm between churches and preachers and God and religion....

The next morning, Evelyn confronted Ralph. She told him that she had expected him to surprise her with a wedding in New York and was hurt that he had not taken any steps to arrange for a ceremony.

She added, "It is quite apparent that you have enough money for us to live in our own home modestly, if you can afford to spend as much as you're spending here in New York."

Ralph stared at her silently for a moment. Finally, he said softly, "Getting married here in New York would not be the right thing for either of us. In fact, our getting married here so suddenly would be ridiculous. We're too old to do such a silly, romantic thing, and I don't think you'd want to lay yourself liable to being laughed at about it, since you hate our affairs being discussed."

Then he added, "I cannot imagine hurting my parents by running off and getting married without letting them know beforehand. I am the only child they had and they would be crushed if I showed that I had so completely forgotten them."

A few days later, when it became abundantly clear to Evelyn that Ralph was still reluctant to marry her, she left him in New York and went home alone.

In a move that surprised her, two months later Ralph invited Evelyn to join him in New York at the end of one of his regular buying trips. At first, she turned him down flatly, but later decided that she would meet him there and demand an immediate wedding ceremony. "...[I]t was the first time I had made up my mind to demand instead of merely ask and go on trusting him to tell the truth about his intentions of righting the situation that had always been such a hell to me," she said.

Evelyn met him at the Astor and told him she would stay with him only if they were married. She did not want to make him angry because she knew that would be counterproductive, but she was determined not "to let him have his way again...."

Ralph responded by accusing her of being unfeeling and inconsiderate. "Your behavior certainly shows plainly that you don't care much for me or trust me. I do care for and trust you, Evelyn," he said. "I still want to marry you more than anything in the world when I can."

Hearing him put the blame on her and use the same old excuses gave Evelyn the courage to stand her ground. For the first time in her life, she stood toe-to-toe with him and made it clear that she could no longer accept his tired explanations. She left New York and traveled to Washington, D.C., to visit her friend Ruth Mills, who was living there at the time.

Despite the unpleasantness that had occurred during the New York trips, Evelyn continued to cling to the hope that Ralph would marry her. In fact, she had no concrete reason to suspect that he would change his mind. After all, she reminded herself, they were still engaged; he had sworn that he loved her and promised to have a wedding as soon as it was practicable; and he had taken no direct action to terminate their relationship.

Although they clearly had their difficulties, they continued to go to various events as a couple. During the summers of the mid-1920s, for example, Evelyn and Ralph accompanied each other to house parties at Julian Pernell's cottage at Kinzel Springs along with a group of their single friends. During the evenings, the entire group, which included Evelyn's sister, the recently separated Mrs. Caldwell, often would go to the Dow's cottage nearby to play bridge or to the creek for a swim.

Evelyn was much too afraid of snakes to swim at night, so at one of these parties Ralph suggested that they stay at the cottage while the others were swimming. Evelyn was grateful for his thoughtfulness and foolishly did not suspect that he had an ulterior motive until the crowd had been gone about five minutes.

Ralph wrapped his arms around her and suggested that they take advantage of being alone. Alarmed, Evelyn pulled away from him and told him point-blank that she would not go to his bedroom or allow him to come into hers. But Ralph continued to pressure her. Even when their friends returned from swimming and were in the room with them, he stayed close by, bent toward her ear, and whispered suggestive remarks.

"Ralph, I wish you would hush," she said to him, raising the eyebrows of the others in their group who assumed that she was being hateful to poor Ralph.

"After a few days of injured-innocence put on by him," Evelyn wrote later, "I tried to convince him how careless his ideas were and told him I thought he himself ought to have sense enough not to consider such a thing there. Then he said that if I would consent once, he would not ask me again. Although he knew how frightened I was and how I hated the idea anyway, it made no difference to him as long as he got his way by hook or crook. After the one incident, which was more nerve-wracking to me than usual, if possible, I saw to it that I wasn't left alone with him any more."

In the summer of 1927, Evelyn received some aid and comfort from an unanticipated source. An acquaintance Carl Stafford, who was planning to attend a different house party at Kinzel Springs, called her mother and asked whether Evelyn or Mrs. Caldwell needed him to take any additional items to them. There were a few items that Evelyn thought she would like to have, and Carl made the delivery to Pernell's cottage.

Ralph did not appreciate Carl's kind gesture. He thought Carl was interfering and made a point of being rude to him. Evelyn, on the other hand, was grateful for Carl's thoughtfulness. Over time, she began to view him as "a port in the storm" who helped her get through "many a bad hour."

Ralph, who had grown increasingly irritated by the appearance of this new man at the cottage, went home to Knoxville a day or two after Carl's visit. Although he told Evelyn that he amused himself for the rest of the week by playing poker with the boys or by going home and spending time with parents in the evenings, he actually was running around town with his married friends and entertaining Grace Wilson, one of the women in his office. Evelyn did not learn of his escapades until later.

Before Ralph left the cottage, he made a comment to party attendee Mildred Eager, one of the schoolteachers at the high school where Evelyn taught, that Evelyn had "killed his love for children."

"How?" Mildred asked, looking truly amazed at this revelation.

"She doesn't like them," Ralph relied.

Evelyn, dumbstruck, waited until Mildred and the others had wandered away and asked, "Ralph, how could you make an unfair statement like that?"

He smiled and said, "Well, you dislike everything connected with sex, so I thought you didn't like children either." Ralph then accused her of calling children "brats."

The comment was a crushing blow to her. Years later Evelyn wrote:

> I shall feel forever that I have been denied what every girl and woman thinks of at some time or another with perhaps the greatest of all seriousness, even sacredness, and that is child of her own. Not that I think now a child of his would have had much chance in the world, but had he not tied me by those invisible chains for so long my very soul became warped, I do not think it too unlikely that a decent man with normal instincts might have come along with whom I might have lived a happy life, with a home and family to fill the days and interests that were totally wrecked by having to go on with uncongenial work, gradually becoming estranged from my old friends, and—worst of all—enduring in silence a living hell of clinging desperately to the one hope that might correct things to outward appearances at least. I gave up hope of anything but outward appearances and peace of mind long ago, but I did not even find that. Perhaps, further to cover up Ralph's treachery, I have pretended not to care about domestic things, just by not talking much about them. But, what would have been the point in talking about them when it would only have made me appear ridiculous? A forced levity I did not feel—but which became almost second nature—has carried me over many a rough place, but at the same time has put me in the wrong light with people who see only the surface. It was, though, either that or exposure. I've never known which is worse—to appear

cold and casual or to show that I am miserable—in other words, whether to cuss or cry!

Sometimes, in answer to one or two people who have reproached me for "keeping Ralph dangling and denying him the home and children he would just adore," I have asked what made them think he would "adore" all the things they talked about, adding that he had never indicated it to me and that he seemed to be pretty well satisfied, going and coming as he pleased with no responsibilities to tie him down. My saying that, however, did not convince them, but whatever he said about me they believed and exaggerated with a lot of driveling sentimentality that often made me want to tell them the truth about their little angel and let them see how they liked that. I venture to say, though, they would have tried not to believe it and would have condemned me, rather than him, as the one causing the trouble....

As the long engagement and the meddlesome criticism of their friends slogged wearily into another year, Ralph suggested that Evelyn start seeing another man occasionally. He told her that being seen with another man occasionally might relieve some of the pressure she was feeling from their friends' impertinent questions about them going together for so long without getting married. He also assured her that they would still get married, but since his business was struggling they would not be able to afford a home in the near future. Their plans would materialize, he promised, "...[J]ust as soon as I can get on my feet well enough."

Again, Evelyn felt she had no choice but to comply with Ralph's suggestion. He had begun calling her less frequently for dates and dinners, and she was staying at home alone several evenings each week where she was miserably lonely.

Chapter 9

Evelyn truly did not understand Ralph's motivation when he recommended that she start seeing another man, but his reasoning seemed to make sense. Perhaps Ralph was right when he told her sweetly and with great compassion that being seen with another man might dampen the criticism caused by her long-term and exclusive relationship with Ralph. Besides, he said, he wanted to play poker with the boys occasionally, and he would not mind if she went to movies with someone else when he was not available.

Ralph had launched the idea with such courtesy and consideration that she was loath to dismiss it. At a minimum, she hoped it might temper the rumors that were beginning to circulate around town that implied she and Ralph might be having sex outside the bounds of marriage.

Evelyn and Ralph calmly discussed who would be her best choice for an escort. None of the men in their immediate social circle was available because each of them was either married or engaged. Finally they agreed that Carl Stafford was the logical choice. He had expressed an interest in dating Evelyn, and he was polite and mannerly, not pushy or aggressive, and was excellent company.

But soon after Evelyn began to see Carl socially, Ralph announced to their friends that Evelyn "had left him flat and had begun going with some one else." He also told them that he had not had anything to do with her decision to date Carl.

In an apparent attempt to bolster his story, Ralph began spying on Evelyn and Carl in order to document her unfaithfulness. He had "no other possible motive than to embarrass me before Carl and make him think that I was 'sneaking off,' so to speak," Evelyn said later.

Evelyn believed that one particular incident illustrated the "monumental hypocrisy" of Ralph's deceit. As she described it, Ralph was "parking his car down the street from my home one night when I had told him I was going to a picture show with Carl since he was

going to play poker, as he had said he was. He peered at us from behind those glasses when we passed as if he were trying to bore holes through us; but for once I had beat him to it, for I had told Carl something of the hateful way Ralph acted in order to put me in a bad light with his friends and excuse himself for some of his meanderings. Carl's comment, that long ago even, was that he wasn't surprised at anything a man as snobbish and smug-looking as Ralph could do."

The next time that Evelyn saw Ralph, she asked him why he had been checking up on her. "...[H]e tried to evade the question by acting as if he didn't know what I was talking about. When he saw he couldn't pull a stunt like that," she said, "and perhaps was just plotting something to blame me for...he looked like a little boy caught in the jam-jar.

"On more than one occasion Ralph...followed me when I was riding with Carl, even though he knew I was going out with him because he had told me he could not come to see me. When I asked him later how it happened he had had time to trail along after me, he would explain that his plans had been changed at the last minute! I told him more than once that if he wanted to waste the gasoline following me, he could, but that he would not find anything to raise a rumpus with me about and he knew it."

Despite their disagreements, Ralph still invited Evelyn to go with him to major events and parties around town, including football games. From the beginning of their association, Ralph had taken Evelyn to the University of Tennessee out-of-town games always with a large crowd of people, usually by train, with the women sharing one drawing room and the men in another. For the 1927 game against the University of Kentucky in Lexington, however, the men and women slept overnight in the same Pullman car. As usual, Ralph asked Evelyn to be his date for the game, and suggested that she take someone with her if she could not go alone. Evelyn suggested that they invite Miss Gertrude Penland, the sister of Ralph's friend Clifford Penland, to go with them.

Evelyn assumed that she and Gertrude would have reservations for adjacent sleeping compartments, and when Ralph purchased the tickets he would ensure that the women were located near each other. But Ralph had other plans.

"I don't want us to be crowded," he said with a wide smile just before they boarded the train. To Evelyn, he added. "I'll just keep your ticket, for you might lose it."

"May I see the ticket, please, so I'll know which berth is mine?" she asked.

Reluctantly, Ralph handed it to her. Evelyn's berth was directly below Ralph's, and Gertrude's berth was at the other end of the car.

Evelyn was furious, but she did not speak out for fear of causing a scene in front of all of the Knoxville people who were boarding the train. "Gertrude [and the others] would immediately have thought...that I was just trying to be disagreeable," she said.

Evelyn hoped to exchange tickets with Gertrude, but Ralph did not give her a chance. He kept Evelyn's ticket, "putting it back in his pocket with an indulgent smile at me as if I were some sweet, silly little thing that didn't have sense enough not to lose a ticket."

Evelyn knew what was in store for her:

Before this time Ralph had voiced a very vulgar ambition, which was—of all the absurd and disgusting things—to experience sexual relations on a train. Incidentally, he first thought of this on the first New York trip in 1926, but I refused to let him carry it out. He made his plans more craftily this time, so that I would at least be accessible.

After every one had retired—Gertrude at the other end of the car—he began writing me notes and poking them down through the crack by the window, begging me to let him come down and insisting that he was going to, whether or no. I wrote back in the strongest terms I could think of and told him what a fool I thought he was to risk clambering down behind the curtain and probably attracting all sorts of attention. I also said, further to try to dissuade him, that the car was full of Knoxville people, any

one of whom would be delighted to snap up even a suspicion of such a thing and talk about it, and also that I simply would not put up with it and that I resented the way he had bought the tickets and then waited too late for me to object to it except in Gertrude's presence.

Notes went back and forth several times, and when he saw I would not agree to his plan, he quit writing and came down anyway. I told him I would give anything in the world if I had the nerve to arouse the whole car, but he knew all I could do was complain to him, and he paid no attention to that as long as he accomplished his selfish aims. And, if that isn't accomplishing them by force, I don't know what it is. I made him go back as soon as I could, but he refused to do so until he had carried out the rest of his plan, after arguing in his usual baby-talk and extreme affectionateness that I knew was most easily overcome by getting the experience over with as quickly as possible, so he would calm down to a point where he could at least hear what I was saying.

I do not think I was showing such a terrible disposition when I became slightly exasperated with him, when he kept on talking his foolishness while I was trying to get a word in edgewise to try to make him see how I felt about it and why. (I am not exaggerating when I say I do not think the man was responsible for all he did and said when he reached the high degree of emotionalism of which he is capable, and I feel sure what I said and how much I disliked it did not penetrate his consciousness until later, when he usually went to the other extreme of being indifferent, sulky, and peevish.)

The next day, Evelyn tried to pretend that she "was having a grand time in Lexington," although she was "almost ill from apprehension about the risks" he took in the Pullman car.

"I recall hardly an occasion that sex did not enter into it in his mind, and in his activities, if there was the barest opportunity for

it—and sometimes when there wasn't an opportunity that was not fraught with all sorts of risks. He was so insanely obsessed with the thing always uppermost in his mind he could not grasp the fact that such as that was controlled in my mind entirely by the fact that I was not married to him," she said.

After the Pullman episode, Ralph never invited Evelyn to go with him to another out-of-town football game. He also reduced the number of dates he had with her each week to three or four. Without Carl's occasional visits and invitations to the movies, Evelyn would felt more alone and isolated than ever.

Ralph, meanwhile, complained to her that managing the business was draining his energy so completely that he had to go to bed immediately after dinner several nights each week. His exhaustion also affected him during the weekends, and he suggested that Evelyn go out with Carl on Saturday night. Ralph said that he knew Carl wanted to see her one night each weekend, and if Ralph "'had to take his choice,' he would take Sunday night rather than Saturday."

Evelyn was suspicious of his true motivations. She asked him whether he was seeing other women, particularly Grace Wilson, who worked in his office.

"Of course not," Ralph responded. "I am shocked and dismayed that you would even think that I might be interested in anyone else. And I want you to know that I would never consider having sex with another woman. I can't stand the thought of it," he said, "because I am completely in love with you."

But she was not convinced. She had heard rumors that Ralph had been seen in Grace's company, even after she got married in 1927. Furthermore, she had received reports that Ralph was going to the Cherokee Country Club and to the movies with a new crowd of younger, married couples and was attending informal Saturday evening buffet suppers at their homes. He also reportedly was playing cards and gambling for an hour or two during lunchtime at his friends' offices.

When Evelyn confronted him, Ralph denied it all. Yet, the rumors persisted. Evelyn wondered whether the Ralph she had fallen in love with—the courteous, thoughtful, respectful church deacon—had been supplanted by a new Ralph—the smoking and drinking bachelor who indulged his fantasies, ignored his obligations, and who had completely bought into the Roaring Twenties' so-called sophisticated life-style.

Years later, Evelyn's friend Louise McClure told her, "All of our old crowd, except the [Asbury and Margaret] Wrights and the [Hugh and Elizabeth] Goforths, who I can't deny really have tried to cause trouble between you and Ralph, hesitated at first to ask Ralph to our little gatherings without you, but we thought, from what he half-silently insinuated, that you did not like us because we teased you and anyway that you had new friends and other interests that you preferred.

"He led us to believe that he was just wandering around loose most of the time, and when he mentioned you less and less and played the part of unattached bachelor, we began asking him," Louise said. "And don't let him tell you for one minute that he did not come all the time…he certainly has been at the Goforths, day and night."

"I hate to repeat it so often, Evelyn," Louise told her, "but it is absolutely inconceivable to me the way that man has lied to you."

By 1928, Ralph's "meanderings," as Evelyn called them, had expanded beyond the boundaries of Knoxville. During one of his buying trips to New York City, for example, Ralph ran into two of his married friends from Knoxville, Louise McClure and Elizabeth Goforth, and volunteered to escort them to dinner and to the theater on several occasions. Weeks later in Ralph's presence someone remarked to Evelyn that he heard that Ralph had "quite a gay time" in the city with Louise and Elizabeth. Evelyn, who knew nothing about the incident, shot a look at Ralph and noticed that he "looked as if he wanted to die."

That fall Ralph continued to go to the out-of-town football games with the same crowd as before, but he did not invite Evelyn. In

70

fact, he seemed to prefer attending social events and football games alone. On one trip, he met a young woman named May Parker in Nashville and wrote letters to her nearly everyday after he returned home. An employee at Gillespie, Shields & Company told Russ Lindsay that she was ordered by Ralph to mail the letters each day, some of which were sent special delivery. Separately, another employee told Evelyn that Ralph called Parker by long distance from the store at night. Ralph's end of the "conversation was very cooey," the employee reported.

Ralph's infatuation with Parker lasted into 1929. Although he never told Evelyn about his affair, she witnessed its impact:

> Ralph changed for the worst faster than before, and gradually (as he did everything else) ceased telling me anything about where he was or what he was doing when he did not see me. He never volunteered a single thing, intending, of course, to say as little as possible...I recall vividly a sort of glittering gleam of satisfaction in his eyes behind those big glasses he used to wear, as if he gloried in his ability to hurt me and to appear the enigma, as well as in my helplessness to stop him.
>
> Not as flagrant and outrageous as his moral conduct and cowardly treatment of me, but very indicative of him as an individual, is the way he acted socially from 1927 on; it was really disgusting to an observer how he showed his petty, grasping, social-climbing tendencies. Lies, deceit, deliberate isolating of me, and any number of other things he did to force a smooth surface and hide his duplicity show clearly that his character, at least, has been consistent throughout. He has plenty of purse-pride but none about things that sicken most people. On a few occasions it was amusing to observe how he actually tried to patronize me and act "coolly superior" to the people I liked best, as if he were conferring a favor on all of us by giving us an evening that he might have spent with his "sophisticates" like Clifford Penland, the Goforths, and others of that ilk—than whom there are no worse. His choice showed his ignorance

and lack of discrimination, but—like all novices at the social game—he thought he must follow the lead of the wildest, most pretentious group rather than the sensible people who were accustomed to it all and did not have to strike a pose and pretend superiority.

After the Parker affair ended, Ralph rekindled his interest in Georgia May Ferris Power, now a grass widow, whom he and Evelyn had known in college. When Evelyn asked him why he had gone to see her, he replied that she had invited him to her home to discuss business and that it would have been rude for him to refuse.

Often though, when Evelyn asked Ralph about his whereabouts, he simply did not reply. He "rapidly increased his capability for noncommittal silences and flat refusal to answer any kind of questions or reply to any kind of conversation by simply staring at me and not answering," she said. "I have not exaggerated anywhere when I have said that one could ask him a direct question, look straight at him, and wait for an answer, and he would look straight back and not say a word. When I think of that and one or two other of his marked characteristics, I wonder if he might not be just a little haywire."

The harsh reality of her situation finally was dawning on Evelyn. She was merely a plaything for Ralph, who used her for sex with no real assurance that they ever would get married. And at the same time he was disparaging her to their friends. In fact, Ralph had convinced their long-term friends that she was abusing him emotionally and was no longer interested in marrying him. In so doing, he had advanced his status as an eligible bachelor.

Evelyn's anxiety and despair deepened. As she described it, she "shrank inwardly and was often on the verge of tears from sheer miserableness," and she was "so self-conscious and humiliated" that she "dreaded coming in contact with people for fear they were thinking uncomplimentary—even suspicious—things."

The realization of her predicament and the emotional pain changed Evelyn profoundly. Her formerly youthful and serene face became hard and creased with worry. Her trusting and pleasant disposition was replaced by defensiveness that was manifested by aggression and hatefulness.

"I know that the change in my own disposition was logical under the circumstances, which I had no choice but to accept at least for the time being...[because] Ralph more or less encouraged his friends' remarks about how I was dangling him along heartlessly," Evelyn recalled.

"...[H]e had lied like a dog and broken every promise he had ever made," she added. "At first, he would have preferred that I did not know what he had been up to, but since I did, the next best thing was to ride over me and any weak opposition I could put up, and then go on with the campaign of social activities that he had started and was not going to give up—as with all climbers, the end justified the means."

Chapter 10

In the heat of the summer in 1929, Evelyn traveled north for a few days to stay with Ruth Mills, who had moved to New York City. She hoped that the trip would give her time to think, gain a new perspective on her situation in Knoxville, and to figure out how to solve her problems with Ralph.

Before she left, Ralph made a point to tell her several times he would not object if she became interested in another man and chose to marry him. To justify his position, he used a sentiment that Evelyn had become all too familiar with. He said that he would not want "to stand in [her] way now that my business is on the toboggan."

Evelyn had become too cynical to fall for his usual, worn out, old alibi. "You wouldn't be trying to slide out of your obligation and promises to me, would you?" she snapped. "Is this your way of pushing me to move on with my life without you?"

"No, of course not" Ralph replied. "I am not trying to get you to break our engagement," adding that she was still his sweet, little girl and the only one that he truly loved.

But a few days later, Ralph changed his tune, apparently gaining the courage to write down on paper what he could not say to her face. He wrote a letter suggesting that she should break their engagement and that they should try "to go on" with their lives separately.

Evelyn described it as one of the "meanest" letters she had ever received. "I replied to this letter immediately, and told him how surprised and dreadfully hurt I was that he would wait until I had gotten away to try to forget my unhappiness for a little while to write me what I thought was a very cowardly, unfeeling letter that he knew would make me even more miserable," Evelyn said. "I let him know also that I would not consider consenting to a break with him and still expected him to live up to his promises to right my situation and give me at least the peace of mind the lack of which he knew was causing all my unhappiness."

Evelyn was so upset by Ralph's letter that she burned it. She said the very sight of it was "hateful" to her.

When Evelyn returned to Knoxville at the beginning of September, Ralph was still involved with Georgia Power and made no effort to call on Evelyn. But after she had been home for about a week, he invited her to go for a drive in the country. As they drove along, Evelyn made it very clear to him that she still expected him to marry her. Ralph capitulated. He told her that in his view, they were "still engaged."

By that time, however, Ralph's continuing excuses about the state of his financial affairs had become more plausible. In 1929, the partners of Gillespie, Shields & Company decided to liquidate the firm. Mr. Shields told Evelyn that when he learned that "Ralph was running the business into the ground by all sorts of improvident expenditures and poor management some way, he went down one day and told them he had come to close out the business, because he was not anxious to lose all the money he had put into it."

When Shields approached Ralph with the news, he exploded. Shields reported that Ralph was startlingly "rude and very aggressive" in contrast to the "meek, rather pious young man" that he had seemed to be previously.

Ralph was in the process of shuttering Gillespie, Shields & Company when the stock market crashed in October 1929. The madcap, devil-may-care days of the Roaring Twenties came to a screeching halt on Wall Street and eventually filtered down to cities, towns, and farms throughout the United States.

Ralph read about the stock market's financial losses in the morning newspaper. While the reports were disturbing, they held little immediate relevance for him. He had his own business problems right there in Knoxville.

In 1929 and 1930, Ralph's silence on the subject of marriage became totally impenetrable, and he began to concoct elaborate lies and long narratives to explain his comings and goings. Yet, Ralph sought out Evelyn when he was in the mood for sex, still insisting

that she owed it to him. In her view, he expected her to be "an unquestioning slave" to him, an active participant in and a compliant receptacle for his "selfish whims and bestiality."

In fact, Ralph seemed more absorbed with sex than ever before, largely because he was suffering from what Evelyn called, a "physical debility in sexual aspects." For the first time, he was confronted not only with Evelyn's opposition, but also his own inability to perform.

"...[H]e forced me to submit to his efforts a few times; and I was glad something had stopped him," she said.

Ralph blamed Evelyn for his physical dysfunction. "I can't react normally because you've made it abundantly clear that you're opposed to sex before marriage," he said.

"That's strange," she replied. "I've been opposed to sex before marriage for years, but it has never stopped you before. In fact, you've never paid any attention to what I wanted."

With his problem showing no signs of improving, Ralph returned to masturbation for relief. And he demanded that Evelyn assist him. She considered his behavior utterly disgusting:

> ...[H]e insisted on that awful self-abuse more at this time than before, and seemed to be beside himself on some occasions with the determination to go through with it to the climax...He seemed so preoccupied and unconscious of my presence that I wondered if he could have been doing something of the kind when there really was no one else around him; he acted like it certainly, and Dr. Acuff said that and other characteristics indicated it to him. When he was with me, he wanted me to help him, but I would not think of it except on a few occasions when I knew the only thing to do was to get the horror over with...[H]e forced me to it by holding my hand so tight I could not get loose and going through the necessary activity himself. I turned my head away and pulled away entirely as quickly as possible. He had the grace to keep my hand protected by his handkerchief, but anything of the kind in that connection was sickening to the point of nausea...

I railed against [it] so strenuously that he began saying I was more "different" than I had ever been. I do not know what he thought he was. I did tell him at this time of our association that I was about convinced that all he cared about me for was the gratification of his desires; then he pounded on my stand on the subject as the cause of his queer state.

Evelyn said Ralph actually trapped her into helping him by insisting on masturbating while sitting in her home while her mother, father, Uncle Lon Mabry, and her sister were upstairs.

I can say truthfully that Ralph really forced me to his will occasionally and got away with it because I did not dare risk creating a disturbance by arguing with him and talking about how awful he was. He never was apparently concerned about the possibility of being overheard in his conversation on the subject or of his tone of voice sounding peculiar to a possible hearer. He knew too how suspicious dead silences are, but he sometimes lapsed into them either from sex absorption or the sulks, and left me to do the best I could to keep up a one-sided conversation for the sake of appearances here at home, where sounds of course can be heard upstairs, and the absence of them even more so...

I suppose I should have caused a disturbance at his expense, but naturally I avoided that, as well as his anger, as much as possible. Nothing but a debasing row would have curbed him in this most extreme moods of that kind, and that is the reason I developed a strong verbal defense to protect myself without everybody around knowing about it, or at least knowing that we were having some kind of rumpus. I believe he banked on my inherent horror of the crude when it came to scenes; that sometimes seems worse than enduring some of his special brand of physical crudeness.

To escape from Ralph's sexual demands, Evelyn decided to travel to Europe in the summer of 1930. Her plans called for her to take the train to Cleveland, Ohio, change trains, and travel on to the port of Buffalo, N.Y., where she would board a ship. Jack McKnight, a man that Ruth Mills had introduced her to in New York City, offered to meet her in Cleveland and drive her to Buffalo. Evelyn's protective and doting father was grateful for Jack's offer and approved the arrangement. Ralph and Gertrude Penland escorted Evelyn to the train station in Knoxville for her departure.

That night at the train station, Ralph never mentioned that he would miss her. Instead, she got the impression that he was glad she was leaving town. In a marked change from Ralph's earlier penchant for letter writing, she got only three letters from him the entire summer. On July 3, 1930, he wrote:

Dearest –

I have been intending to write you all this week but I think I told you that Mr. Wood [one of the partners in Gillespie, Shields & Co.] was leaving us at the end of June and as a result I have been busy every minute. At night I have been too tired to write or do any thing else. However I hope this will reach you soon so that at least you will know I am thinking about you and loving you.

I received your card from Montreal and your letter from the boat came this morning. I am sorry you are not particularly pleased with the other members of your party but maybe they will improve on longer acquaintance. I am sure the remark about your outward appearance is no reflection on the others for you would be smartly dressed in any group. Just act as nice as you always look and nobody can resist you. Perhaps I shouldn't have said that because it may put bad ideas in your head particularly in the light of a dream about you that I had the other night.

It seems that I was along on the trip and we were in England or France. I came into your bedroom and there were several people visiting there. You were sitting on the bed dressed in a most alluring nightie and seemed to be

enjoying yourself thoroughly. In the crowd was some man whom you invited over to the bed for a kiss. When he responded I naturally objected and when you persisted, I left in a very perturbed state of mind. That was all, but I can still see you in the nightie and can remember how sweet you looked. I guess I wanted to kiss you myself.

There is no news to write. I have been working and have not seen or heard from any of our mutual friends. However think I will call Gertrude & Lida shortly. Tomorrow is the 4th and we will be closed until next Monday. I expect to rest and maybe play golf or tennis. I have thought about you and wondered how you are getting along. It is too bad you missed Niagara but from your card you will see the falls on your way home. At this moment you are plowing through the waves and I hope you are having a glorious time and are not sick.

Take care of yourself. Have lots of fun and write when you can. All my love,

Yours,

Ralph

When Evelyn returned from Europe, Jack McKnight met her at the dock and escorted her to the train station so she would return home safety. Evelyn and her family were grateful for his kindness, so that Thanksgiving they invited him to stay with them when Jack traveled to Knoxville to look for a job. With the economy worsening, he had lost his position in New York.

To entertain him during his visit, Evelyn suggested that she, Jack and Ralph go to the U.T. football game in Knoxville together. Initially, Ralph agreed, but he changed his mind at the last minute. Evelyn was convinced that Ralph was setting her up by making it appear that she was more interested in Jack than him.

She was right. Ralph had managed to serve up one more false example of Evelyn's apparent cruelty to him, thus enabling him to ingratiate himself further with his married friends. They felt sorry for Ralph, took pity on him, and to ease his emotional distress they

stepped up their efforts to invite him into their homes for drinks, parties, and casual suppers on weekend evenings.

According to the rumor mill, Ralph took full advantage of his status as the wronged and abandoned bachelor. That fall, he reportedly developed an infatuation with Louise McClure, and later became interested in Elizabeth Goforth, the wives of two of his best friends and the same women that he had escorted in New York a few months earlier. When he shifted his attentions from one to the other, his change of heart led to some heated words between the two women.

When Evelyn heard about it, she observed that she did not think that "...Louise would stoop to have a rumpus about an affair of that kind, even though it is just about Goforth's speed."

It was clear to Evelyn that Ralph had escalated his meanderings to a new level. They had become so blatant and so noticeable, and so threatening to their engagement and wedding plans, that she had to take definite action. With the rumors about Ralph's activities swirling around her and throughout the community, Evelyn decided that she would tell her father about Ralph's behavior and what she termed his "particularly acute inconsiderateness and surliness." In early spring of 1931, she asked her father to speak with Ralph.

"I hoped that a reprimand from Father would be sufficient to bring Ralph around without my having to wreck completely what little was left of a possibility for saving the rest of my existence," she explained. She hoped that a few words from her father would spur Ralph into marrying her:

> Father spoke to him rather positively about it and said that he had noticed a very decided change in him in recent months, and asked him if he wanted to quit coming to see me, why he did not say so instead of indicating it by rudeness. That was my chance to have put the whole situation before my father, and Heaven alone knows how hard it was for me to stand by and not do it. But Ralph went on at such a great rate to Father about how I misunderstood him and believed idle rumors that were not true and so on and on, until he convinced Father of his sincerity. He made

the positive statement there in my presence *that he had never gone with or been interested in another woman since he had known me and that it was the greatest tragedy of his life (his very words) that he had not yet been able to make a financial go of things,* adding very plausibly then that my father knew how bad business was and so on. (This is late as 1931!) He said also that he felt I knew that his one aim was business success so we could be married.

Father told him that he was not intending to ask what his intentions were, so to speak, but certainly thought he had been coming here long enough to have made up his own mind about them. Ralph was so frightened at the probability that almost any minute I might let the cat out of the bag that he put on the best and most convincing performance I had seen since much earlier days, and even I believed him enough to decide to give him at least one more chance to do what he had promised to do, when he could.

You see I still believed *he really meant to do so,* and I thought a while longer of hell was better than crashing down with a drastic move that would have accomplished the marriage ceremony but little else, if there were any possibility for anything else. At any rate, it would appear better on the surface, and only Ralph and I would know the truth. His tale about business also put me in the light of being really unfeeling and unreasonable if I pushed him at that time.

After the conversation with her father, Ralph was more attentive to Evelyn. But by summer, he had reverted to his usual pattern of seeing her a couple of times a week and spending more time at the homes of his married friends.

Evelyn complained bitterly to him. "Complaining was my great offense; it annoyed his highness, for I was supposed to be flattered that he noticed me at all, I suppose," she said, blaming his rudeness on "his arrogant, German attitude toward women."

In mid-July 1931, Evelyn again traveled to New York to escape her lot in Knoxville, and to attend a secretarial school. She figured that she would need to learn new skills if she ever decided to find another career. By this time, she had been teaching school—a profession that she did not like—for several years. When Mildred Eager, a fellow schoolteacher who was a few years older than Evelyn, heard that she was going to New York for a few weeks, she asked to go along and insisted that Evelyn ride along with her in her car.

"The arrangements were to divide expenses on a 50-50 basis, but when it came to her paying her part of the apartment in New York, where she stayed over three weeks in all, she ignored the fact that it was the most expensive item of the whole trip, and paid nothing—neither did she refer to it in any way. One would have thought she was a guest," Evelyn noted. "I think she was peeved because I did not drop my work and find some men to entertain her, but she did fairly well by herself, if Fred Bonham can be called an attraction, for she ruined one of my best hats on a 'petting party' with him!"

Ralph wrote only two or three letters to Evelyn that summer. In them, he stressed that he was leading a "simple life," and was watering the flowers in his parents' garden after dinner and then retiring to bed early. He also mentioned that he was playing tennis with Hugh Goforth, Elizabeth Goforth's husband, from time to time.

After Evelyn returned to Knoxville just before the beginning of the school year, Ralph's visits to her became even less frequent. Then, when Carl Stafford left Knoxville in September to work in New York for a marble company, Evelyn was without an escort once again. She felt deserted and alone. She was afraid to go out at night by herself, and it was improper to attend any social events, including parties and the movies, without a man. So after work each day, she went home and stayed in her room, hoping to avoid spending any more time than necessary with her family members.

Evelyn speculated that her sisters and at least two of her three uncles were jealous of her because she clearly was her father's favorite. Each time he showed his obvious affection for her, they seemed to grow more hateful. To protect herself from their

disparaging remarks, Evelyn avoided them as much as possible, particularly her uncle Lon Mabry. In her view, it was easier to keep to herself than to interact with people who seemed to resent her very existence.

In the fall of 1931, Ralph went to the U.T. football games and sat next to Elizabeth Goforth and her husband. His attraction to Elizabeth was becoming increasingly obvious, and he was criticized thoroughly by others in his social circle. Even Ralph's closest friends said he was "making a complete damn fool of himself."

Occasionally, Ralph called Evelyn and invited her to go to a movie, usually accompanied by Gertrude Penland. Evelyn began to call Gertrude "inevitable," because Ralph rarely went out with Evelyn in public without Gertrude by his side. Although he did not offer an explanation for Gertrude's near constant presence, he did attempt to explain why he was unable to see Evelyn very often. He said he was completely exhausted from working at his new store, a small dry cleaning establishment on Clinch Street in Knoxville, and that he went home to his parents' house nearly every night and collapsed into bed.

In actuality, as Evelyn learned later, he was "stepping out" socially.

"I know now that those months, and the first two or three of 1932, were the high point in his social career as the popular bachelor in attendance on his sophisticated married lady, Mrs. Goforth," she revealed. "…[A]t football dinners and big dances at the Country Club, [Ralph] always [was] very noticeably taken up with and dancing attendance on Mrs. Goforth."

Evelyn told Ralph that she had heard he had been the country club with his married friends, but he denied it, adding that he did not know that the club even held such parties and dances. He also promised her that he "would not go to those people's homes to any entertainment including the women and that he would not go out publicly with the men and their wives."

Yet, the reports about his social activities persisted. "One would think he had told me he would be with them as much as possible, but

he promised whatever it took to keep me from wondering about him and having a possible eye and ear on the alert to find out what he was up to on the sly, during the many days and evenings I didn't see him or even hear from him for over a week at a time," Evelyn noted.

"The contrast between the Ralph I saw and the Ralph other people saw was so great I could not help feeling disgusted at his deceit, as any one knowing both sides of him would have felt. But others knew only one side, and of course did not see why I did not wax as enthusiastic and as 'gurgly' over 'that sweet Ralph' as they did."

During the Christmas holiday, Evelyn escaped from Knoxville and traveled to New York. Upon her return, she was told that Ralph had spent nearly every evening with the Goforths, either at their home or at the club. When she confronted Ralph with the story, he told her not to listen to "idle gossip."

"He *denied everything*, even after he knew people who had seen him had told me," she said. "His attentions to Mrs. Goforth were so marked that even the steward at the country club and his wife remarked on it and wondered if Hugh knew about it."

Ralph's lies and his carefree, single man-about-town lifestyle had become an embarrassment to her. Evelyn finally had had enough.

Chapter 11

By the time Evelyn returned from spending the 1931 holiday season in New York, she had made up her mind to tell her father the whole story about Ralph and ask him to settle the matter by insisting that Ralph marry her immediately. But when she arrived at home in early January 1932, she discovered that her father was sick and in bed with what appeared to be a bad cold. She decided to wait until his condition improved.

But the cold worsened. Evelyn began to worry that her father would not recover. She feared both for his health and for her own situation. Rush Hazen was the one person she could count on. With his unwavering integrity, sound judgment and good sense, he had been like a clock ticking in a hurricane, a dependable and steady force that had weathered wars, the boom and bust of the economy, and the changing mores of society. She loved him dearly and admired him more than anyone on the face of the earth.

"I was so afraid Father would not get well," she recalled later, reflecting on how much she was depending on her father's help. "Somehow I felt it and knew instinctively that I was slipping fast from every angle."

Evelyn also was afraid that Ralph might take advantage of her father's illness as a means to abandon her entirely. To keep him interested in her and to buy some time, she continued to give in to his sexual demands:

> The physical incompetency that had been so marked in 1930 and 1931 was still recurrent, according to him, but by 1932 he had almost regained his usual physical—as well as mental—rampant state on the subject of sex. (The mental never diminished; in fact it seemed at times worse when he was practically incapable of accomplishing his desires than it had been before, and Heaven knows that was more than enough.)

Even though he had apparently recovered to a great extent, he seemed still to prefer an abnormal cause for his reactions, and twice in May of 1932 wanted me to do as he had always wanted a year or two earlier—the self-abuse he tried to make me a party to by holding my hand so tight I could not get away from him. Although the thought of such sordidness made me ill, I had made up my mind by that time that I would steel myself to almost anything this side of actual nausea to gain my goal, if it were only the formality of a ceremony that would free my mind of the agonizing thoughts that had been my lot for so long...But I could not stand much of it; it seemed worse after the long absence of such things, but I had to give in once or twice to that as well as to a normal sexual relation.

...[I]n none of his rottenness in any degree, normal or abnormal, did I take any initiative. My terrible position and the reactions it had brought in every phase of my existence have been like a sword dangling over my head from the very beginning, but I had become so accustomed to it I took almost for granted that unhappiness covered by a mask of pretence at indifference was my lot. The ceremony I asked would have done a lot to help, but I do not believe anything would have given me the life I might have had had I never seen that skunk.

Evelyn finally had come to the realization that having a home and a happy and secure marriage to Ralph Scharringhaus was only a dream, a shadow that grew pale and vanished in the full light of day. She acknowledged that her involvement with him had become a self-destructive habit based on the frail and false hope that he would honor his commitment to her.

So early in 1932, Evelyn stopped clinging to that dream and felt it slip silently away from her fingertips. The empty void was filled immediately with remorse and bitterness, and the terrible realization that she must have a wedding ceremony to preserve her fractured sense of self and her standing in the community. She no longer

expected Ralph to live with her as husband and wife after the wedding, but she believed he had an obligation to make her an honest woman. More than anything, she wanted "peace of mind," and for the first time in her life she said that she "had the stamina to stand on [her] feet and fight back...."

Armed with a new goal and a renewed sense of purpose, Evelyn questioned Ralph more aggressively about rumors she had heard and demanded that he verify or deny them. Around the first of April, she told him that one of her friends had seen him in Todd's and Liggett's drug stores with Elizabeth Goforth on several occasions. She also told him that she had been driving down the street one day and Evelyn herself had witnessed Ralph and Elizabeth going into a drug store apparently for a drink at the soda fountain.

Ralph denied the allegations vigorously and told Evelyn that he was adhering to his earlier promise to avoid gatherings where his friends' wives would be present. But he did admit meeting Elizabeth at a drug store once, saying that she called him at his store and asked him to meet her there. She told him that she had a message for him from her husband Hugh, and using an excuse he had told Evelyn before, he said he could not turn her down "without appearing *rude.*"

Then he added a bit prematurely, "If you hear that I have been at their house *a few times recently,* you can know *now* that I *had to go* to see Hugh on business."

Evelyn replied accusingly, "Well, I've been told that you are at the Goforths' all the time, and that Hugh and Elizabeth are very fond of you and enjoy having you at their house."

"I swear that I've never been in their house more than a dozen times in my life," he exclaimed, "and never except on business!"

She pressed him harder, and Ralph finally admitted that he had been going to the country club in the company of several married couples for the past year. But in his opinion, he said, "he did not think he had broken the *letter* of his promise even if he had broken the *spirit* of it."

Then Ralph promised that he would not go out with his married friends ever again, "...if it will make you feel better and prove to you

that I am not doing as idle gossips tell you I am…because I would not do those things anyway."

Evelyn, disgusted by Ralph's prevarications and yet desperate to keep their engagement intact, decided not to push him farther. She felt she could not risk him breaking off what remained of their relationship.

The confrontation did have a positive effect. Ralph became much more attentive and pleasant to Evelyn. He staged what Evelyn called "the remarkable come-back" with her in late April and May of 1932. He told her that he mistakenly thought that she did not care what he did or where he went. Evelyn considered his explanation "ridiculous," but she did not challenge it. "I knew contradicting him would just make him worse instead of better," she said.

If Ralph was actively attempting to hide his social activities from Evelyn, it clearly was not working. In fact, she was beginning to receive a significant amount of information about Ralph's whereabouts from anonymous telephone calls that were coming into her home. Sometimes a man would call, sometimes a woman. She was convinced that two of the calls placed to her in the spring of 1932 came from Asbury Wright and Elizabeth Goforth, because she thought she recognized their voices.

"Mrs. Goforth used to have the habit of annoying people by anonymous telephone calls when she was a kid, and she may not have completely outgrown it," Evelyn postulated.

At first, Evelyn hung up on the callers, assuming that they were children pulling a prank. But as the calls persisted, she began to listen. The callers nearly always informed her where Ralph's car was parked at the time. "We wonder if you know that Mr. Scharringhaus's car is parked at the Wrights'," or at the Goforths', the callers said.

Evelyn did not tell Ralph about the calls, but she did ask whether he had been at the Wrights' or Goforths', as the callers had reported. He always denied it.

Evelyn decided it was time to find out who was lying—the anonymous tipsters or Ralph. Despite her fear of leaving the house at

night, she checked on the veracity of the information by getting in her car, often as late as nine or ten o'clock at night, and driving to wherever Ralph's car had been spotted. On a few occasions, she took Mildred Eager with her.

"I found that he was always at the Wrights' when reported there, but never at the Goforths', so far as I could see by turning around in their driveway thus throwing my car lights down their drive," she said. "This left something of a doubt in my mind, but I could not account for the complete accuracy about the Wrights' and the failure on the Goforths'. I learned later that the reason I never saw his car at the Goforths' was that he parked it either behind the house, when Hugh was there, or behind the hedge on Midland Avenue when Hugh was out of town."

At about the end of April, Ralph's mother fell and broke her arm. Ralph called Evelyn and told her that he planned to stay home for a few days so he would be available in case his mother needed help. Evelyn sent flowers immediately and did not question Ralph on his plans, although it was widely known that the Scharringhauses had employed the services of trained nurses on and off for several years. The older Scharringhauses, both of whom required professional medical help, were very affluent and always had been able to afford the best medical care.

A couple of days later, however, Evelyn received another anonymous telephone call around nine o'clock at night, telling her that Ralph's car was parked at the country club. Since the report contradicted Ralph's plans to stay home, she decided to check it out.

Despite her fear to venture from the house alone at night, she got her car out of the garage and drove across town to the club. She noticed that the Wrights' driveway next to the club was full of cars and several cars were parked along the Pike. Then when she drove onto the grounds of the country club, she spotted Ralph's car, just as the caller had reported.

Evelyn was furious and wanted an immediate explanation:

I came back home and decided to make him admit for once that he had lied to me by telephoning him at the Wrights' and asking him what he meant by his actions. I

called and asked the woman who answered to ask Mr. Scharringhaus to come to the phone, rather than asking if he were there. She hesitated a moment, as if she might deny that he was there, but said finally to wait a minute. (I asked directly to speak to him, indicating that I knew he was there, for I thought they might think it was his mother's nurse calling.)

Ralph came to the phone and answered in an apprehensive tone of voice; he became almost speechless when he recognized me. I knew exactly how he looked from the sulky, aloof silence he tried to maintain. I told him that I did not wish to discuss it over the telephone but that if he were not out at my home within twenty minutes, I thought he would regret it, for I would not hesitate any longer to make things very embarrassing for him, since he saw fit to lie to me and double-cross me so continually.

Then he began to explain that he just could not leave, because he was playing poker with "the boys" and was ahead, so he would not look like a good sport if he left. Such an argument! I asked him if he was sure he was playing poker with only men, because I had seen both women and men, apparently dressed in evening clothes, passing back and forth before the windows when I had driven by. He denied that there was any party in progress and said he could not get out home in less than thirty minutes, so we agreed on thirty minutes.

He arrived in due time, very ill at ease and guilty looking, and told me some great story about "the boys" having called him at the last minute about a poker game, and since his mother was asleep, he decided to go. (Russ [Lindsay] told me later that the plans for the game had been made at the previous game the Wednesday night before, and said also that when Ralph came back from his telephone call, he looked mighty funny and said that he would have to leave immediately, because his mother's nurse had called him to go up town for some medicine. Russ said that one of

the other boys remarked, after Ralph's hurried departure, "That Fish had better watch his step, or he is going to get his business in a swell jam. I thought Mr. Todd still had a delivery service." They all laughed.)

When I told Ralph about how I learned where he was, he looked scared to death, but had very little to say—as is always the case when he is trying to cover up and sneak out unnoticed. When I asked who the people were in the house, he said that the Wrights' nurse was having a bridge party but that he had seen none of them, because the poker crowd ·was playing down in Asbury's den in the basement.

Elated at an opportunity to prove that he had been telling the truth on that score, he wanted to take me down there to prove it. Of course I would not go, and anyway he was looking for his usual double accomplishment in that he could make me appear a very suspicious accuser and thereby probably gain more sympathy for himself and create more hostility toward me—for of course those boys knew nothing of the lies he had told me about going first one place and then another, as well as his plausible tale about that particular night.

After Evelyn refused to go to the Wrights' with him, Ralph seized upon a different strategy.

"Actually, Evelyn," he said, "I'm glad that you called me. Please don't think for a moment that I am mad at you for calling. I'm just glad that you've told me about the anonymous phone calls. They obviously are coming from interfering people who are just trying to upset you and turn you further against me. Why are you paying any attention to them?"

Although the callers had given her accurate reports in every instance, Evelyn decided not to argue with him. But she was so depressed and exasperated with Ralph that she wondered aloud whether he would care if she got out of his life altogether by committing suicide:

I had come to believe he would actually rejoice if I should pass out of the picture permanently even if I died or committed suicide or something as drastic as that. He looked straight ahead and did not change expression or commit himself in any way, either for or against; finally he said he didn't know what to say! Can you beat that? (He might have been flattered that a woman would kill herself over him!)

Well, I said then that he need not count on it, for I was not inclined to accommodate my enemies that much, and dropped the subject. As usual, he tried hard not to say anything that would commit him to anything definite or that would give him away; but when it came to patching up or concealing a lie in which he had really been caught red-handed, he was as glib as you please and expected me, actually, to believe him, when I had just called him away from one of his lies, so to speak, in order to avoid his efforts to say later it wasn't true. That was his scheme; when I could not prove he had lied by catching him really at it, he would say that what I had heard was not so, no matter how many people said it was!

Evelyn continued to receive reports about Ralph's comings and goings from anonymous sources as well as from old friends. Russ Lindsay, for example, told her that he had seen Ralph drive into the Goforth's one Sunday. He said he was playing golf at the club with Asbury Wright and two other men when he happened to see Ralph on the Goforth's lawn. Russ speculated that he was there for dinner. "...[H]e and the Goforths sauntered about the yard in the clubbiest fashion for awhile before going into the house," he reported.

Then Russ said he turned to Asbury and asked, "How do you and Bill feel about Fish's ditching you all for Jew Goforth?"

Asbury replied, "It is pretty bad, isn't it? He practically lives there day and night, I hear."

94

One of the other men said, "I believe you boys have got it wrong. I hear it isn't Hugh that Ralph is so interested in. Maybe a little of 'mamma Hattie' is coming out in Elizabeth!"

The remark struck Evelyn as being quite plausible. "…[M]amma Hattie" is Mrs. Goforth's mother, Mrs. Harriet McClellan Young, who was terribly criticized for years because of her penchant for roping in as many men as possible, married or single," she recalled.

Russ told Evelyn that several people "had been disgusted with Ralph for sometime about being so constantly at Mrs. Goforth's house, even in the afternoons, and so obvious in his attentions to her in public…[O]ne Saturday afternoon sometime during the winter of 1931, some one suggested a poker game in Asbury's den and began calling the various players. When they called Ralph's store, they found that he was 'out for awhile on business,' but Asbury said he would bet 'the business' was down at Elizabeth Goforth's; and sure enough, his car was parked in the drive when they got to the Wrights', which is just across and down the road a little way from the Goforths'."

Evelyn heard similar tales from other people at the club. One woman told her that everyone was aware of Ralph's infatuation with Elizabeth. She said she heard someone wonder aloud "if Hugh knows about it yet. Scharringhaus had better be careful about making such a complete damned fool of himself over that disgusting woman."

Evelyn also heard that Elizabeth learned about the gossip concerning her and Ralph at a bridge party one afternoon. One particularly juicy rumor claimed that Ralph had been seen leaving her house late at night when Hugh was out of town and that Ralph was the father of her expected child. Elizabeth reportedly "threw a fit of hysterics about it."

That rumor offered an explanation for an argument that Evelyn observed while she was driving past the Goforths' home one night, looking for Ralph's car. "I looked toward their house in passing and saw Hugh dashing up and down, gesticulating, in front of the open door, and Elizabeth gesticulating from the other side of the room. Mr. Shields told me about that same time that some one had told him Hugh had heard [about] the scandal and was perfectly furious…."

Although Ralph had stepped up his visits to Evelyn and was calling her more frequently for dates in the spring of 1932, he also was becoming what she called increasingly "peevish" and "inconsiderate" to her in public. While attending a function at Lida and Harry McLean's home, he said in essence that he was free to come and go as he pleased and that his activities were none of Evelyn's business.

At that, she grew disgusted with Ralph's "showing off," as she put it. She tried to explain it away by telling Lida and Harry that some of Ralph's friends were trying to cause trouble between them.

Lida listened to her patiently and then turned to Ralph. She asked, "Ralph, why have you picked out people who are hostile to Evelyn for your friends? Evelyn would never do that to you."

He replied, "I can't give up all of my friends that I have known all of my life, just because she doesn't like them."

Evelyn, who was completely disgusted with his behavior, said scornfully, "It is news to me that your married crowd is composed of life-long friends, for I am sure you never knew some of them until after you began side-tracking me in 1927. And I do not think even your adored Goforths are very averse to criticizing you, because Louise McClure told me that both the men and women that you know, especially Elizabeth Goforth, had commented on the fact that you seemed perfectly willing to hang around that little old store on Clinch Street and didn't seem to care whether you did anything that amounted to much or not, as long as your father's money held out."

Evelyn added, "I suppose I'll be sorry in a little while that I said this, especially since Lida and Harry have heard it, but it's true. And you have goaded me into saying it by being so consistently nasty all evening."

As the conversation continued, Lida asked him why he played poker and drank when he knew how much that Evelyn hated it. He said that he banked his poker earnings because he was not drawing a salary from his business.

Evelyn scoffed at his claim of poverty. She knew that he was still receiving at least $100 a month from his business as well as getting paid for serving on the board of the Morris Plan Bank.

He also owned stock in another local bank. As Evelyn recalled, "Ralph told me he had to pay his assessment of $3,000.00 (I think) on City National Bank stock; and he was furious about it, saying, 'I am getting damned sick and tired of paying out money for nothing, and I have good mind to put everything I have in somebody else's name and say I haven't got anything, or take the bankrupt law if necessary.' He then said, rather jokingly, 'How about you keeping it?'"

Evelyn responded by saying, "I don't think such a slick trick would be very honest."

Ralph shrugged his shoulders and replied, "Well, I wouldn't give it to you anyway, for you might not give it back to me. I'll just get Papa to keep it for me."

Evelyn learned how Ralph had handled his debt to the bank from Mr. Shields. He told her "that Ralph signed an affidavit that he had nothing, and then settled with the City National Bank for fifty cents on the dollar, explaining that his father was paying this for him."

Yet Ralph had enough money to make frequent business trips that spring to Cincinnati, Ohio. He told Lida McLean that he had plans to establish franchise operations all over the country to sell ready-to-wear clothing, and he was trying to convince a Cincinnati advertising firm "to put on a big campaign for him."

With their relationship becoming openly hostile, Evelyn was not at all surprised when Ralph called Evelyn at school one day in May 1932 and asked her to meet him in town so they could talk. When she arrived, she noticed that he was in a bad mood and seemed to have something on his mind.

Finally he asked, "You wouldn't want to marry me if I wouldn't be happy, would you?"

Evelyn's eyes narrowed. "After all of the water that has gone under the bridge during the past fifteen years, your question is absurd. This has little to do with your happiness; but it has

everything to do with you correcting a situation that is entirely of your own making—and under false pretences."

When he saw that Evelyn was adamant about getting married, he tried another approach to win his freedom. "But you're not happy either, and it's abundantly clear that your attitude toward me has changed. You have been listening to idle gossip against me, and you've allowed my friends to influence you against me."

"If you're so concerned about your friends' influence, why haven't you taken some initiative to stop them? And why do you continue to do the things that hurt me?" she asked. "You're the one who has failed to give me the security of marriage, not them. And it is your failure that is encouraging them to speculate about our relations."

"So, why don't you hire a lawyer," Ralph challenged her, "to settle your difficulties, if you don't think you can do it yourself now that your father is ill?"

"Maybe I will," she fired back. "Maybe a lawyer can settle your breach of promise."

At that, Ralph retreated into silence.

Remembering the conversation later, Evelyn said, "Had I been in his place and had made up my mind to play the cad regardless, I should have preferred being openly brutal rather than pusillanimous and meek to cover up meanness."

A few days after this discussion, Evelyn decided it was time for a showdown with Ralph. She told him that she wanted to review their entire 15-year-long relationship so they could come to an understanding "and stop this eternal drifting and indefiniteness that was making me unhappier by the day."

Ralph agreed, and he arrived at her home that evening in a brand new Auburn automobile. When she "expressed surprise that he could buy a new, rather expensive car after crying hard-times so loud and so long, he looked as if he had accidentally let a cat out of the bag that he hadn't intended to, and he switched the automobile-buying talk into a safe channel by saying, 'I am not going to buy it, but Papa can if he wants to.'" He added that despite the economic downturn his father was quite wealthy and able to buy almost anything he wanted.

Ralph and Evelyn rode around in the new car for several hours while she reviewed their entire relationship:

> I began at the very beginning and tried one last time to make him realize how terrible I had felt all along about the position he had kept me in, how I had tried for awhile to believe what he said and see things as he did, but how it was impossible for me to go on without at least the security of some kind of marriage—secret or otherwise. I went on to try to explain why I had not been able to help feeling as I did about sexual relations, and begged him to try to put himself in my place and try to see how I could not have felt differently.
>
> I even told him I was bitterly disappointed that I had been deprived of a home and the domestic happiness that I saw my friends surrounded with. In order to touch on and offset any possible mental reservations he might have, I told him as vividly and as convincingly as I could how I had felt about the comments at my expense all these years, and how I had taken refuge in a caustic self-defense at times rather than embarrass both myself and him by showing how hurt and unhappy I really was. Like a fool, I actually talked to him as if I might have been wrong and he right....
>
> For the only time in years he did let down a little and tried to act a bit more human by being less cold and uncommunicative, when he saw I was having a hard time controlling my feelings and the tears that he knew so well I hated to give way to. But that was the biggest concession he made. When we got home, I asked him if he thought he understood any better, and he said he did and was glad I had talked to him, also that he would "think about it."

As a result of the conversation, Ralph was nicer to Evelyn than he had been in years. He called her at school nearly every afternoon and asked her to meet him for a soda or for dinner. One afternoon he asked Evelyn to pick him up at his store after work so they could go for a drive. After he climbed into her car, he told her that he had to

break his date with her that evening because "a man we do business with is in town, and I have to see him." Evelyn agreed to move their date to the following evening. But before they parted, they rode around a little while and continued to talk.

In the course of the conversation, Evelyn mentioned that one of the teachers at school had found a notebook filled with pornographic sketches. She said she was appalled by "the rottenness that went on all around, even among those young kids at school."

Ralph's eyes widened and he began asking her for information about the sketches.

Evelyn was put off by the gleam in his eye and his strong interest in the notebook. "I am not exaggerating when I say that he was actually aroused. I had heard of 'inflammable literature' before, but I had never believed that a person could be upset by reading or seeing such stuff. Hearing a little and imagining the rest, however, was enough for Ralph, and the next thing I knew he was telling me very sweetly that he wanted me to have dinner with him that evening as well as a date the following evening, for the man he was going to meet wouldn't mind waiting until about nine o'clock."

Ralph and Evelyn did go to dinner that evening, and Ralph tried in vain several times to convince her to have sex. He left her home at about 9:30.

As his car pulled out of her driveway, Evelyn wondered whom he really had an appointment with that evening.

Chapter 12

About the 23rd or 24th of May 1932, Mrs. Mary Burnett, one of Evelyn's older friends, called her and asked her to come to her home. When she arrived, Mary told her that while she did not want to intrude into Evelyn's personal affairs, she thought Evelyn should know that several of her older friends had been worried about her.

"You must think that I have an awful lot of nerve to say this," Mary said, "but the time has come for someone to ask you point-blank about what is going on. You've seemed so unhappy for the past year or two, and I resent any circumstances that make you feel that way."

Evelyn tried to laugh it off, but Mary persisted. Finally, Evelyn said, "Well, it's not of any consequence really, but Ralph has been rather hateful to me for sometime now, and naturally I've been feeling a little hurt by it."

"So I've heard," she responded.

Evelyn was surprised. "What have you heard?" she asked.

Mary grew uncomfortable. "I'm sorry, Evelyn, but I really would prefer not to repeat some of the tales that I've heard. I'm sure they are nonsense and aren't worth talking about."

"I would much prefer to hear it no matter what it is, for I've already heard many rumors about Ralph's being seen in drug stores and where-not with a certain young married woman," Evelyn said.

Mary breathed a heavy sigh. "Well, if you insist," she said reluctantly. "I heard that Ralph's car had been seen parked by the Goforths' hedge on Midland Avenue on the night that a robbery occurred in that neighborhood. When the police started to investigate the car, some man in the crowd that had gathered in the excitement said, 'That car is all right, officer; it belongs to Ralph Scharringhaus.' Then he turned to another man in the crowd and said, 'Hugh Goforth is out of town again.' According to the story, the two men laughed very significantly."

"Who told you that?" Evelyn demanded.

"I promised I wouldn't tell," Mary said, " but I think you'd better prepare yourself to learn that it really was Ralph's car."

Evelyn decided to confront Ralph with the story. The next day she met him after school, and together they went to Lane Drug Store for a Coke.

She broached the subject slowly and with great care so she would not offend him and inadvertently end the conversation prematurely. "Ralph, I am going to say something that may surprise you," Evelyn began, "but I am not mad and do not want to appear to being accusing you."

Ralph looked concerned. "What is it?" he asked cautiously.

When Evelyn told him Mary's description of the tale, his hands shook so hard that spilled some of his drink.

Evelyn was amazed at Ralph's strong reaction. "So, it's true?" Evelyn asked.

"Of course not!" Ralph hissed, trying not to be overheard. "But if some one told you something like that, wouldn't you be scared?"

"No, I wouldn't be scared," she said pointedly, "as long was it weren't true and I had not been caught red-handed. And, if it weren't true, I would be angry, but certainly not frightened."

"Well, it's not true," Ralph said defiantly. "In fact, I haven't been to the Goforths' lately, not even to see Hugh on business. And I've never been there when Hugh was out of town."

"Oh really," Evelyn said. "Well, my sources tell me differently. You and I both know that Elizabeth has the habit of inviting other men to dinner whenever Hugh is gone."

"Maybe other men have been there, but I haven't," he insisted.

"Then how can you explain the fact that I've heard from several people, in person and over the telephone, who've seen you sneaking away from the Goforths' house after midnight?" Evelyn said.

Ralph stared down at his drink.

"Ralph, you've put yourself in a very bad position. Don't you see how foolish you look?" Evelyn said. "You're being criticized all over town for fawning over Elizabeth. And from what I've heard, she laughs at you behind your back, and calls you her 'errand boy.'"

Ralph gave her a hateful look.

"There's more, Ralph," Evelyn said, "more gossip about your association with Elizabeth."

"Go on," he said.

"Well, it's not very pleasant," Evelyn began, "but it's rumored that the baby she's expecting is yours."

Ralph gasped, turning red. "Where did you hear that? Who says that she's expecting a baby? She certainly doesn't look like it!"

Evelyn felt a wave of disgust surge over her. "Why don't you just admit the truth?" she fumed. "You and your ultra-modern, sophisticated views. You and Elizabeth have indulged in a 'Strange Interlude,' just like in O'Neill's play, and now your cowardly and deceitful sneaking around has gotten you into a rotten mess!

"And look at the ridiculous position that you've put me in," she continued. "Until recently, I was totally ignorant of what you've been doing. It would have been better for you to admit to me that you had broken your promises to me, rather than let me hear it from other people."

"But none of it is true," he said. "I swear! I have never been to the Goforths' when Hugh wasn't there. In fact, I bet I've been to their house no more than a dozen times in my entire life."

"Do you deny that you've been seeing Elizabeth? I myself have seen you and her walking into a drug store in the afternoon. And you looked very much absorbed with her."

"I met her only once, and that was at Hugh's request. It was about business."

"You certainly are full of business, to hear you tell it!" Evelyn said.

"Evelyn, I just wish you could read my mind," he pleaded. "Then you would understand."

"Ralph, I'm really sorry, but I simply cannot accept your version of the truth. If you want me to believe that your car was not behind the Goforths', you will have to offer me some proof."

"I don't know how to prove it," he said, nearly whining.

Angry and impatient, Evelyn challenged him to ask his family's chauffeur and his cousin Oscar Tate if they had had Ralph's car and

had been in the vicinity of the Goforths' house the night of the robbery. Only later did she realize that she had handed Ralph an alibi.

The following day Ralph called Evelyn to report that˜ he had talked with young Oscar and had discovered that on many occasions Oscar had borrowed his car and had parked it on Midland Avenue while he and his girlfriend went out to the country club golf links at night where they could be alone. Furthermore, Oscar said that he had had the car on March 1, the night of the robbery.

Ralph was practically gleeful as he reported his findings. "I knew there had to be a simple explanation for this," he added. "Oscar had the car, not me. I was home and in bed."

Evelyn was silent for a moment while she absorbed the information. Despite her better judgment, she truly wanted to believe him and to salvage her hopes of a marriage ceremony.

Finally, she sighed. "Ralph, I told you months ago that you would get into trouble by allowing Oscar to borrow your car."

"I wish I had listened to you," he said. "I had no idea it could cause so much trouble between us and that it would leave me liable to such mean-spirited speculation. You mustn't believe the rumors, Evelyn. Believe me instead." Ralph sounded sincere and almost pathetic.

"All right," she said. "But you must agree to never see Elizabeth Goforth again. And now that the truth of the situation is known, you must straighten out the Midland Avenue rumor by telling a few other people about Oscar having your car."

"Won't you help me, Evelyn?" Ralph asked. "Please tell whoever told you the story. But please don't mention Oscar's name because my mother would be very hurt to hear about her nephew's nighttime activities."

Evelyn agreed to help him dispel the rumors around town generally. The first person she spoke with was Mary Burnett. Mary listened and thanked Evelyn for her phone call.

That weekend Ralph invited Evelyn to a movie on Saturday night and was more congenial and talkative than he had been in months. As

they strolled along the sidewalk toward the Tennessee Theatre, Ralph made no mention of the Goforth rumor or any of the gossip. Instead, he talked about his mother's health and his parents' plans to leave home Monday morning and travel to Kentucky to visit his father's sister. He also agreed that he and Evelyn should quickly work out any future disagreements or misunderstandings they might have, rather than allowing them to fester.

After the movie, they returned to Evelyn's home. About five minutes after they arrived, Evelyn said she "saw the signs of sex interest in the way he talked and acted." By the end of May 1932, she was willing to do nearly anything to attain her goal of a wedding ceremony, so she reluctantly gave in to him.

That evening Ralph suggested that he and Evelyn should make plans to go to New York at the same time during the summer so they could spend some time together.

"When will you be going to New York this summer?" he asked.

"Well, if you continue to be half-way decent to me so I won't feel as badly as I've felt in the past few years, I might not go at all," she answered.

The remark put Ralph on edge. "What do you mean by that? Are you accusing me of not really wanting you to meet me in New York?"

"No, that was not my intention," she responded, realizing that her statement had been too strong. She tried to move the conversation to a more positive vein. "What would you like to do in New York this summer? Where would you like to go?"

"To some good hotel, any one you would like," he replied immediately. "Where would you like to go?"

That was not the answer that she wanted to hear. "To the Little Church for the marriage you have been putting off so long," Evelyn said coldly.

"That's impossible, totally out of the question," he protested. "And frankly, I'm surprised that you would even say such a thing when you know that I don't have any money."

"Well, it seems to me simply being married legally would not cost any more than going as you want to go to some expensive hotel

and staying in New York a week or two," she said. "And if you want, we can keep the ceremony a secret. I will go on with my schoolteaching, until you are reestablished in business.

"Ralph," she explained, "I feel more miserable in this situation every day. After all of the time that has passed, you ought to be willing to make it possible for me to go on with some semblance of peace and security, especially now that Father's illness has gotten so serious."

"I'm not in a position to go through with a ceremony right now," he said. "But that should not prevent us from enjoying some time together in New York. Sometime soon perhaps we will be able to work out something that will enable us to get on a better basis, when we will be able to make some definite plans. In the meantime, we can go to New York this summer see some shows and enjoy each other's company."

"No," she said flatly. "I will meet you in New York only on the condition that we are married as soon as we get there. Otherwise, I will not go at all."

Evelyn sucked in a breath, eyed him steadily, and asked, "Are we ever going to be married?"

Ralph replied coolly, "Of course we are going to be married, honey; just give me time to get on my feet."

Looking back at the conversation, Evelyn recalled her impression of the exchange. "This was the best I could do that evening, but I thought it was an improvement, perhaps, over his recent flippant attitude in saying, 'I think I love you, but I am not in love with you any more' and—what is worse—after kissing me and occasionally getting away with worse than that because I was afraid to offend him, saying, 'Maybe I ought not to have done that since I am not in love with you any more.' Did you ever hear anything as inane and inconsistent as that? And you should have heard the smarty way he said it in a silly, stupid tone of voice."

Just before Ralph left Evelyn that evening, he said he would call her the next day. Just as he promised, he called in the middle of the afternoon, Sunday, May 29, but he reported that he was not feeling well and planned to stay home. Evelyn accepted his explanation and

did not challenge him. In truth, however, Ralph had other plans. He took his parents for drive that afternoon and went to church that night. Then after church, as Evelyn learned later, he took the widow Mrs. Ben Fowler on a date.

Since Ralph was unavailable on Sunday, Evelyn drove to Chris Carroll's home, where her friend Blanche Preston was visiting from New York. She took advantage of the social occasion to help Ralph mitigate the damage from the rumor about his car being seen behind the Goforths' by telling Blanche about it. Just as she was finishing her story, Mrs. Carroll and Mildred Eager walked into the room and overheard the end of the tale. They looked at Evelyn suspiciously but did not ask her to repeat the rumor. Evelyn let it drop and did not offer to explain.

Monday, May 30, was the beginning of the last week of school. That morning Evelyn reported to her classroom, grateful for the fact that summer vacation was nearly at hand but dreading the heavy workload that always came at the end of the year. In addition to holding classes and wrapping up the final assignments, there were papers to grade, official records to complete and file, and a classroom to prepare for the next semester.

While Evelyn was calling her class to order, Mary Burnett was on her way to Ralph's store. All weekend long, she had fretted over telling Evelyn about the Goforth gossip. Since she knew that Evelyn had spoken with Ralph about it, she assumed that Ralph knew that she had been the source of the story. She did not want him to think that she was a scandalmonger who would either listen to or spread idle and damaging chatter, so she decided that she should talk with him herself to set the record straight.

When Mary reached his store, she shoved open the door and rushed inside like a gust of wind before a storm. In an almost incomprehensible stream of words, she blurted out her reason for coming to see him and told him about his car being seen on Midland Avenue the night of the robbery. He gazed down at her, trying to absorb the meaning of her jumbled story. As Mary prattled on, he

grew pale and tense. A shudder coursed through his frame as his initial bewilderment was replaced by rage.

In her haste to protect her own reputation, Mary had forgotten that Evelyn had promised not to divulge her as the source of the story:

> ...[S]he told him only that she had repeated the story to me because I insisted that she do so, after she had mentioned having heard something about him in connection with a married woman...[H]er going up there so wildly simply gave him grounds to say that one of my own friends had thought it necessary to come to him and tell him that I was going around picking information about him out of people and then telling what he asked me not to—the latter idea being in reference to using Oscar Tate's name.
>
> [Her actions] gave Ralph enough nerve to call me that night and speak to me as he had never spoken before—and as nobody will again and get away with it...[H]e was in a towering rage—mostly theatrical, perhaps—and said that "several people" had come to him that day to inform him that I was doing all I could to spread gossip about him and Elizabeth Goforth "all over town."...He talked so fast and so furiously that I do not remember all he said, but it was all in the nature of untrue accusations and deliberate insults.
>
> Finally I told him that I thought he was a "fiend incarnate" and a "vile seducer" and that I saw now, too late, how he had lied to me all his life.

Evelyn's mother, who was standing nearby, overheard part of the conversation.

"Evelyn, what is wrong between you and Ralph? Perhaps I should talk with him," she said.

Ralph could hear Mrs. Hazen's voice through the receiver. Before she could reach for the phone, he hurled a few insults at Evelyn and dropped the receiver, leaving it off the hook.

"Ralph!" Evelyn demanded. "Pick up the phone!"

He did not respond. The receiver was hanging below the telephone table, swinging like a pendulum in the air.

Chapter 13

Evelyn nearly screamed into the phone. "Ralph! I am talking to you!"

But again there was no response. She hung up and tried to call him back several times, but the line remained busy.

Evelyn immediately called Mary and asked her to go to Ralph's house with her, explaining that she had to talk with Ralph and did not want to go alone. They arrived at about nine o'clock and Evelyn parked her car on the Pike near the Scharringhauses' driveway.

Evelyn trembled as she walked up to the house alone. She had only been to the Scharringhauses' home a couple of times, and then only with Ralph for a special occasion such as a dinner or birthday celebration. In each case, the events were rather formal affairs, carefully planned and orchestrated, and not the kind of gathering that would allow her to get to know the Scharringhauses better. As a result, she never quite felt at ease with his parents. During her entire relationship with Ralph, she had never had a conversation with his father. He had seemed stern and unapproachable, and he did not seem to be particularly interested in talking with her.

Evelyn glanced nervously around the front lawn and garden as she approached the front door. The porch light was off, making the bushes around the house seem black and threatening. Deep shadows fell across the perfectly symmetrical flowerbeds, where even the roses were flawlessly erect, as though they had been trained to stand at attention. Mr. Scharringhaus had designed the gardens, and they seemed to reflect his approach to life in general: it was to be bent to his will, subjugated, contained, and kept orderly and meticulous.

A sense of foreboding crawled up her spine and made her shiver. No lights could be seen through the windows on the first floor, but a couple of the windows upstairs were illuminated, indicating that Ralph probably was getting ready to go to bed. She placed her hand on

the railing to steady herself, went up the concrete steps to the front door of the imposing brick structure, and rang the doorbell.

After a minute or two, she could hear someone coming down the stairs and assumed it was Ralph because his parents had been expected to leave that morning to travel to Kentucky. She was quite surprised when his father opened the door.

Old Man Scharringhaus, as she called him, was not pleased to see her. As she put it, he was wearing "a glare and a scowl such as you have never seen." She thought he looked absolutely "satanic."

Evelyn mustered as much dignity as she could and asked to see Ralph.

"I think Ralph has gone to bed," Scharringhaus said, making no effort to call out to him.

"I apologize for insisting," Evelyn said, "but it is necessary that I talk with him tonight." She made a point of staring the elder Scharringhaus straight in the eye to emphasize the importance of her visit and to convince him to bring Ralph to the door.

Without asking Evelyn to come inside or showing her any courtesy, Scharringhaus turned his back to her and stalked up the stairs. Evelyn strained to hear the sound of Ralph's voice, but could not hear him. She did, however, hear Mrs. Scharringhaus inquiring about their evening visitor.

Scharringhaus stomped heavily down the stairs and returned to the door. "Ralph (he pronounced it 'Rolph') cannot come down," he said, clearly aggravated with her sudden appearance at his home.

Evelyn's initial fear was rapidly turning into fury at Scharringhaus's rudeness and attitude toward her. She was not about to be dismissed by him so easily. "I hate to insist," she repeated, "but I think you have enough sense to know that I would not come here unless it were important that I see Ralph at once."

Scharringhaus narrowed his eyes and glowered at her. Drawing himself up "like a stuffed toad" she recalled, he bellowed, "I am master in this house. I'll say who comes to the door here! Why are you here? What do you want to see my son about?"

"Your son and I had a very unpleasant conversation on the telephone tonight," she said, "and after he hurled all sorts of false

accusations at me, he quit talking and left the phone down so I could not call him back."

"And that gives you the right to come here uninvited and interrupt us at this hour?" he demanded. Then looking even more sinister, he leaned down into her face and said, "You have always fussed at Ralph and have never wanted to do anything but dominate him."

Evelyn struggled to stay as calm as possible. "Ralph and I agreed last Saturday night to make a point of straightening out immediately any difficulties or misunderstandings that might arise. That's why I have come."

"All right," he said, backing off a bit, "I do understand how people want to straighten out difficulties, or as in your case to apologize, before the day is over. I have often said things that I was sorry for and worried about because I could not take them back right away. I will tell Ralph why you came here tonight. You and he can resolve your spat tomorrow."

His use of the word "apologize" was an affront to Evelyn. "That won't do any good. There are a couple of issues that we must discuss tonight that cannot be dealt with through another person," she insisted. "And Ralph has made it impossible for me to talk with him because he has left the phone down."

"That's absurd. My son would not do such a thing like that, for it might inconvenience his mother in the morning when she tries to use the upstairs extension," Scharringhaus said, staunchly supporting his son.

"Well, if that's what you believe, you don't know your own son very well. Just step to the phone to see what your son will do," Evelyn said.

He stared at her a moment and then turned toward the telephone. The receiver was indeed off the hook.

"It's your fault!" he exclaimed. "You have driven my son to do something that he has never done before. All of the fusses that you have had with Ralph have been your fault! What is this one about? What have you done to upset him so much this time?"

"Why don't you ask Ralph what we were fussing about?" she said. "And while you're at it, ask him if the trouble has always been my fault."

"How dare you insinuate that Ralph has done anything wrong. I have seen Ralph stand at the telephone and fuss with you for an hour or more at a time. The silly disagreements that you have caused have created great turmoil for him and worried his mother. You are responsible, not Ralph."

"Ask Ralph. Ask him if I have always been to blame for his fussing. I doubt that he will tell you what the most recent fuss is about," Evelyn demanded.

"Since you seem to know everything, why don't you tell me?" he fumed.

Evelyn was losing patience. "It concerns the gossip that is circulating about Ralph and that he has been promising to straighten out."

With a wave of his hand, Scharringhaus brushed it aside. "Oh, that gossip. That is nothing."

Evelyn's eyes widened. "I am surprised that you taking it so lightly. I would have thought that you would be upset about your son spending day and night at the Goforths' house and being so obviously attentive to Elizabeth."

Scharringhaus nearly choked when he had to admit that he had not heard the rumor. "Who is spreading such viciousness? There is absolutely no truth to it! The Goforths are good friends of Ralph's, and he has every right to go there whenever he wants to."

"Even after he promised me he would not go there, and when he knows they are trying to cause trouble between us?"

"Certainly! I would have tried to cause him to stop going with you five or six years ago if I could. But I knew he was so stubborn he would have gone more determinedly than ever if I had openly tried to stop him."

"So you tried quietly and sneakingly, just as he does most things, to stop him, did you?"

"Yes!" he bellowed, "and I'll see to it that he never sees you again now! He has told us how you have been going your way and ignoring

his feelings for you. He has told us about the men you have been seeing!"

"I have been going with one other man casually because Ralph suggested it for the sake of appearances," she said. "He's the one who has been lavishing his attentions on other people. He's the one who insists upon spending time with a new crowd of pseudo-sophisticates who drink, smoke and gamble! I have tried to make him stop it, but he won't listen to me."

"Well, he will listen to me. And I will encourage him to go with another woman, someone who is better than you!" Scharringhaus said vehemently. "I do not condone his drinking and smoking, but Ralph has a social position in Knoxville and his friends are the most prominent people here. He doesn't need you."

"I am amazed that you would admit he has any flaws at all," she said. "Why don't you ask him what else he is capable of doing?"

Scharringhaus was seething with anger. He doubled up one fist and shook it in Evelyn's face. "You will regret ever coming here. You with your pride and outrageous accusations. What audacity! Do you expect me to believe that my son does not have a sense of honor?"

"That is exactly what I am saying," Evelyn confirmed.

Scharringhaus exploded. "You are to blame for everything Ralph has ever done that he shouldn't. You are the cause of his unhappiness and the way he refused to eat yesterday and sat in the garden and moped. You have cheated him of what another woman would have given him. You are the cause of his gray hairs that his mother and I noticed yesterday as he sat disconsolate in the garden where you had driven him. I am very jealous for the happiness of my son, and will see that he has a home and family in spite of you."

Scharringhaus' threat shook Evelyn like a thunderclap. Tears began to stream down her face. With quiet dignity, she said, "I have not denied Ralph anything. He has denied me the home and happiness that he promised so many years ago."

"That's not true!" Scharringhaus screamed at her.

"Yes, it is," Evelyn said. "Ralph is already married, if the truth were known; at least he has been saying he feels married for God only knows how long."

"Prove it! Prove it!" he shrieked, shaking a menacing fist in her face.

Evelyn replied quietly, "Unfortunately I do not have any legal proof, because your son would not give it to me although he is still promising it, after fifteen years of lies."

"I feel sure you have said more than you realize and you will regret it, but you can rest assured I will never mention what you have said," he said. "You have led him astray. Because of you, my son has neglected his prayer life. I think you should go home and pray about the difficulty you are in."

"I do not think praying will do any good as long as your son acts as much like a devil as he has done so far. I think the Devil rather than the Lord has had a hand in what your son has done to me."

Scharringhaus slammed the door in her face.

Evelyn stood there a moment in stunned silence, and then found her way back to the car. Glancing back at the house, she realized that all the time that she was arguing with Scharringhaus, his "cowardly son [had] remained safely hidden away in the very room he had tried to drag [her] to on numerous occasions when his parents were away and could not know what he was up to...."

As soon as she sat down in the car, Mary told her that she had seen Scharringhaus shake his fist at her and raise his voice in anger.

"Could you hear me?" Evelyn asked her. She had not wanted the conversation to be so apparent to the entire neighborhood.

"No," Mary answered. "And at first I thought that was Ralph who was storming at you. I would have come up to the porch but I didn't think it was any of my business to get involved."

Evelyn was too distraught and exhausted to respond to her. She took Mary home as she turned her argument with Scharringhaus over and over again in her mind. She was amazed at his remarks, which she termed a "hypocritical mixture about God and praying and fist-shaking and insulting accusations."

Upon reflection she said, "I have never witnessed a more determined effort to force a person, considered weaker, to the

background, but I decided then and there I had taken my last insult from any of that crew."

When Evelyn reached home that night, she was much too upset to sleep. Instead, she wrote a letter to Ralph to explain how she felt.

"It was the most desperate mass of scribble I ever wrote," she said. "I told him I had said enough, I was afraid, for his father to have become aware of the actual situation, and said I was sorry I had done that. I also reminded him that he had certainly not acted as if he intended living up to the high-sounding plan he had suggested just the Saturday night before for straightening out difficulties immediately."

In the letter, Evelyn also asked Ralph to call her as soon as he knew that she had had time to reach home after school the following day. She did not even try to go to bed until nearly five o'clock in the morning, and she got up at seven to go to the school.

That Tuesday morning, May 31, 1932, Evelyn asked one of her students to deliver the letter to Ralph's store. Ralph received the letter before noon.

Chapter 14

The last week of school in 1932 was a struggle for Evelyn. "Nothing but sheer force of will got me through it," she wrote, "and I was a wreck at the end of it...." She was distracted, consumed with worry, and desperate to talk with Ralph.

During the day on Tuesday, the day after she had argued with Old Man Scharringhaus, she called Ralph at his store in hopes of making arrangements to see him that night. But she was told repeatedly that he was not there. Mildred, who was aware of Evelyn's distress, also tried to call him. She told Evelyn that she had left her phone number at Ralph's store, but that he did not return her call.

At about seven o'clock that evening, Evelyn called Ralph's home. The cook answered and said that Ralph was expected home for dinner shortly. When Evelyn's call was not returned after an hour, she called again. This time the cook told her that Ralph would not be home for dinner after all.

Evelyn suspected that Ralph was there at the time and was trying to avoid her. So she drove to the Scharringhauses'. When she arrived, the house was completely dark. She pulled into the driveway and waited. After an hour or so, there still were no signs of life, so Evelyn drove by the Wrights' and the Goforths' looking for Ralph's car. Having no success, she returned to his house and waited until midnight before giving up and going home. She said she had never been out that late alone before and she "was scared to death."

Throughout the next morning, Evelyn and her mother called Ralph at his store and at his home, but they were unable to reach him. Mildred told Evelyn that she had tried to find him, too. By the time Evelyn returned home after school late that afternoon, she was nearly ill with worry. Thirty minutes later, she received a special delivery letter from Ralph that had been written on the first of June.

With shaking hands, she opened it slowly as she stood in the foyer. She read the letter slowly, becoming increasingly agitated as

certain phrases nearly jumped off the pages at her, lines that claimed Ralph could endure no more of her "punishment," and an accusation that she had "ruined" his life. Her heart started to pound and she reached to her breast to quiet it. As beads of sweat broke out on her forehead, her eyes arrived at the main point of the letter, a sentence that read simply, "There is no solution but to stop."

Evelyn emitted a low moan as slumped on the staircase. Gasping, she dropped the letter to the floor and wrapped her arms around her chest in a feeble attempt to keep from exploding and flying apart. Ralph not only had ended their relationship, but he also had announced that he had left town and did not know when he would return. There was no way to reach him, no way to bring him to his senses or to patch up the dispute they had had a few nights before.

Evelyn heard a scream and then realized that it was coming from her.

"Evelyn, what's wrong?" her worried mother said, as she hurried toward her.

Evelyn rocked to and fro on the stairs, doubled over as if in tremendous physical pain. Her frame was wracked with sobs as tears coursed down her cheeks.

Her mother stood over her and watched helplessly as Evelyn seemed to disintegrate before her eyes. "Talk to me," she commanded. "Evelyn, tell me what's the matter!"

Slowly Evelyn began to regain control as a possible solution began to take form in her mind. "Reading that letter crystallized my disorganized thoughts into some sort of action at last," she recalled.

Evelyn dried her face, went straight to her car, and drove to the home of Mrs. Tate, Ralph's aunt and the mother of young Oscar Tate, to tell her the whole truth of their engagement including his sexual demands. As she put it, she wanted Mrs. Tate to know "what a skunk her fine nephew was and let her read his letter to prove it."

She believed that the Tates were honorable people and would demand that Ralph fulfill his commitment to her. After Mrs. Tate heard Evelyn's long, woeful story, she sympathized with her. "You should have demanded your rights long ago," she said.

When Evelyn told her about her confrontation with Ralph's father, Mrs. Tate shook her head and said, "That certainly sounds exactly like him. He has always been very hard when things do not go exactly his way. He also has been very stern with Ralph, and my sister's life would not have been very pleasant had she not been an invalid from the time that Ralph was born.

"Ralph was never willing to tell his parents anything about his personal life," Mrs. Tate added, "because his father has always been so exacting and critical."

Mrs. Tate also told Evelyn that despite Ralph's protestations of poverty, he easily could afford to support a wife because of his father's wealth. "I do not see why his father does not give him right now enough for you to live on, for he will get it all some day," she volunteered.

Evelyn asked, "But his father couldn't possibly have enough money now for us to live on, could he?"

Mrs. Tate looked at her incredulously. "Why of course he has. Mr. Scharringhaus has not been active in the business for years and has lived on other income all that time." Although Mrs. Tate did not admit it at the time, he also was helping to support her financially.

Mrs. Tate offered to arrange a conference with Mrs. Scharringhaus in hopes of settling the issue in Evelyn's favor. Although the offer was somewhat encouraging, Evelyn was worried. She knew that Mrs. Scharringhaus might not return to Knoxville for several weeks, and that was too long to wait.

By the next morning, Evelyn's desperation was turning into panic. As each hour passed, she felt that she was losing ground in her struggle to force Ralph to marry her. She wished for her father, knowing that he would have been able to handle her difficulty calmly and with his usual business-like efficiency. But his physical condition had worsened measurably. A few days earlier, he had been moved to a sanitarium for treatment.

In hopes of finding another man who could help her, Evelyn called her cousin Flem Hazen and asked him to come to the house. Flem was the closest thing she had to a brother, and he was the one man other than her father that she thought she could trust. She also

believed that Flem might be able to exert some influence over Ralph; they had been fraternity brothers and had lived in the same fraternity house on campus.

Flem could hear the urgency in her voice and rushed to the house. As soon as he arrived, Evelyn pulled him into the parlor and closed the door where they could talk in private. Evelyn's face was contorted as she choked back sobs. Telling Flem about Ralph's deceit and her seduction was difficult and humiliating.

Flem was shaken by Evelyn's story and angered by Ralph's failure to take responsibility. He pledged to force Ralph to marry her immediately.

"...Flem really thought Ralph would do as he insisted," Evelyn recalled, "but I told him then that Ralph by himself was bad enough and with his father backing him he would be much worse."

Evelyn suggested that they contact Shields, Scharringhaus's former business partner, to enlist his help, but Flem argued against it. Shields would side with the Scharringhauses, he said.

"You've got it all wrong," Evelyn said. "Mr. Shields was a friend of Father's and he will side with us."

But Flem would not hear of it. "What are you thinking?" he demanded. "He's been their business partner for too long. He won't come to your aid. No, we'll have to settle this ourselves."

Evelyn's did not have the strength to argue with him. "Flem, you've got to help me," she begged.

While Evelyn waited for Flem and Mrs. Tate to act on her behalf, she turned to Mary Burnett and Mildred Eager for solace and companionship. Both women "expressed all kinds of wrath at Ralph and his father," and Mary insisted that Evelyn stay with her for the remainder of the week. She knew that Evelyn would not receive any emotional support at home from her mother or her uncle Lon Mabry.

Evelyn moved in with Mary and continued to go to the school every day where she finished up the school year. She also kept in touch with her mother, Mary and Mrs. Tate by calling them on the school's telephone. Some of her conversations were overhead by the women who worked in the office:

120

...[S]ome of those rotten, prying women at the place eaves-dropped and dashed out to spread what they had heard...One of the interfering women at the school said that she thought she heard me say over the telephone that I was going to kill Ralph (that killing idea certainly appealed to the excitement seekers). I was talking to Mrs. Tate, so you can imagine how near I came to saying that; I said, as a matter of emphasis and she agreed with me, that I thought a man like Ralph ought to be killed. I have always used that expression, as well as the expression, "I'd like to kill so and so" or "So and so makes me so mad I'd like to murder him."

Mrs. Tate said herself that Ralph's father was so stern and uncompromising her children "would like to kill him at times."

Evelyn continued to stay at Mary's house after school closed for the summer. The final week of the semester and her problems with Ralph had taken a toll. Physically and emotionally, Evelyn was a wreck:

I was so completely exhausted from that ghastly week of hard work and agonizing worry and desperation, which I had had to cover up with a complacent exterior, I could hardly lift my hand or move. It was the most terrible experience I ever went through—perfectly helpless to accomplish anything and the people who seemed to willing to try to help doing nothing but waiting.

Ralph, the sneaking coward, had fled and was out of reach before I knew what he had in mind to do. And, all the time, remember, he and his father were acting just as if nothing had happened and were going on their complacent, smug way just as unconcerned and arrogant as you please. They were confident that Ralph could get away with this plan if he stayed out of town until I had had to force myself to accept his ultimatum.

Evelyn was still at Mary's house when she got the news on Saturday evening, June 4, 1932, that her father had died.

"Exhausted as I was already from having endured more than a week of the Scharringhauses' German brutality and iron-heel methods, the news that my only hope of striking back at them was gone, not to include that that hope was also my father, who was the only person who had ever done anything for me, stunned me so I actually felt something die within myself, and I turned both limp and to stone at the same time."

After she recovered from the initial shock, Evelyn climbed into her car and drove home. Flem was there and seemed to be taking her father's death very hard, much harder than the members of her immediate family. Flem clasped her hands between his and tearfully uttered his sympathy for her. But her mother, sisters and uncles kept their distance, watching her warily.

"I shall never forget their coldness to me, now that they thought I was alone for the first time in my life," she recalled. "It was only my father's presence that kept my sisters (one of them especially), and my mother and her rotten brothers, from turning on me long ago. Father knew it and said to me more than once that he regretted bitterly their jealousy. God knows I never could see why they would be jealous of me, for I worked like a dog all my life and lived under a cloud that would killed a person of less iron will and determination not to show torture."

The following day, Flem wired every hotel in Cincinnati and tried to find Ralph. He thought he might return to Knoxville if he heard about Evelyn's father's death. He could not find him. Mildred announced that she had gotten his address from Mrs. Tate and had reached him by wire.

That Sunday afternoon Evelyn received a telegram from Ralph. It read: "Nothing in my life has ever saddened me so much as the news of your father's death." He asked Evelyn to extend his sympathy to her mother and sisters. Ralph and his parents sent flowers, but they did not cut their trip short and return to Knoxville for the funeral.

Several family friends and business acquaintances showed their respects by coming to the Mabry-Hazen house that Sunday and offering their condolences. Among them was Gertrude Penland, who insisted upon visiting Evelyn in her bedroom. She arrived just after Evelyn had received Ralph's telegram.

"Just read that," Evelyn was saying to Mary Burnett. "Why can't that hypocrite let me alone? He makes me so mad I would like to kill him."

Apparently shocked by Evelyn's comment, Gertrude turned on her heels and left. During the next few days she told several people in the community that she had heard Evelyn threaten to kill Ralph. Adding a little color to her narrative, Gertrude told her co-workers at the Knoxville News-Sentinel office that Evelyn sat in her room on a chaise lounge and "cursed and swore about Ralph and no one would ever have thought that there was a corpse in the house."

When Evelyn heard about Gertrude's untrue and embellished version of the facts, she sent a hateful message to her through a friend. Evelyn wanted Gertrude to know that she was not surprised by her actions or the tone of her tale. As she put it, the last part of the rumor was typical of "the common, uncouth, countrified way [Gertrude] usually expresses herself." Gertrude was furious at Evelyn's insults and threatened to get even.

Mildred, on the other hand, talked seriously about considering ways to kill Ralph. As Evelyn remembered later, "she thought Ralph deserved it and she would see to it that I had a chance to do it. She actually offered to take me down there in her car or in one that she would borrow!

"I can say truthfully that I got more free advice from her and Lon Mabry on that subject than I have ever gotten on any one subject in my life. They talked so much about it I did not have a chance to say much had I wanted to…Every body seemed to be waiting for me to do something definite instead of trying to do something for me themselves. They talked a lot about 'going to do something,' but they never quite got around to it."

Chapter 15

The pallbearers carried the casket containing the remains of Rush Strong Hazen through the front door of the Mabry-Hazen house and put it in the hearse for the trip to the Old Gray Cemetery. Evelyn, clothed in black and wearing a veil to cover her swollen eyes and tear-stained face, followed along behind, flanked by family members.

Evelyn gazed at the somber procession of black vehicles carrying mourners to Hazen's final resting place. Those in attendance included her father's business associates, members of their church, and a large contingent of Knoxvillians who had been touched by his charity and kindness during his long, admirable life. Hazen had helped strangers find jobs during The Great Depression; he had paid off the debts of his church at the end of each fiscal year; and he had never turned away anyone who was hungry or down on his luck.

There were many people who owed him a debt of gratitude and wished to show their respect to this great man. Ralph and the Scharringhauses were not among them.

A day or two after the funeral, Evelyn received a letter from Ralph. It had been written on Hotel Gibson stationery and was postmarked in Cincinnati:

June 6, 1932

Monday Morning

Dear Evelyn,

I want you to know how distressed I am about your Father's death. It was a great shock to me because the last report I had as to his condition was very favorable and I was looking for him to return to Knoxville in a few more weeks at the very latest.

It is hard for me to realize that he is gone. He was always so strong and generous and although old in years yet he never gave the impression of being an old man.

It should be and I know is a comfort to you all to know that the entire community grieves with you. He led such a full life and had so many interests that almost every one in Knoxville had had some contact either directly or indirectly with him.

I had thought of him so often during his illness and was so in hopes that he would be restored in health so that he could fully resume the active life that he loved so well. I knew how he disliked inactivity.

It is only natural that you and your mother and sisters and all of your friends should grieve for him but I am sure he would not have it that way. He believed so profoundly that all of these things are in the hands of the Lord, and if it was his time to go I believe that he would have preferred to die as he had lived, an active life until just a few weeks before the end. His was a life to be proud of and he set an example that might well be followed by all who knew him.

I hope that you and your Mother and sisters are getting along as well as could be expected. There is so little that any of your friends can say at a time like this that has any real comfort in it but I think it helps to know that others are sharing your loss with you.

Please remember me to your Mother and to Marie and Lillie. Also your Uncle.

Sincerely,
Ralph

Evelyn was not impressed with Ralph's remonstration of his sympathy. She described the letter as "hypocritical, mousey, and suave," and she thought that it described her father "in an impersonal, somewhat stereotyped manner." And because in her view the letter conveyed no honest, heartfelt emotions, she concluded that Ralph wrote it to cover his failure to attend her father's funeral.

126

Indeed, several members of the local community were chagrined that Ralph had not returned to Knoxville for the funeral and they commented on it openly. But Ralph had two apologists who stuck up for him. Mildred Eager and Gertrude Penland defended him and responded to his critics by "[explaining] demurely that Ralph had had to be out of town, and 'Isn't it just too bad that he could not get back?'"

On Wednesday, June 8, Evelyn left for New York City where stayed with her friend Ruth Mills for five weeks. But before departing, she made Flem promise to call her "the minute that Ralph set foot in Knoxville." She warned him not to attempt to resolve her dispute with Ralph alone because she believed that Ralph would tell him some rather convincing lies in order to buy time and possibly make another escape.

Flem agreed, and for the next three weeks Evelyn and Ruth waited for Flem's call. But the call never came. Ruth figured that Flem had come to the conclusion— perhaps under the influence of Evelyn's family—that it would be better not to contact Evelyn as long as she was willing to stay in New York.

Ruth and Evelyn discussed the situation with Carl Stafford, who was living in New York at the time, and sought his advice. Carl agreed that Evelyn could not depend on anyone to help her as long as she was not in Knoxville and acting aggressively on her own behalf. Together they decided that Evelyn could not wait any longer. She needed to call Flem:

> He was not at home, but I left a message with the operator to call him constantly until she got him. Finally the call went through, and Flem was slightly peeved to be caught so red-handed, for he had to admit that Ralph had been in Knoxville and had gone again, "to rest up in the mountains because he was so nervous and worn out." He had made a believer of Flem in spite of the fact that I had warned him to look for just such deceit, but I suppose Flem,

being a man, went on the assumption that a woman's opinion didn't amount to much.

It amounted to just this: if he had listened to me and done as he promised faithfully he would, I would have come home from New York in time to force Ralph to see me in Knoxville. Then, too, I would have gotten in touch with Mr. Shields sooner, and he would have done something before all of the Scharringhauses made their escape to Jamestown, New York. They stalled Flem for time...to make their get-away...Stalling for time and sneaking out of things like a yellow cur is one of the Scharringhauses' greatest accomplishments.

Feeling that his integrity was being called into question, Flem lashed out at Evelyn. "If you don't like me using my own judgment and not calling you until the time was right, then I'll just wash my hands of the whole thing," he huffed.

"Frankly, I don't care what you do," Evelyn stated flatly, "because it's pretty clear that you couldn't keep your word with me."

"I am making progress despite whatever you might think of me. I have spoken with Ralph, and we are coming to New York to meet with you around the Fourth of July," Flem said.

"You still don't get it, Flem," she said. "He probably wants to meet with me in New York and not in Knoxville so I will have no access to his mother." She reminded him that Mrs. Tate was trying to arrange a meeting with Mrs. Scharringhaus.

"Don't worry about that," Flem said, "I can force Ralph to go through with a ceremony in New York."

Flem arrived in New York on July 3, and told Evelyn fully about how he had contacted Ralph and gotten him to agree to a meeting. He said he met with Ralph every day and that Ralph "had been so nervous he had knocked over glasses of Coca Cola time after time in Todd's [Drug Store] while they were talking."

"Don't you know pretense when you see it?" she demanded. "Surely you realize that Ralph was simply attempting to play upon your sympathy."

128

Ralph arrived in New York at noon on Monday, July Fourth, and in accord with Flem's instructions, he went to the Hotel Commodore for the meeting in Flem's room.

Just before Ralph arrived, Flem told Evelyn, "Don't try to make him admit any of the facts of your association, because if you do, it will just make him mad and he won't do as I tell him to."

"Ralph is not going to do as anybody tells him to, and the sooner you get that through your head the better off I will be," Evelyn insisted.

"Don't start this meeting with that tone," Flem warned. "I didn't come all the way up here to fail. You have to do as I tell you to do. If you say anything to Ralph that I don't like, I will ask Ralph to leave the room."

Evelyn glared at him, mystified at his willingness to play into Ralph's hands and perhaps to give him the opportunity to say later, "Even Flem did not approve of what she expected of me and [he] *told* me to go on."

Ralph arrived at the appointed time and entered the hotel room looking coolly suave and unruffled. Not a hair was out of place, his suit was impeccably pressed and fit his body perfectly, and his bearing was aloof, nearly regal.

At the very sight of him, Evelyn had to fight to keep her anger in check. She began their meeting by telling Ralph what his father had said to her the night that she had spoken with him on the steps of the Scharringhauses' home.

Ralph said that his father had not told him the same story. Rather, he said his father had told him, "Evelyn felt very badly about having been rude to you over the telephone, and I tried to make her feel better."

Evelyn assured him that Old Man Scharringhaus's rendition of the story was not the same as hers. Then she added that she went to the Scharringhauses' that night only after being told that his father and mother were not at home.

"You yourself told me that," she said. "Yet, you had the nerve to accuse me, as you did in your letter, of deliberately going down there

without any consideration for his mother and the possibility of worrying her."

Then Evelyn "confronted Ralph with the general facts of the situation, and including his perverted tendencies...and he did not deny them." She also informed him that she and Flem expected him to agree to a marriage ceremony immediately.

Ralph responded by uncrossing his knees and then crossing them again in what Evelyn called "a very superior manner." Then, with as much self-possession as he could muster, he tilted his head to one side and said, "That is impossible."

"Why?" Flem asked.

Ralph did not answer. He stared straight at Flem and never opened his mouth. Flem repeated his question, "Why?"

Finally, Ralph said, "I consider that I have discharged my obligation I may have owed to her."

"How?" Flem asked. "How have you met your obligation? What have you done to resolve this issue?"

Again Ralph remained silent, refusing to answer.

Evelyn looked hard at Flem, hoping that he would force the issue. But Flem seemed undone by Ralph's arrogant stubbornness.

Evelyn spoke up. "So you refuse, do you?" she said bitterly.

With no hint of agitation, Ralph rolled his necktie between this thumb and forefinger and said, "Yes, I refuse, flatly."

Flem was unprepared for Ralph's unemotional and cold response. With the color draining from his face, he said, "Ralph, where are staying in New York in case I need to get in touch with you?"

Ralph tucked his tie back into his jacket as he stood to leave. "I am staying with a man we do business with," he said vaguely.

"That is a new arrangement, isn't it?" Evelyn scoffed. "It is certainly news to me that anybody in this town, much less the Jews you do business with, have gotten so hospitable that they entertain their business friends as house guests."

Ralph peered at her from behind his round glasses but offered her no additional information.

Flem interrupted, "Look here, Ralph, you owe a debt to Evelyn. You have to do something to right the wrong that has been done to her."

"I will have to speak with my father about this matter before I can do anything," he said. Ralph turned and headed for the door.

With Flem was making no effort to stop Ralph from leaving, Evelyn shouted, "Wait! I would like to speak with you alone for a moment."

Ralph turned toward her. "I prefer to have Flem hear everything we say," he said in a controlled, quiet tone of voice.

"You're not a coward, are you?" Evelyn said scornfully.

In keeping with his long-standing habits, he did not answer.

As Ralph reached for the door, Flem sputtered a series of questions at him and was able to get him to say that he planned to be in New York until the end of the week. But the fact is that he left the city that night and was seen at Mildred Eager's house a day or two later.

Chapter 16

Evelyn returned to Ruth Mills's apartment, sat down heavily next to the window, and gazed down at the street below. With her father dead and Flem acting more like Ralph's ambassador than her protector, she was beginning to reach the conclusion that her situation was hopeless.

Ruth grew increasingly concerned about Evelyn's mental state as well as her physical health. Evelyn's sadness and utter despair clung to her like an invisible shroud that exuded a pall throughout their cramped living quarters. It was as though she had become stuck in space and time, unable to move under her own power. At times she seemed glued to the chair by the window, more of an inanimate fixture than a living, breathing person. On many days, she was unable to get out of bed.

Then more bad news struck. Ruth received a phone call informing her that her secretary had been involved in a serious automobile accident and would not be able to work for several weeks. Ruth was very concerned about the young woman, but she also recognized that the accident presented an opportunity for Evelyn. She asked Evelyn to work for her temporarily as her secretary's replacement. The arrangement would force Evelyn to leave the apartment and to begin to function again. Evelyn hesitated at first, but finally agreed to accept the offer.

That summer Evelyn received several letters from Mary Burnett and Mildred Eager. She answered each of them, spilling out her feelings of anger and disillusionment to these two women, whom at the time she trusted most. Mary made a point of destroying Evelyn's desperate and jumbled messages, but Mildred kept them all.

Mildred also appointed herself Evelyn's liaison with Ralph's aunt Mrs. Tate. In her letters to Evelyn from Knoxville, she reported that Mrs. Tate was doing everything imaginable to arrange for a meeting

between Evelyn and Ralph's mother. She assured Evelyn that Mrs. Tate was on her side, not Ralph's.

Mildred also took it upon herself to suggest to Evelyn that she should buy a gun for her own protection. Evelyn showed Mildred's letters to Carl and then tore them up and tossed them into the wastebasket in Ruth's office.

That summer Carl was receiving his own letters from Mildred. Without informing Evelyn, she wrote two letters to him. The first one was written in early June when Evelyn was still in Knoxville. When Evelyn learned about the letter, she was incensed:

> In what I consider the most high-handed and insolent manner I ever heard of, [Mildred] took it upon herself to write Mr. Stafford and tell him that I was perfectly miserable in Knoxville, had had a big split-up with Ralph, and he had acted terrible when my father died. She then asked him—imagine it—to write me and ask me to marry him and come to New York to live!

> Naturally he was dumbfounded at such presumption on her part as well as the news her letter contained. He wrote her back asking her how she had gotten the idea that I would marry him whether I had had a fuss with Ralph or not. He said his entire letter was made up of questions on the whys and wherefores of her evident position as manager of my affairs. He never liked Miss Eager and resented her impudence.

> When she got his letter, she went down to Flem's office—also without my knowledge—and told him that Carl had written her to ask if she thought I would consider marrying him now that I had had a fuss with Ralph! Of course she did not tell Flem that she had written Carl or that he answered asking her all kinds of questions concerning her interference in my affairs. When I learned about this from Carl in New York, I got my first suspicion that Mildred had tried to engineer things to suit Ralph instead of me.

In the second letter written later in the summer, Mildred practically demanded that Carl stay in New York and not come back to Knoxville. This letter was sent after Carl and Flem had had talked on the telephone about how they could work together to force Ralph to marry Evelyn. At one point during that conversation, it was suggested that Carl should take his gun with him to Knoxville because it was rumored that the Scharringhauses had armed their chauffeur and had discussed securing police protection for Ralph. Since many telephones in Knoxville operated over party lines at the time, it is likely that Flem's and Carl's discussion about the gun might have been overheard. A few days later a new rumor surfaced, indicating that Flem had talked with a "gangster" who was plotting Ralph's untimely end.

"It was more or less a joke by the time I got home," Evelyn said, "for several of the boys knew that Ralph had told Flem if I 'annoyed' him again, they would take steps to prevent it. Russ says he believes the idea of my being after Ralph came largely from the way the boys began ridiculing him behind his back for making such a statement as that to Flem. They were disgusted with him for being such a cowardly fool who seemed to have no pride about running from a girl, and one who was out of town at that."

In truth, it was Evelyn who had a legitimate reason to be concerned about safety. That summer she received an anonymous telephone call from someone who said he worked in a filling station, claiming that the Scharringhauses' chauffeur had told him that "he had been given a gun and told to shoot at [Evelyn] if [she] came on their premises or...tried to talk to 'Mr. Ralph' anywhere."

After a few weeks in New York, Evelyn decided to return to Knoxville to talk with Mrs. Tate. She had not heard from her directly and was learning about Mrs. Tate's activities only through Mildred. So, as soon as she arrived in town, she went straight to Mildred's house.

What she heard was a suspiciously "colorful narrative" detailing Mrs. Tate's conversations with Ralph's family. Mildred reported that

that Mrs. Tate had met with Ralph first and had asked him whether he intended to "make things right" for Evelyn. Mildred said that Ralph responded by telling her to mind her own business.

Next, according to Mildred, Mrs. Tate had gone to the Scharringhauses' home to acquaint his mother with Ralph's "short-comings," as she called them. Mildred told Evelyn that "Mrs. Scharringhaus was thoroughly stunned by it." She supposedly stayed so late talking with the Scharringhauses that she spent night with them.

During that conversation, Mildred claimed that Mrs. Tate said, "Ralph's mother lay on her bed with tears streaming down her face and begged him to make things right with Evelyn; His mother told him that he was treating Evelyn as no man should treat any woman and that he was hurting her as well; His father told him that he must think long and carefully before he made his final decision on what he was going to do, for it was a very serious situation; I never dreamed Ralph could show such stubbornness; he refused to speak a word, except 'Yes' and 'No' even when his parents questioned him directly; I never saw a person in the grip of such a stubborn silence."

Evelyn said she thought Mildred's story sounded "fishy," so she went to Mrs. Tate for confirmation. Just as she suspected, Mrs. Tate said not a word of the story was true. In fact by mid–summer, Mrs. Tate was angry with Evelyn and had decided not to help her at all.

She asked Evelyn how she could expect any help from her after Evelyn herself had called her on the telephone and called her the "biggest liar in Knoxville." She also said that she had decided to take Ralph's side in their dispute.

"Ralph has told us everything, and he has never lied to us, so of course we believe him now," she said.

Evelyn, who swore that she had not been the person who called Mrs. Tate, said, "I have made no such comment of any kind about you, but Miss Eager is rapidly proving herself the biggest liar in Knoxville, after the great tale she had told me about your conversation with the Scharringhauses.

"And how do you know that Ralph has always told you the truth?" Evelyn added. "I thought he was honest, too, until the opposite had been proved and he admitted it."

Evelyn quickly realized that trying to convince Mrs. Tate that her charming nephew was a heartless cad was an impossible task. Too many rumors had circulated through town during her absence, and too much damage had been done. According to the grapevine, it had been Evelyn who started the vicious rumors about Elizabeth Goforth and the parentage of her unborn child.

Spreading a rumor was unconscionable behavior in the view of Knoxville's elites, and they shunned Evelyn for her alleged rumor-mongering. Many of her former acquaintances adopted the view that she was a brazen and willing participant in her and Ralph's sexual escapades, and that Ralph, the meek and mild church deacon, was justified in terminating the relationship.

With her reputation under assault, Evelyn became convinced that Ralph was engaging in a conspiracy of sorts to destroy her. "…[H]e was…determined to stick it out longer than I could," she wrote. "And the fool actually believed he could eventually force me to silence or into a total collapse and be really better off than before, because people were now believing the malicious, lying version of the story he and his supporters had put out."

As a result of the rumors, Evelyn's isolation was deepening to a level she had never experienced before. Even some of her oldest and most trusted friends were beginning to wonder about her credibility. In their eyes, she was damaged goods and quite possibly had brought her troubles upon herself. In their view, it was better to avoid her than to be seen with her socially.

With no love or support from her family and no help from her friends, Evelyn moved in with Flem and his wife Martha. At least she had some companionship there, despite the fact that she and Flem did not agree on how to resolve the problems with Ralph.

At about that time, she received an anonymous letter warning her that she was being "double-crossed by a person…who was posing as an intimate friend." Since she already was suspicious of Mildred,

she confronted her. "I'm going to ask you a question point-blank," she began. "Are you and Ralph plotting against me?"

Mildred denied it at first, but under pressure she panicked. That very day Mildred suddenly left Knoxville, deciding on the spur of the moment to take her mother by automobile on an extended vacation to West Virginia, Washington, Philadelphia, New England, and New York City. She was gone for the rest of the summer.

Before she had evidence of Mildred's treachery, Evelyn told Flem that she wanted to hire an attorney and sue Ralph. In her opinion, it would be the best way to set the record straight and reclaim her formerly unblemished reputation. Flem suggested that they contact Mr. Cates and Mr. Long, and on at least one occasion Evelyn, Flem and Mildred met with them.

Evelyn was not at all satisfied with their advice and counsel. "Since Flem was going to handle it, he went to his fine friends, Charlie Cates and Mitch Long, who, to make a long story short, dragged along doing nothing and getting nowhere, which was exactly what Ralph...wanted," she said. "Mr. Long tried to get me to accept [the Scharringhauses'] $5,000.00 insult with no statement from Ralph admitting anything...

"That was enough for me, so I made the decision I should have made long before to take things into my own hands and listen to no more advice from people who were against me rather than for me."

With each defeat and bitter disappointment, Evelyn grew stronger and more indomitable. She had lost several battles, but she was determined not to lose the war. She made up her mind that no one would stand in her way to seek a satisfactory solution to the hell that she had endured, particularly not Ralph. Late that summer after Ralph had returned to Knoxville from one of his vacations, she called him at his store.

"I tried to make him listen to reason and make him see what a hideous thing he had done to me and how cowardly and cruel he was

to leave me in such a position," she said later. "Very foolishly, I cried, and asked him if he would be doing as he was if my father were here to deal with him."

Ralph refused to answer her questions directly. In what she called an "egotistical arrogance and cold-bloodedness," he dismissed her as though he were brushing a fly from his sleeve.

In response to her questions, he said as Evelyn recalled later, "'It is all in the past, and I do not care to discuss it'; 'I will do absolutely nothing, *for it is settled as far as I am concerned*'; 'I will assure you that I will not make it public. If it is made public, you will make it so'; 'I will not see you now at all, but I may several years from now if you keep quiet about this'; '*I do not wish to appear rude*, but I cannot talk any longer, for I have an engagement for dinner.'"

While he made these pronouncements, Evelyn could hear him tapping a cigarette on his desk as though he was preparing to light it. Occasionally he ignored her entirely and spoke quietly to someone in the store. "He made a great point of being just as rude to me as possible and just as patronizing as he knew how to be," she said.

In response to Ralph's unconcerned arrogance, Evelyn called Mr. Shields and asked him to come to the house. As soon as he arrived, she told him the whole story about her relationship with Ralph and how he had acted since her father's death. Shields said he would take action immediately.

The following day, he contacted one of Knoxville's most respected and well-known lawyers, John W. Green. Together they sent a wire to Ralph's parents, who were vacationing in Jamestown, New York, enjoying as Evelyn called it, another of their "casual jaunts." Green and Shields advised them to return to Knoxville at once.

"Mr. Shields and Mr. Green thought they could arrange a marriage," Evelyn recalled, "but I told them they would find that Ralph would not listen to anybody and also that his father was backing him in his diabolical meanness."

Evelyn's words were prophetic. Shields and Green were unable to secure a wedding ceremony for her. Worse yet, Mr. Scharringhaus hired Green away from Evelyn to represent Ralph. Green maintained

that his actions did not represent a conflict-of-interest because he would refuse to argue against Evelyn in a court-of-law. Instead, he pledged to work with both parties to reach a settlement.

Angrier and more resolute than ever, Evelyn contacted Ralph one last time by telephone. "...[H]e was colder and more brutal than before, if possible. To most of my pleas and questions he remained coldly silent, but when he did deign to talk he repeated some of what he had said in the other conversation...."

Evelyn wanted to make Ralph admit that he had initiated their affair and that he had introduced her to sexual perversions. She also wanted someone to witness his admission of guilt. At her request, Evelyn's mother listened to the conversation on the extension.

Evelyn asked him, "I understand you have been saying that you never attempted rotten perversions and that I am just a liar and an evil-minded idiot to say so. Although you never thought I would find out what a pervert and perversions are, I have at last, and know exactly what you are. If those perversions are not true, deny them to me right now."

Ralph was silent.

Evelyn challenged him again. "If they are not true, I want to hear you deny them to me."

Ralph did not reply.

Then Evelyn said, "Your silence is all the admission I need, for you know and I know that you would jump at a chance to deny something to my face if it were not true."

Still Ralph offered no response.

"Since you will admit that only by silence, what is your method of admitting all of your other rottenness, including your tendency toward what I have learned is self-abuse?"

Finally, Ralph said calmly and in a superior tone of voice, "I do not wish to discuss it. It is all in the past, and is settled as far as I am concerned."

Chapter 17

Ralph's iron-heeled tactics and high-and-mighty, condescending attitude had to be dealt with, Evelyn decided. And she knew just the man who could take him on. His name was W.T. Kennerly, a lawyer and a Democrat who had been a friend of her father. She called him and made an appointment.

Gen. Wesley Travis Kennerly was a native Tennessean with roots that ran deep into the back woods and the State's pioneering past. He was born in 1877 in West Tennessee's Henry County where the meandering streams flow toward the mighty Mississippi. In this land of sultry summers, red clay dirt, and cotton fields, Kennerly grew to be over six feet tall, learned to hunt and fish, and attended the common schools where he learned a basic education. He was a good student, and eventually moved to Nashville where he entered a business college. With his thirst for knowledge still unsatisfied, he traveled east to just below the confluence of the French Broad and the Holston Rivers to the bustling metropolis of Knoxville to attend law school at the University of Tennessee.

The rolling foothills of the Great Smoky Mountains suited him well. He liked the rushing brooks, the tall stands of oaks and hickories, and the deep, shaded valleys that the wind, rain and snow melt had carved out of the wilderness eons before. He made Knoxville his home and eventually built a cabin in Hurricane Hollow where he could fish and hunt on Norris Lake.

Kennerly bridged the Nineteenth and the Twentieth Centuries, with one foot firmly planted in the South's proud, agrarian past, and the other on the modern sidewalks of Knoxville's Gay Street. Although his frame was well-suited for rough-hewn clothing and a gun or fishing pole leaning on his shoulder, he also cut an impressive figure in the wool business suits and stiff collars of the day. Tall and broad-shouldered, with a rugged build reminiscent of his frontiersmen ancestors, he was steady, clear-eyed and courageous. In

the courtroom, he was a warrior who "neither asked for nor gave quarter," according to Ralph's lead attorney John W. Green.

Although Kennerly had pledged to uphold the law, he was not above taking the law in his own hands to support a just cause. In the early 1900s, he had been a member of the "Flying Squadron," a group of vigilantes who banded together to protect Knoxville's election process. Whenever the Squadron's members received reports of ballot-box stuffing, fraud or intimidation, they would arm themselves with shotguns, go to the polls, and "drive the rascals out," as Green described it.

Volunteering to right wrongs and fight for justice was part of Kennerly's heritage. Some of Tennessee's earliest settlers—called "long knives" by the Indians for the saber-like weapons they often carried in their boots or strapped to their legs—volunteered to fight in virtually every major regional or national conflict during the 1800s. Tennessee native Col. Davey Crockett fought and died at the Alamo. Sam Houston defeated the Mexican leader Santa Anna and restored order in Texas before becoming Tennessee's governor. Thousands of Tennesseans volunteered during the Civil War and fought alongside Gen. Robert E. Lee in Virginia's army. A generation later, thousands more volunteered for active duty in 1898 after the Spanish fleet sunk the U.S.S. Maine in Cuba's Santiago harbor.

Kennerly joined the army at the beginning of the Spanish-American War and became a sergeant in the 1st Tennessee Regiment, which was the only one of the State's four volunteer units that saw combat. Initially the regiment was sent to Camp Merritt in California for training and then to the Philippines after Admiral Dewey destroyed the Spanish fleet in Manila. When the war ended, Kennerly was named Commander of the Tennessee chapter of the United Spanish-American War Veterans.

But it was the Civil War, the "Lost Cause," as he and some of his acquaintances called it, that held a particular fascination for him. He traveled throughout the Southeast visiting the sites of major battles, including those where his father had fought as a Confederate soldier. Green once said that Kennerly "knew more about the history of the conflict, its leaders and their careers than any man I ever met."

The honorary title of "General," which was bestowed on him after he was appointed U.S. District Attorney for the Eastern District of Tennessee by President Woodrow Wilson, seemed to fit his courtroom style. He approached each case with the concentration and commitment a military officer. He armed himself with the facts, carefully considered the strengths and weaknesses of his opponents, and fought for each client as though he were engaged in battle.

Kennerly was about 50 years old when Evelyn approached him about her case against Ralph. She hired him because of his politics and his support for her father when he had served on the city council. But it is also likely that his plain-spoken, earnest manner, and his appearance appealed to her. Kennerly had a strong, handsome face with a determined jaw and a high forehead. His large eyes were patient yet penetrating, the eyes of hunter who can sit motionless for hours waiting for and studying his prey, and then strike suddenly and humanely with surgical precision.

He was exactly the kind of lawyer that Evelyn wanted and needed.

Kennerly and Evelyn worked together to develop their legal strategy and gather evidence that would lay the blame for her failed romance at Ralph's feet. Evelyn dug into the task with relish and was considered to be a participating member of her own legal team.

Preparing the case against Ralph was so time-consuming, she decided that she should resign from teaching or request a leave of absence. She spoke with Mrs. Beardsley, who was a member of the school board, and Dr. Clark, the school superintendent, to get their advice, but both advised her to continue working.

"Dr. Clark even telephoned my mother and said my position was mine as long as I wanted it and that the English Department at High School could not get along without me," Evelyn reported. "Mrs. Beardsley also told me a good deal about Ralph and Mrs. Goforth, which affair, according to her, had been well known in the fall of 1931. She also said that [her husband] despised 'Old Man Scharringhaus' and thought he was the biggest crook in Knoxville. She said too that she had heard so many things against Mildred Eager

for years she had decided she was a menace to the schools and had wanted to get rid of her the year before."

On the first day of the fall semester, Evelyn reported to school along with the rest of the teachers and attended the annual teachers' meeting in the high school gymnasium. Mildred was there as well, and Evelyn said she appeared "frightened...now that I was on to her." In fact, several of the teachers at the school were wary of Evelyn that fall because Mildred had made a point of telling them that Evelyn was plotting to shoot and kill Ralph.

"Mildred said she had gone with Evelyn in her car with a gun to shoot Ralph," said Dannie Mellen Payne, a fellow teacher. "Evelyn drove, and the pistol was on the seat between them. [Mildred] said she was trying to help Evelyn, but she got herself fired."

In fact, both Mildred and Evelyn were fired in the fall of 1932. As the rumors about Evelyn's affair and the alleged murder plot began to spread, Dr. Clark decided that it would be inappropriate for either of them to continue teaching young, impressionable children. Dannie was a witness to Evelyn's and Mildred's dismissal.

Dannie said that she was walking down a hallway at the school with Mildred on one side and Evelyn on the other, when someone walked up to them and handed each of them a letter. They gave each other "sickly" looks, she said. The letters instructed them to report to Dr. Clark's office. When they arrived, they were told to leave the premises immediately.

Although Evelyn swore that Mildred's story about the alleged murder plot was a complete fabrication, she did consider killing Ralph that summer and apparently she asked Carl Stafford to help her. He gave the idea some serious thought.

In a letter to Evelyn that was postmarked in New York on July 22, 1932, Carl wrote:

Dearest,

> Your letter of doubt is not justified. If you have an impression that my conversation on the telephone was cool and my note from Albany was also cool you are wrong. I

explained the reason for that when you were here. I am not cool. I have not changed my mind. There is one thing I'm very doubtful about and that is your being able to do what you plan and cover it up. If you had not implicated yourself so much I would say yes, but circumstantial evidence is too much against you now. Please Evelyn think that phase of it over very carefully. I agree with you it's the only thing to do, but not now. I would much prefer doing it myself and you being here, because I know with the things you have said it would end disastrously.

I have worked all day and slept in Pullmans at night all this week. Have forty minutes to get train. Will be in Philadelphia to-day, Baltimore tonight and Saturday. Mr. Harris is there so don't know when I'll get away....

Yours –
Carl

Another letter from Carl on Knoxville-Gray Eagle Marble Co. stationery, postmarked in New York on Aug. 23, 1932, encouraged Evelyn to meet with his supervisor so he could take leave from his job and go to her aid:

Dearest –

Just received your special [delivery letter]. Why couldn't you have acted that way before, regarded me as a human being, instead of slinging slurring remarks about my being a coward, another person just like R, etc.? Evelyn, you surely haven't realized it but your talking that way has caused me to act the way I have. I really had begun to believe you were using me only as a tool and were slinging those vindictive remarks at me trying to make me mad enough to lose my reason. Your Sundays special is the only letter I've received from you in months that you have not called me a coward or some thing similar.

Now as to my coming down there. Disregard my Saturday night letter. I think it can be done in a much better way. I talked to Mr. Harris over the telephone last night but

of course couldn't go into much details. He seemed willing for me to do anything I could for you but he was a little in the dark as to what it was all about. He asked me to write him a letter explaining the situation. I merely told him that a rank, dirty deal had been pulled on you and I wanted to help you if possible. He knows that John Sadler and Flem know about it. What I thought would be [best is] for you Flem and Col. Sadler to see him and let him understand the whole situation and it would put me in a position to do anything for you. This should be done immediately tho as he is in K. [Knoxville] very little. Also ask him to not announce that I'm in K.

I had just started to tear this up and had dictated a wire to you to call me to-night when your wire arrived. I'll send this any way. I'm sorry about Saturday night, but can't you see how I felt too?

> Love,
> Carl

On Aug. 30, 1932, Carl wrote that he was unable to take leave:

Dearest Evelyn:

Have just talked to Mr. Harris and he says no. The business as it is just now caused the decision. I will not under take to defend my position because I know your thoughts in the matter and I realize anything I might say for it would be useless. The no does not mean a definite no but with the few jobs that are in the market and the condition of the company he felt it was the only thing he could say just now.

It is against my better judgment to not abide by this decision because I know it would mean what little job I have left and also, as you know I've never wholly approved of your plan. If Harris had approved of the leave I would have gone into it simply because you wanted me too, (and I'm still willing) not because I approve or think it's a good plan.

I will be in Philadelphia Thursday, Washington Friday and Baltimore Saturday.

I'm sorry to have to change plans on such short notice but circumstances over which I have no control have caused it. Please try to hold yourself and not make a bungle of things for what might be only a week or so. If I didn't intend to help all I can I would say so.

> Love
> Carl

He wrote to Evelyn again on Sept. 3, 1932, and called off the plan:

Dearest Evelyn:

I cancelled my Washington and Baltimore engagements in order to get away to myself and think over your plans and decide definitely what to do. I have been alone at the coast for a day and night and I can come to no other conclusion than that its an insane idea, one that will mean the end to you, even tho the world knows nothing about it, and to me also. That means of righting a wrong does not wright (sp) it and I think if you could sit off to the side of your self and see it from a neutral view point you would come to the same conclusion. Your motive is only revenge with no thought or care of the aftermath. I have come to this conclusion with no selfish motive in view of my part but a very selfish one on yours. I have gone into your threat of doing it yourself. I can't control what you do Evelyn, but for your own future, I plead with you to be more sensible. You no doubt will call me, as you have the last few week[s], a coward, brute, etc. but my frank opinion is that the two people who are urging you in this thing are more so than I. They are willing to let you go into something, even to the point of helping you, but always behind a screen for themselves, shoving you and me forward. Evidently this is the path of least resistance for them to do a thing, and rather than try to make you see

light and protect you against your own will, they help to the extent of not being involved themselves.

This Evelyn is a decision that I came to myself, no outside influence, and after hours of debating with myself as to what would be the best thing to do. I offer no apologies, I think I'm doing the right thing, and I feel sure after you get to the point where you can think clearly you will agree.

In making this decision I have taken into consideration the fact that threats have been made and repeated and exaggerated that there is no doubt in my mind that every suspicion would be centered on you immediately, no matter how perfectly planned the thing might be, and I feel while you may achieve a certain revenge now the penalty that you will have to pay afterwards would be so violent and so drastic and so dis-proportionate to what you could deserve that the achievement of the revenge would not off-set the results.

I feel, Evelyn, there are only two sensible courses to take. First as much as I would hate to see a court battle with the resulting news-paper publicity I would advise legal action, if not that drop the thing and get away from Knoxville. The first might be some vindication for you as far as people are concerned, and I believe it is the only sane course left. I would advise immediate action in either case, putting the thing behind me and start living your own life more to your own making, and away from the things that remind you of past difficulties.

I want you to feel, Evelyn, that my friendship for you is just the same. I'm taking this action because I honestly feel it is the best thing for you, and I believe after you look back on the situation you will see as I do. The situation now is such a blow to you that I realize you cannot get the proper proportion to which such a course would lead.

I simply cannot be a party to some thing that will be a further ruin of a person whom I'm very fond of. You have

discussed me in connection with F. and R. and your mother.
I would appreciated (sp) your letting them read this letter.
> With love,
> Carl

With this letter, Carl removed himself from any involvement in a bloody and untimely end to Ralph Scharringhaus. But it is likely that he unwittingly set into motion another set of events that led to Evelyn's greatest humiliation. By following Carl's advice and sharing the Sept. 3 letter with her mother, she inadvertently confirmed the rumor that claimed she was planning to kill Ralph.

Evelyn's prim and proper mother was shaken to the core. She turned to her brothers for advice, especially Lon Mabry who had lived with Evelyn's family for several years. Mabry, a lawyer, felt that something had to be done. He could not stand by and allow Evelyn to kill Ralph and destroy herself and taint the family's reputation. And he certainly did not want to be implicated in a crime. Mabry was one of the two people—the other being Mildred Eager—who had talked with Evelyn about murdering Ralph, and he did not want to be blamed for planting the idea in her mind. So he found a way to destroy her credibility and move her to a location where she would not be able to hurt anyone. He and her mother petitioned the court to have Evelyn committed.

Mamie Winstead, a neighbor who lived below the crest of Mabry Hill where her parents served as the caretakers for the Confederate Cemetery, remembered the stories that had circulated about Evelyn's incarceration.

"Her mother put her in Lyons View because she didn't want Evelyn to kill anybody," she said. "Nobody had anything to do with [Evelyn]. They were afraid of her, afraid that she'd shoot them."

Mamie said Evelyn was visiting her friend Sadie Birdsong when orderlies from the Lyons View asylum were dispatched to pick her up in October 1932.

"Evelyn Hazen was at Sadie's house when they came to get her," Mamie explained. "Mr. and Mrs. Birdsong were there. There was a knock at the door, [and] a man in a white coat asked, 'Is she violent?'

"Mr. Birdsong said, 'Is who violent?'

"[The] man said, 'Evelyn Hazen. Her mother has put her in Lyons View so she won't kill anybody.'

"She went with them. [She] did not put up a fight," Mamie said.

Lyons View was the name that the locals gave to the Eastern State Hospital for the Insane, an imposing red brick bastion looming over a promontory in West Knoxville. Looking like a relic from ancient times, this old building still stands rock-solid as a monument to the mistakes and misery cast upon the poor lost souls who were imprisoned there. Glass-fronted display cases on the first floor house hand-written records and a few of the implements that were used to treat patients before the days of lithium, thorazine and Prozac. Prominently featured is a collection of crude medical tools for the purpose of extracting teeth in the belief that dental infections could cause a variety of physical and mental ailments.

At the time that Evelyn was thrust into the hospital system for the mentally disturbed, many medical practitioners had radically changed their treatment methodology. Instead of prying open the mouths of unwilling patients and pulling teeth or forcing their victims to be sprayed with or submerged in water, they prescribed a clinical approach that was significantly more humane. It involved the "talking cure," which was the precursor to modern psychological treatments, and a modified form of the "rest cure." This approach was based on the premise that mental health could be restored by removing individuals from their day-to-day surroundings and sequestering them in a serene location where they would eat large quantities of healthy food, receive massages, lie in the sun, and relax. Thus, patients at establishments like Lyons View were encouraged to take walks and rest in the park-like setting during the day.

It was supposed to be quiet and peaceful, nearly idyllic. But this charade of imposed serenity vanished at night when the patients were herded into large, austere wards with 20 or more other incarcerated people to sleep in rows of narrow hospital beds. The thin mattresses and heavy iron headboards offered little comfort and no privacy.

There also was very little security, except the nurses and orderlies who were charged with protecting the patients from each other or, in some cases, from themselves.

The women's ward would have housed patients with a wide variety of mental and physical conditions, ranging from mild retardation to severe depression and paranoid schizophrenia. For Evelyn, who had grown up in comfort and luxury, it was a horrifying experience. She described it as being cast into Hell, where she was forced to live among people who were social outcasts; people who had been discarded by their families and the community; women who were demented, deranged, or who quite possibly represented a clear physical threat. It is also likely that some of the women had been warehoused there for lesser offenses, such as becoming pregnant out of wedlock or for simply being unwanted.

She was desperate to escape what she called this "den of iniquity." Evelyn managed to contact Kennerly and begged him to help her get out. He immediately began working to secure her release.

While Evelyn was held at Lyons View and was unable to defend herself against idle chatter, additional rumors about her character and sexual proclivities began to circulate. One rumor alleged that she had become emotionally and perhaps physically involved with a schoolboy that she had been tutoring. Another bit of gossip claimed that she had had a passionate liaison with her friend Jack McKnight.

As the rumor mill continued to churn, those who counted themselves among Knoxville's high society split into two camps—those who believed that Ralph had deceived Evelyn, and those who believed that she was a scheming vixen who could not be happy with just one man. Dannie Mellen Payne sided with Ralph. She said he was a "nice" man, and claimed that Evelyn "was carrying on extra activities [with other men] while she was with Ralph." Dannie also believed that Ralph wanted to marry Evelyn, but "he got sick of her stringing him along."

Mamie Winstead believed Evelyn's version of the story. She blamed Ralph for initiating the engagement, forcing Evelyn into having sex, and then refusing to marry her. She said she heard that when Flem and Evelyn met with Ralph in New York in July 1932,

"[Ralph] told Flem that he'd rather jump out the hotel window than marry Evelyn."

With Evelyn securely locked away, Ralph was able to live his life in a normal and totally unconcerned manner. In late October 1932, he played golf and tennis at the country club, spent many pleasant hours with the Goforths and Elizabeth's new baby girl, and went to the University of Tennessee football games as usual.

But Ralph's sense of security was short-lived. One month after Evelyn was kidnapped, as she called it, and imprisoned, she was discharged. Dr. Lee Smith, superintendent of Lyons View, provided the following document to Evelyn and her attorney Kennerly to prove that she was not insane:

This is to certify that Miss Evelyn Hazen of Knoxville, Tennessee, was committed to the Eastern State Hospital, of which I am Superintendent, by order of the County Court of Knox County, October 15, 1932, being admitted thereto on October 17, 1932. She remained in this institution for observation and treatment until she was discharged on November 15, 1932. After a thorough study of her case and an observation of Miss Hazen, it was determined by myself and staff that she was not insane, either when she was admitted to this institution, while she was confined therein, or at the time of her discharge. She was discharged because she was, in my opinion, of sound mind.

R.E. Lee Smith, M.D.
Superintendent, Eastern State
Hospital, Knoxville, Tennessee

The news about Evelyn's release unnerved Ralph. As soon as heard that she had been discharged, he packed his car and left town. He drove north into Kentucky during a cold, late fall rainstorm that made visibility poor and the narrow, mountain roads treacherous, leaving his family, his business, and his friends behind.

That night Ralph sent the following letter to Elizabeth Goforth. It was written on stationery from the historic Boone Tavern in Berea, Kentucky:

Wednesday night

Dearest –

I still feel very much like a man without a country. It was a gloomy afternoon, a gloomy road and a gloomy frame of mind. However a good drink and a warm dinner have helped somewhat. I made up my mind that I would not let this letter show that I am still "low", but I am sure nothing I would say or leave unsaid would conceal my real state of mind from you.

I had lunch at home and finally got away about twelve thirty. The trip here took five hours and it was as lonesome a five hours as I ever remember. The clouds were very low and it was dark by four thirty. I was very comfortable with my heater going but the car would have been disagreeably cold without it. The paper predicts much colder weather tomorrow and if it's too cold to drive comfortably I will stay here and go on the next day. However I don't anticipate that will be necessary.

Honey, I have thought about you constantly and I can't tell you how much I miss you and how much I am going to miss you. I hope you will remember every thing I told you last night because I meant every word of it. You mean so much to me in so many different ways that I can't put it into words.

I don't suppose you will ever believe me about the phone last night, but what I told you was the truth. I can't bear to have you think I would lie to you after what I told you only an hour before.

No doubt by this time you have all of your forces marshalled and I know if you have no information it is because none was available. I will be anxious to hear from you, not because of the information but because I want to

hear from you. Darling, I am sending you and the baby all
my love.

> Yours
> Ralph
> [P.S.] This letter is indiscrete
> to put it mildly. Tell me if I should
> write more impersonally.

1933-1987

Chapter 18

Between May and November of 1932, Evelyn Hazen had experienced a greater number of horrific and emotionally scarring events than most people face in a lifetime. She had been deceived by her fiancé, betrayed by some of her friends, had grieved terribly over the death of her father, and was fired from her job and lost her only source of income. Then, her own family had imprisoned her, forcing her to stand by and watch helplessly as her reputation was destroyed by scandal-mongers.

A lesser person would have been shattered by these experiences, but Evelyn seemed to grow in strength and resolve. Ralph, his father, and their henchwomen, as she called Mildred Eager and Gertrude Penland, were not going to beat her. She explained her feelings about them to her attorney:

> You know what…hell it has been my lot to endure from spiteful, cowardly skunks who sneaked up on me because of hatred and the love of vengeance the moment my father was no longer here. You cannot imagine the stark tragedy and heart-breaking agony of my feeling toward both Ralph and his father and those fiendish brothers of my mother's. No one of them has the sense of justice or of decency that a barbarian would feel, and my pitiful effort to deal with any of them could not have been expected to accomplish anything against the cold, hard, cutting steel of such vile characters. Although their aims were somewhat different and their motives prompted by slightly divergent circumstances, I feel sure there is a connecting link just as I am sure of the treatment and the rotten injustice I suffered at the hands of all of them—and will again if they are ever loose and I am unprotected. I cannot stress too strongly that both the Scharringhauses and the Mabrys must be dealt with and my score settled, before I shall ever have a

moment's peace, not to mention the ability to go on to anything at all in the future…I feel sure you understand something of the ghastliness of my existence since I was little more than a child, and of the hideousness and almost unbelievable experiences of the days since my father's death. And, I am depending upon you absolutely to stand by me to the bitter end, for you are the only person in the world in whom I have a real confidence.

After she was discharged from Lyons View, Evelyn went to Flem's and Martha's house for the next few weeks because she believed it was not safe to live in her own home. She figured that her mother's brothers, whom she thought were engaged in a conspiracy with the Scharringhauses, might manufacture another reason to get rid of her and send her back to Lyons View, or worse.

Since Evelyn had no income, she also tried to find a new job with the help of Mr. Shields. In early 1933, Shields wrote a letter to an acquaintance at *The New York Times* in an attempt to get her a job as a photo editor. *The Times* had a tradition of hiring summer replacements for its vacationing staff members, and a few years earlier Evelyn had worked briefly in the Sunday Picture Department at *The Times* while she was spending the summer in New York City with Ruth Mills.

But no jobs were available in 1933. *The Times* had decided against hiring extra people for the summer. Fred T. Bonham responded to Shields' letter. "I shall, however, keep Miss Hazen in mind," he wrote, "for a position here or elsewhere. I know her personally and know that she has real ability."

By 1933, jobs of any kind were hard to find. The economy still was reeling from the aftershocks of the October 1929 stock market crash and the impact of misguided economic policies. Millions of Americans were unemployed, and many people who had jobs were barely making a living. Farmers were unable to sell their crops for a profit, able-bodied men without means were riding the rails, and the nation's industrialists and bankers, who arguably were the wealthiest people in America, were watching their fortunes dwindle.

Among the hardest hit were sharecroppers who could not pay the rent on their small farms. With no shelter or food for their families, they loaded their few possessions on wagons and carts and wandered across the country like gypsies, searching for a way to exist.

The Depression hit home when Knoxville's major banks began to fall like dominoes in late January 1933. Many of Knoxville's wealthier citizens lost their life savings, and workers lost their jobs or had to accept salary reductions. In the Knoxville school system, including the high school where Evelyn had taught, teachers' salaries were reduced by a few hundred dollars a year.

Knoxville's Gay Street, once a bustling and thriving commercial district, began to lose its vitality and optimism. The city that had boasted of the Burwell skyscraper and the National Exhibition of Conservation began embarking on a long, slow decline. Storefronts were shuttered as despair and desperation set in. Ralph's earlier comments about the state of business at the now-defunct Gillespie, Shields & Co. had turned out to be prophetic.

Around the corner on Market Street, Hazen, Trent and Harrell Co. was suffering a similar fate. With Rush Hazen's death and the economic downturn, the wholesale grocery business began to have cash flow problems. Its customers were retail grocers who in years past had placed orders for food and other commodities, and paid for them promptly. But after the banks closed, cash was scarce. Hazen, Trent and Harrell could not survive in an economy where barter became the primary currency. The tall, imposing warehouse eventually closed down. Years later, what was left of the business was sold.

Despite all of the bad news on the business front, Ralph was living as though he were immune from the economic downturn. When he left Knoxville in November 1932, he had a new Dodge automobile and enough cash to travel to Northern Kentucky to avoid any form of punishment—either death by shooting or legal action—that Evelyn might mete out. His plan was simple; he decided to move into his aunt's home in Erlanger, Ky., which was near the Ohio River just south of Cincinnati. The location provided two benefits: as long as he remained outside of the State of Tennessee, Evelyn would not be able to serve him with papers and pursue a court

case against him in Knoxville; if she filed suit in Kentucky or tried to approach him, he could make a hasty getaway by driving over the river and into Ohio.

But Ralph's escape did not deter her. She worked closely with Kennerly and launched an effort to track Ralph's movements and discover his whereabouts through a network of "spies," as she called them. Some of her informants were acquaintances who had greatly admired her father and felt duty-bound to help her; others were individuals who believed her side of the tale being told around town but who chose to remain anonymous. In hushed tones, these informants called her on the telephone and told her where Ralph had been seen. They also sent letters that cautioned her to avoid certain people who sympathized with Ralph. One informant, who called himself "L.I.B. Broker," monitored the Knoxville rumor mill for news of Ralph's travels. Evelyn was very grateful for his assistance and tried to repay him for his kindness by trying to find him a job.

Ralph, too, engaged in espionage. From his hideout in Erlanger, he closely monitored Evelyn's whereabouts and her developing legal plans. His informants, who included Mildred Eager and the brother-and-sister team of Clifford and Gertrude Penland, wrote him letters, met with him in Kentucky, and called his mother to deliver status reports on Evelyn's legal activities. Ralph also exchanged letters with Elizabeth Goforth who gathered information about Evelyn from an acquaintance at the country club nicknamed "Krutch." At Ralph's suggestion, she made a point of cultivating a relationship with him and spent time with him at dances and dinners. Ralph was grateful for her deviousness. In a letter to her, he said, "now that you have broken down the flood gates, no doubt he will tell you all that he knows." Over a period of time, Krutch became a regular visitor to the Goforths' home on Sunday afternoons and occasionally accompanied Elizabeth to parties at the country club.

With Ralph living out-of-state, his father managed his legal affairs and met frequently with their attorneys to plot their strategy against Evelyn. They figured that she would be willing to accept cash to drop her threatened lawsuit. In return for the payment, they

demanded that she refrain from speaking about her relationship with Ralph.

Evelyn and Kennerly rejected their initial financial offer, so the Scharringhaus legal team increased the amount of the cash settlement. In mid-December 1932, Ralph described the negotiations to Elizabeth Goforth:

Had another letter from home yesterday but nothing encouraging. Evelyn has now intimated through Kennerly that although she prefers to be made an honest woman through marriage, she will accept $20,000.00 instead. Wouldn't that take your breath away. I prefer you keep that strictly to yourself and not even tell Hugh. Of course the whole thing is absurd but Kennerly says since she insists, that he feels it is his duty to bring suit unless we meet her terms. At the present, I am more disgusted with him than with Evelyn. He is supposed to have some little sense even if she isn't. Of course he may be bluffing but that seems a rather forlorn hope.

At any rate you will realize that the situation is such that we don't know what to say about my coming home. At present I am thinking seriously about not coming back to Knoxville until after our trip to Florida if that materializes and I am so damned mad that I am willing to go to the N.C. mountains in May and stay until September [when the term of the court would expire] which would defer any action until a year from this January. I wrote Papa that I am willing to do almost anything rather than have the suit or pay her a large sum of money. I have even thought of your suggestion about Majorca or China where I understand living is inexpensive.

It's tough being away from home and my friends but I have had plenty of experience during the last ten years, in doing the things that I haven't wanted to do. I never completely realized how one woman could ruin a man's life until now. But I guess that's all in a life time too and certainly it won't make any difference 100 years from now.

I sometimes think that we take our difficulties too seriously. The trouble lies in the fact that we are taught that we are intended to be happy. I think that's a myth kind of like Santa Claus.

If I do decide to stay away, I may with Papa's approval, come to Knoxville Xmas eve after dark and spend Xmas day, leaving that night. In this event I will reach Knoxville about nine o'clock and thought I might stop by your house and then go home later. That sounds wild but I may do it and if so will let you know when I have made definite plans.

I appreciate your invitation for supper Friday (tomorrow) night and I had hoped I could be there. Now the thought of such an occasion seems as remote as the North Pole.

Write to me when you can and of course I will write you. Take good care of yourself and don't have a relapse. Hope Hugh and the baby will stay well.

Yours
Ralph

At the end of December, Ralph learned that Evelyn had increased her demand to a minimum of $35,000:

Had a letter from Papa yesterday afternoon. Mr. Green saw Kennerly Tuesday. Evelyn was at the conference and modified her demands somewhat. Only wanted $35,000. Big hearted of her wasn't it, to come down? Mr. Green of course said any such settlement was out of the question and also told them he would be out of town for a few days. Evelyn then said that they would defer any action until Jan. 3rd but that Mr. Kennerly would be instructed to file suit at that time unless we settle. Naturally we are not going to settle, so the next move is up to them, and at the present writing it looks as though that move would be suit. Of course Evelyn's idea is revenge and persecution but I can't understand Kennerly turning down a reasonable settlement

162

with a nice fee for himself, to bring the suit. However suppose you can look for me to break into print most any time now.

Saw a picture "Cynara" the other night when I went to town to mail your letter. I like Ronald Colman and am rather addicted to Kay Frances so enjoyed the picture. Probably the main reason, I liked it was because the hero got a bad break too, even though he certainly was not without blame.

By early January 1933, it was clear that a settlement could not be reached. Both sides had dug into their positions. Evelyn was continuing to demand a wedding ceremony to clear her name and her reputation. Anything short of that was simply unacceptable to her. Since Ralph and his father were unwilling to accede to her demands, she instructed Kennerly to draw up the papers to file suit.

Although Ralph knew that it was risky to return to Tennessee where he could be served with legal papers, he sneaked into Knoxville that winter to pick up his parents and take them to Florida for another one of their regular vacations. Ralph, always the dutiful son, explained it away by saying that his mother's doctor thought the warmer climate would be good for her health. He drove his parents south through Georgia and on to Miami Beach where he stayed with them in a rented cottage in Coconut Grove.

The Scharringhauses were not the only Knoxville residents who spent the winter in the Miami area. Bill and Louise McClure and Ralph's cousin "Son Charles" and his family also spent time in southern Florida that winter. When they received word that Knoxville's banks were failing and being shuttered, they shared the news from home with one another and passed around articles about the financial crisis that had been published in the Knoxville newspapers.

Fidelity was the first Knoxville bank to collapse. The Scharringhauses owned bonds and a limited amount of stock in the bank, but their losses were not significant enough to force them to end their vacation. Ralph did travel by train back to Knoxville in early

163

February, but he stayed in town just long enough to check on his family's investments and to visit Elizabeth.

Evelyn's informant L.I.B. Broker wrote her a letter about Ralph's sojourn back to Knoxville. He reported that Ralph was traveling "incognito" and was using "his same old tactics in evading certain people here that he didn't want to see him":

> I believe perhaps that you are misinformed as to the purpose of Ralph's recent trip back to Knoxville...It of course is highly probable that he and his father are disposing of some Fidelity bonds (if they possess any) but I am informed that Ralph was here alone. I think perhaps Mr. Scharringhaus did own some Fidelity bonds at one time but I don't know whether or not he has them now.

By the time that Evelyn received word that Ralph had been in town, he had already returned to Florida where he spent the next few weeks with his father and ailing mother. He also enjoyed occasional side trips to tourist attractions. He and Son Charles made a leisurely drive to Sarasota to see the Ringling Brothers circus at its winter home, to the beach at Clearwater, and then to St. Petersburg to watch a pre-season baseball game. Perpetually unperturbed and protected by his parents, Ralph floated through the winter of 1933 in a carefree and leisurely state of mind, insulated from and apparently unconcerned about Evelyn and her suit.

While he vacationed, Evelyn and Kennerly were putting the final touches on her legal brief. On March 24, 1933, they filed suit for seduction and breach of promise to marry against Ralph in Knox County, Tenn.

The suit sought $100,000—a huge fortune at the time—in damages from Ralph. It alleged that it was Ralph's fault that they had engaged in sex before being married, and it accused him of breaking his promise to marry Evelyn and using "over-persuasion, artifices, false promises, deceit declarations of love, and his seductive arts and fraudulent promises and statements," while inducing her to submit

164

"to [his] carnal desires...on many occasions...the last act of intercourse between them taking place on May 28, 1932, four days before the defendant announced, as before averred, that he would not marry [her]...."

The suit also made it clear that Evelyn and Kennerly did not believe Ralph's declarations of near poverty. Not only was he able to take frequent vacations, but also he still had the titles of Secretary-Treasurer of Gillespie, Shields & Co. and Vice President of Morris Plan Bank. The suit described Ralph as "a man of large financial means," implying that he had substantial personal wealth. Additionally, the suit blamed Ralph directly for Evelyn's firing from the Knoxville school system and stated that she was a former schoolteacher who had been paid a modest salary of $2,400 a year until she lost her job due to "the publicity and notoriety" generated by the rumors about her relationship with Ralph.

The local newspapers published front-page stories about the suit and quoted the court documents that outlined her case against Ralph. Evelyn's informant L.I.B. Broker described the community's reaction to the articles in a letter:

> Yes, I read the stories in both of the local papers concerning your suit against Ralph and although I very readily recognized the fact that the main point which you were anxious to get over to the public, was not published, I hardly think that this should cause you very much worry or concern for public opinion seems to be decidedly in your favor. Having been associated with Ralph for many years, and this fact being known to all of my friends and many of my acquaintances, naturally placed me in a position to hear many reactions on the subject and I have yet to hear anyone express any sympathy for Ralph or to place any part of the blame on you. I don't know whether you know it or not but, generally speaking, it seems to be an accepted fact that many girls in the best regulated homes and society, are led to go just as far as you went with Ralph, and inevitably, when the case turns out as yours did with Ralph, the responsibility and blame is placed on the man, just as it

should be in most cases. In cases of this kind it is not an uncommon thing to hear the remark "he deceived her." That seems to be the consensus of opinion in your case. However, you may rest assured that in the event I contact anyone who seems inclined to place the blame on you, I shall waste no time in getting them straightened out on the proposition. It of course is very unfortunate that the newspapers did you such an injustice by not printing your side of the case if they were going to print anything at all. I am not surprised at the News-Sentinel however....

For Evelyn, filing the suit was a life-altering action, one that sent the message to the world that she would stand up to Ralph as well as the behavioral restrictions on women that were implicit in society in the early and mid-Twentieth Century. As a strong woman who by this point had practically nothing to lose, Evelyn refused to be trivialized or ignored. She turned a hard eye toward social convention, stared it down, and went public with her affair. By admitting that she had engaged in sexual intercourse outside of the bounds of marriage, she laid bare her embarrassing past to the world, knowing full well that she would be criticized and shamed. Evelyn prepared herself emotionally for the inevitable—the embarrassing newspaper articles and the spiteful gossip.

The suit had little or no immediate impact on Ralph. From his location hundreds of miles away in Florida, his day-to-day life continued to be unaffected. As long as he remained outside of Tennessee's boundary, he could avoid being served by a summons ordering him to appear in court. But it did add several months to his self-imposed exile. To avoid being apprehended, Ralph figured he could not safely re-enter Tennessee for one year. Then he could return home when the statute of limitations expired.

In early May 1933, Ralph's parents were ready to return to Knoxville. Ralph drove them only as far as a train station Asheville, N.C., put them safely a comfortable coach, and drove alone to his aunt's home in northern Kentucky.

In letters that he wrote to Elizabeth, Ralph complained bitterly about being away from home and his inability to make a living while being on-the-lam. He told her that he barely had enough money to live on and was considering becoming a traveling salesman selling cotton suits from his car. Yet, he had enough cash to go the latest movies and vaudeville acts. Never one to deny himself an opportunity to take a vacation, that summer Ralph also drove to North Carolina to play golf at Blowing Rock.

Just as Ralph had anticipated, the Knox County Sheriff was ordered to deliver a summons to him, but Ralph could not be found in the State. Over and over again, the sheriff searched for him or his car at the country club and other locations, but was forced to return the unexecuted summons back to the court. Sheriff J. Wesley Breure wrote on the back of each summons, "I have been unable to find the Defendant in my County. I return that since this suit was instituted the defendant has at all times been out of the State of Tenn. & in the State of Florida & other states."

While Ralph remained beyond the reach of the law, he and his supporters discussed Evelyn's suit and devised a plan to counter the allegations against him by inventing another rumor to discredit her further. In May 1933, he met with informants Mildred Eager and Gertrude Penland in Corbin, Ky., and together they agreed to spread the tale that Evelyn had had an affair with Carl Stafford.

"The story on Carl is that one night he & Evelyn both spent the night at Mildred's when Mrs. Eager was away. Evelyn went into his room to tell him good night after she was ready for bed and it took her three hours to do it," Ralph wrote to Elizabeth Goforth.

Eager and Gertrude Penland also sent Ralph information about Evelyn's alleged activities involving other men in Knoxville, some of whom were supporting her in her dispute against Ralph. "I had a letter from Mildred this afternoon," Ralph wrote, "but there was little information in it except that Evelyn is now chumming with a boy or man by the name of Floyd Chandler who is an ex high school boy. Mildred says he is now a deputy sheriff and from what little I know of him he is just the type to do Evelyn's dirty work such as snooping, spying, etc."

Occasionally Mildred and Gertrude were able to pass along information about Evelyn's legal strategy to him. "Mildred is going to visit [me] in Middlesboro...I told her I would meet her there if she preferred to talk rather than write me," he reported to Elizabeth in a letter. "Mildred also said Evelyn told Dannie Mellen that she could sue me through or in the Supreme Court and get service on me in any state. That is a new one on me and I have asked Papa to find out if such a thing is possible. I might have to go to Mexico...."

Months passed, and Evelyn waited impatiently for the sheriff to find Ralph and drag him into court. Ralph, who had been on-the-run for nearly a year, was poised to return to Tennessee as soon as the statute of limitations expired.

Then in a lucky break, Evelyn discovered that Ralph was staying with his aunt in Erlanger, opening another route to capture him and bring him to justice. Kennerly filed suit in Kenton County, Ky., and the Kenton County sheriff served Ralph with a summons before he could drive across the bridge and into Ohio to avoid Evelyn's suit.

Ralph informed Elizabeth Goforth of his capture by mail:

Now for a little unpleasantness. Suit has been filed against me in Kenton County Ky., of which Covington is the county seat. The summons was served on me last night and I am given twenty days in which to reply. I went to the Court House this morning and find that the case can't be tried until the first Monday in October. The bill is signed by Kennerly & Key & by a firm of Covington lawyers.

I phoned Mr. Green last night & told him about it and he said to send him the information I have just given you and he will write me what to do. He also suggested that we might have a conference some where and go over the entire matter. Of course I haven't decided what to do and won't until I get his advice.

I also got a phone call from Papa about midnight telling me that the Journal had just called him about a dispatch it had received relative to the suit being filed here.

So of course it is in the paper there this morning and every one knows all about it.

As the matter now stands the suit would be tried here and dismissed in Knoxville. I mention this for fear you would think that the summons I received would compel me to come back and stand trial in Knoxville. I guess there will be a pretty good story in the Covington afternoon paper. (They have no morning paper). The Cincinnati Enquirer had nothing this morning and The Times Star only a short notice in the second section and in an inconspicuous place.

In spite of all this the condemned man enjoyed a good nights sleep and also a hearty breakfast. So much has happened to me that with each additional blow I seem to get a little harder. The human constitution is a wonderful thing....

Yours
Ralph

Chapter 19

After much legal wrangling and several delays, Evelyn's case against Ralph went to court. Reporters crowded the courtroom fully expecting a spectacle, a contentious and fractious contest between two strong adversaries. They were not disappointed. The *Hazen v. Scharringhaus* case was a war, pitting women against men, and the remnants of the Southern, genteel manners of the Nineteenth Century against the modern ways of the Twentieth Century.

The case also featured a commodity that everyone wanted but few people had—money. By the winter of 1934, the depressed economy had dipped into the pockets of families across the country and had made them poorer. Jobs were difficult to find, and children were going hungry. The all-mighty dollar was becoming a national obsession, and Evelyn's desire to win $100,000 from Ralph for her pain and suffering was big news.

By the time the case finally found its way into the courtroom, Evelyn's original suit had been amended. In accord with Kentucky law, it now accused Ralph of breach of promise to marry aggravated by seduction, and it charged Ralph with using the engagement as a guise to have sex with her. It stated that Evelyn was "a person of chaste and virtuous character" who had received Ralph's assurances and declarations of love many times during a 15-year-long relationship until the contract of marriage was "unlawfully broken and breached by the defendant" on June 1, 1932, just a few days after Ralph engaged in his last act of intercourse with Evelyn.

The suit also repeated the earlier claim that Ralph was to blame for Evelyn losing her job. It asserted, "In the fall of 1932 the acts of the defendant became known and due to the publicity and notoriety thereof the plaintiff was dismissed as a teacher...[A]s a result of the aforesaid wrongful and unlawful acts of the defendant she has been caused to suffer great mental torture and anguish, as well as the loss

171

of her aforesaid position…she is entitled to recover from the defendant exemplary and punitive damages."

In his written response to the suit, Ralph refuted literally every one of Evelyn's accusations. He claimed he never promised to marry Evelyn or that he seduced her and had sex with her. In an apparent oversight, his legal papers even denied that Evelyn had ever been a schoolteacher. Furthermore, Ralph asserted that Evelyn could not take legal action against him because "the Statutes of Limitation of the State of Tennessee that apply to contracts for breach of marriage provide that such action is barred by limitation if not commenced within one year next after the date that such action accrued to plaintiff…." He also alleged that she was dangerous. He claimed that she had "threaten[ed] to injure, do personal violence to, and to kill [him], arm herself with a deadly weapon, to wit, a pistol…."

Furthermore, Ralph said that it was Evelyn, not he, who should be blamed for their failure to marry. If there ever had been a marriage contract, he said, it had been breached by her. He also noted that she was not suitable marriage material. In his written reply to Evelyn's suit, he accused her of "lewd and lascivious conduct, such as showed her to be unchaste and unfit for a wife."

Ralph asked the Court to dismiss Evelyn's petition and give her "nothing."

"I thought he was such a gentlemen," Evelyn's mother said in a deposition. "Because she was engaged to him I thought he would take care of her."

For 76 of her 77 years, Mrs. Hazen had lived in her hilltop home, where she had been sheltered from the societal changes that had occurred in America. World War I, the turmoil of Prohibition, flappers, and speak-easys had had very little impact on her carefully maintained and controlled environment. They were the stuff of dreams, as fanciful and remote as a child's bedtime tale, and as foreign as Gandhi's fasts in India and the growing unrest in Germany. On her island, perched high above the swirling miasma of bank failures, unemployment, regional conflicts and widespread hunger, women

172

were expected to conduct themselves with mid-Victorian propriety, men were suppose to provide for the fairer sex's comfort and security, and sex was never discussed.

In Mrs. Hazen's world, women were not supposed to enjoy sex. It was to be endured as a part of marriage, and engaged in only for the purpose of procreation. A proper woman would allow her husband to fulfill his carnal desires occasionally, but she would never consider playing an active role. In fact, well-mannered women would keep a bowl of apples near the bed so they could chew on fruit as a distraction while their husbands were pleasing themselves by enjoying their wives' bodies.

Mrs. Hazen believed in discipline, and she demanded that her three girls adhere to her high moral and social standards. Her small stature did not diminish her capacity for control. Those who remembered her said she was a tiny, prim woman with curly brown hair, who favored long sleeves, high collars trimmed in lace and ribbons, and long hemlines. Mamie Winstead said she was a "dear" and provided delightful company for her mother during the few rare occasions when Mrs. Hazen left Mabry Hill and traveled to the Winstead home at the nearby Confederate cemetery.

Evelyn, on the other hand, called her mother "the little pris." She told two stories about her mother that, in her view, seemed to define her personality. She said that her mother did not like or trust children, and she frequently forbade them from entering her house when their parents came to visit. The children were expected to stay outside and play on the porch or under the magnolia and oak trees on the front lawn. On at least one occasion during a party, Evelyn admonished her mother for making the children remain outside. Under pressure from her youngest daughter, Mrs. Hazen directed the cook to take food and drink to the children, but still refused to allow them to enter the house.

Evelyn said that Mrs. Hazen also believed that it was crude to broadcast the fact that the family was descended from landed gentry and had significant wealth. To cite an example, Evelyn told a story about her first trip to Europe. She said she had traveled across the Atlantic Ocean with students from her school and had visited a site in London where the Magna Carta was displayed. Evelyn stood at the

glass case and scanned the document carefully, searching for the name of an ancestor who had signed it. A guard who noticed her obvious interest in the ancient document arranged for her to receive a copy as a souvenir. When she returned home, young Evelyn placed her copy of the Magna Carta on the wall of her bedroom. When her mother saw it, she demanded that she take it down and put it away, saying it was simply too "pretentious." Evelyn moved it to the back of her bedroom door where her mother was less likely to see it.

The publicity surrounding the trial must have been extremely difficult for Mrs. Hazen. But by the time the trial was set to begin in 1934, she finally had come to terms with her daughter's relationship with Ralph. No longer overcome with embarrassment, she decided to accompany Evelyn to the trial in Covington. She determined, perhaps on the advice of General Kennerly, that someone from the family needed to attend the trial in a show of support.

A month before the trial began, Mrs. Hazen told Kennerly that she held Ralph responsible for all of the pain that Evelyn had endured. "In the last ten years she has been sad at times and irritable. I didn't ask her why," she said. "I can look back and see what was the matter, the way this man was treating her. I consider him a villain and deceitful...I never would have allowed him to come in my house had I known what kind of man he was...

"You see a mother never knows some things that go on. I have led such a quiet life all my life I don't know anything of the things that happen in modern life."

Winter in Covington, Ky., blows through the Ohio River Valley with a wet, penetrating cold. On a cloudy day, the streets, the sky and the river dissolve into each other at the horizon into a slate-gray sameness. Even the faces of passers-by on the concrete sidewalks reflect the dull pallor. Expressionless and powerless against the elements, they lean into the gusts buffeting around the corners of the brick and limestone buildings and trudge heavily to their intended destinations.

On the morning of February 8, 1934, Evelyn Hazen, wearing a heavy wool coat buttoned up around her throat, and her elderly mother entered the courthouse for the showdown with Ralph. The reporters and spectators who had stood in line to get seats in the courtroom murmured to one another as she walked down the center aisle toward the well of the court. She was, as one reporter noted, "comely," a strikingly beautiful woman despite her anxious expression. Her dark hair waved around her cheekbones and framed her pale face. Although her gait was determined, her green eyes flitted about the courtroom in a display of nervousness and apprehension.

Kennerly greeted Evelyn and escorted her to the plaintiff's table. They were met there by Stephens L. Blakely of the Blakely and Murphy law firm in Covington. Because the case was being tried in Kentucky, Kennerly knew it was necessary to add a member of the Kentucky bar to Evelyn's legal team. Together, he and Evelyn had chosen one of the best. Blakely was a seasoned courtroom litigator and active Democrat with strong ties to the Covington community. At that time, he also was the City Solicitor, the title given to the lawyer who was tasked with representing the city of Covington against legal action. Twenty years earlier Blakely had served as a Commonwealth Attorney, a position that had won him respect and admiration among the judges and his colleagues.

Blakely's jaw was clenched and his thin lips were set in a tight line as he glanced at the defendant's table to size up Ralph and his legal team. He watched them for a moment while his and Kennerly's legal strategy played like a recording in his head. As the lead attorney in Evelyn's case in the Covington courtroom, Blakely had had to memorize all of the details of Evelyn's relationship with Ralph, put them in chronological order in his brain, and be prepared to shine the full light of day on them before the jury. As a husband and a father of three daughters, Blakely also had an appreciation for Evelyn's dilemma. He knew that young women could be cajoled into less than desirable conduct by persuasive men.

Blakely figured that the odds were stacked against Evelyn. The court system was dominated by men. The judges, the lawyers, and even all of the jurors that had been selected to hear Evelyn's case were

men. Blakely wondered whether they would give Evelyn the courtesy of listening to her story and judge her fairly and without bias, or think of her as a shrill, hysterical woman who had willingly participated in sex and was largely responsible for her own problems.

A group of prominent women in Covington shared his concerns. These 16 local women, who called themselves "the jury of women only," attended the trial every day to show their support for Evelyn. They arrived early each morning and were among the first in line to enter the courthouse. Often they brought their lunches with them, so they could keep their seats and not lose them to other spectators during the meal break. One of the women, Thelma Sullivan, wrote to Evelyn after the trial and reported that several of the women were the wives of city and county officials. She said that due to their stature in the community, they felt they could not speak out in Evelyn's behalf, but they firmly believed it was important to be seen at the trial.

Blakely thought that if he could lead Evelyn through her testimony carefully and avoid potential minefields, she might have a fighting chance. In the final analysis, whether she would win or lose would be up to her. She would have to tell her story and Ralph's impact on her life; she would have to elicit sympathy from the jury; and she would have to convince these 12 men that she deserved vindication.

Ralph sat at the defendant's table, wearing a tailored, well-fitting three-piece suit. His hair was parted slightly off center and slicked down. A handsome man, fit and trim at 37, he looked around the courtroom confidently from behind his round glasses. Next to him sat Judge Jennings, a younger and more aggressive member of John Green's Knoxville law firm, and Covington lawyer Sawyer Smith of the Smith and Murphy law firm.

Like Blakely, Smith had served in public office and had local political connections. As the U.S. District Attorney for the Eastern District of Kentucky, where his actions led to the convictions of more than 17,000 accused criminals, Smith was known as a very competent, tough-minded prosecutor. Later in his career, when he returned to private practice and focused on defending accused clients

rather than putting them in jail, he developed a reputation for winning acquittals for murder suspects.

Smith's role was to provide legal and political advice and to sign the defense's pleadings and motions. He was not hired to argue Ralph's case before the Court. That job was left to Jennings.

Jennings was not one to shy away from a controversial case, nor was he reluctant to badger uncooperative or hostile witnesses. A few weeks before the trial, when he and Kennerly had deposed Evelyn's mother and several other witnesses who had been subpoenaed to vouch for Evelyn's character, Jennings had gone on the attack. He was particularly tenacious when he asked them how they could respect and trust a woman who had willingly participated in sexual acts.

Most of the witnesses objected to the premise of Jennings's question, saying that they had no evidence that Evelyn had gone along willingly with Ralph's repeated demands for sex. Initially they withstood his verbal onslaught and criticized his methods, refusing to answer his speculative and biased questions. But under his intense questioning, some of them faltered and cracked, admitting that they would be less likely to trust anyone who had behaved in the manner he suggested.

Jennings's questioning of Gertrude Beardsley, a member of the school board, was a case-in-point:

"Isn't part of Miss Hazen's general reputation that she had told every one almost in town that she has talked about [her sexual relationship with Ralph Scharringhaus]?" Jennings asked.

"I do not know," Beardsley answered.

"Don't you know she has talked freely to various persons about it?" he asked pointedly.

"To some, but not generally I wouldn't say."

"...Well, if it is a part of her general reputation that she has habitually gone armed and has used profane and vulgar language, and has voluntarily over a period of sixteen or seventeen years had sexual relations with Mr. Scharringhaus or with a man to whom she was not married, would you, if those things are true, would you give her full faith and credit on her oath in a case wherein she is interested, the same faith and credit that you would give a virtuous woman?"

"Not if it became known," Beardsley responded.

"If these things are true," Jennings probed deeper, "you would not give her full faith and credit on oath, would you?"

"No," Beardsley stated.

"All rise," the bailiff commanded.

Circuit Court Judge Rodney G. Bryson strode into the Kenton County courtroom in a long, flowing black robe. The left sleeve of his gown hung empty and swayed slightly as he took his seat at the bench. A childhood accident had led to the removal of his arm below the elbow, but it had not diminished his ability to become a well-respected jurist. Although fairly small in stature, Bryson's position as well as his manner commanded respect. He had a stately bearing, a dapper appearance, and a serious expression. Bryson peered through his thick glasses at the people standing at the plaintiff's and then the defendant's tables and prepared to start the day's proceedings.

At the bailiff's command, Evelyn's mother sat down quietly in the gallery, as the reporters and observers took their seats. Edward Scharringhaus, Ralph's father, took his position on the defendant's side of the center aisle, wearing a stern and proud expression.

The inflammatory accusations contained in Ralph's answer to the suit already had provided plenty of grist for the reporters. But when the trial began with opening statements, Ralph's attorney Judge Jennings hurled even more charges at Evelyn. He told the jury that she had stated she would never be satisfied with just one man and had claimed that she had "had" several men, including Carl Stafford and Jack McKnight. Jennings said he would prove, for example, that in the summer of 1930 after she traveled to Europe, Evelyn had spent the night with McKnight.

Evelyn's attorneys immediately refuted Jennings's accusations in their own opening statement. When it came time to present the plaintiff's case, they called Evelyn to the witness stand.

Evelyn had been stunned by the accusations lodged against her in Jennings's opening statement. One would have thought that she

was on trial instead of Ralph. So when she walked into the well of the courtroom and to the witness stand, she carried with her a renewed sense of purpose. With a defiant and angry gleam in her eyes, she swore to tell the truth and settled in for what was the first of several days on the stand.

Blakely got to the point immediately and asked whether it was true that she had had sexual intercourse with any man other than Ralph Scharringhaus.

"It is absolutely untrue and malicious," she said firmly.

"[But Jennings] told this jury in his opening statement, that you met McKnight at Cleveland and went with him to a hotel, and that you both registered in this hotel, and that you and McKnight spent the night in the hotel, if Mr. Jennings means that you and Mr. McKnight spent the night together in the room, the same room, I want you tell this jury whether or not that's true?"

"It is not true," she said.

Then Blakely deftly led Evelyn through her relationship with Ralph, starting in 1914 when she entered the University of Tennessee when she was just 14 years old and proceeding to how Ralph began to court her by helping her with her trigonometry problems while she, in turn, helped him write letters to an out-of-town girlfriend during the fall of 1916. Evelyn also described how Ralph left love notes to her at the campus bookstore and told the jury that she had kept approximately 300 letters that Ralph had written to her over a period of several years. Then she told the jury about their engagement.

"Well, in the spring of 1917 he definitely asked me to marry him and I said I would, I was in love with him, I realized that I cared very deeply for him, because I had respect for him, one thing he did that some others didn't, that I always respected him for, he was rather interested in his church."

"What was the date of that engagement?" Blakely asked.

"The spring of 1917," Evelyn replied.

"Did he at that or any other time give you an engagement ring?"

"He didn't have enough money to buy an engagement ring, but he gave me his fraternity pin, that, he said, would stand for that, and it did in some cases, when soldiers…."

Her attorney broke in. "What significance did it have for a soldier to give a girl a fraternity pin?"

"When it was an official pin that they had and registered number in back of it, it was supposed to stand for an engagement, sometimes possibly it didn't, it did in our case, at least he said it did."

Blakely read the registration number from the back of the Sigma Alpha Epsilon pin and was allowed to admit the pin into evidence.

"Did he at any time give you an engagement ring?" he inquired.

"Yes, sir."

"Is this it?"

"Yes, sir."

"When did he give you that?" he asked.

"He gave me that either in 1920 or 1921, I don't recall exactly which, it's been so long, I chose this kind of ring rather than a solitaire because I thought it was prettier," she stated.

"Where were you, under what circumstances did he give you the engagement ring?"

"Well, he asked me to go and select one, I might say, that by 1920 or 1921 we had been teased so about being so much in love with each other, going so much together, we were teased by our mutual friends, that we more or less hated for them to know everything that we planned, so he asked me to go to the jewelry store in Knoxville and select a ring that I liked and he didn't go with me because he knew I would have rather felt self conscious about it and I suppose he did too, anyway, we did not go together, I went with a friend, a girl I was teaching school with, and I chose this ring or one like it and just described it to him."

Blakely continued to lead Evelyn gently through her long relationship with Ralph, pausing occasionally to read Ralph's letters to Evelyn aloud to the jury. Each one confirmed that Ralph had been deeply in love with her. He read slowly and thoughtfully, allowing the emotion expressed in the letters to wash over the jurors.

"Dearest Evelyn," he read. "...Little Tim I love you more every day, almost too much for my peace of mind, because I can't help being afraid that you will change your mind about me and then I don't know what I would do. I am very happy because you have my

180

pin. You must be proud of it and love it because it means so much to me…I want to be with you because I love you. Yours, Ralph."

Under questioning, Evelyn explained that the letter was one that had been left for her at the campus bookstore early in their relationship. Then Blakely turned his attention to Ralph's military training during the summer of 1917. It was during this time, her attorney established, that Ralph became intensely interested in sex.

"Yes, sir," Evelyn said, "I think when that first training camp was opened, well, Ralph said to me…in a way that was not offensive, he wasn't offensive, that he had never known a girl who knew as little about, well, about marriage and matters of sex, I suppose I should say, and that was true, I suppose, because I had to study in school, I entered young, I had, my two sisters were years older than myself."

"How much older?" Blakely asked.

"Twelve, thirteen, and the other fourteen, fifteen years older. I had grown up almost as an only child and my parents, of course, were older than perhaps the average parents, and I had been, unfortunately I can say sheltered too much, my mother had not set me down and given me a lecture on that sort of thing, I had no curiosity about it, I wish I had had a curious little mind," Evelyn answered.

Ralph's attorneys objected, and their objection was sustained.

"Well, anyway," she continued, "I knew absolutely nothing of things of that kind, and I wasn't interested in it. Ralph said to me that he thought that a girl of my age should know more, of course, I knew that there was a difference there, but I hadn't been curious about it to try to find out what it was. As a matter of fact, coarse remarks on the part of people and kids of my age embarrassed me, and I had formed no opinion on that subject one way or another, so I didn't know anything about it. Ralph said to me he thought I should know more of the, one of the most important things of the world, and he undertook and later did tell me and very beautifully, as I think it should be told."

"Did you have…confidence in him at that time?" Blakely asked.

"Oh, absolutely, of course I did. And his telling me what he did in the way he did increased my confidence in him, he wasn't crude and

he wasn't vulgar, and he wasn't, he told me as a big brother, or even a big sister might have told me, the relationship of the sexes, and he said that it was not a thing that should be treated profanely, that it was sacred, and he also said that, well to give me an idea to carry me from what I could grasp and understand to the thing he was trying to explain to me, he told me about the pollination of flowers."

"The old story?"

"Yes, sir, anyway, I think that's all right, I think if I were going to tell a child that I think that would be a very good way."

Then Evelyn described how Ralph had seduced her during his first leave from Camp Jackson in October or early November of 1917. She told the jury how they had driven in his father's Haynes automobile to the courthouse to get a marriage license but had discovered that the license bureau was closed.

"The next morning he called me by telephone," Evelyn explained, "and said that he had to take his mother somewhere and that he would see me that afternoon."

"...Do you remember what day of the week the next day was?"

"Saturday."

"Well, did he get the marriage license on that day?"

"No, sir, he didn't, he said that he had to take his mother somewhere that morning, and the office was closed on Saturday afternoon...when he came out to see me that evening after dinner, I think we went and took a ride, or went to a picture show, I don't recall just which, and he began making very ardent love to me, as he always did, and began saying that he simply could not go back to camp, he didn't want to go back to camp without me...He said he was going away, he didn't know if he would ever have another leave or not soon, and he might be sent to France and that he, even though we hadn't been able to be married then that if I loved him enough to marry him, I would prove it to him by allowing him to do as he wanted to do, and I didn't want to."

"What did he say with reference, if anything, with reference to marriage being a matter of love and not of ceremony?"

"He said that, he said that marriage...was in the mind, people in love [did] not [need to have] a few words said over them as a matter of

182

ceremony…And then he said we would really be married in the sight of God, when I think of this now, I think now of two things he repeated so many times in those years, one was, we were the same as married in the eyes of God, and the other was, ten ceremonies could not make him feel more bound to me than he did. It was always a matter of finances, he could not support a home and he would be criticized for not being able to."

"On this particular night did he say anything about being willing to support a home?"

"No, sir…He said all kinds of endearing terms that he loved me more than anything in the world, and that he did not believe I loved him as much as he loved me, if I did I would do as he asked, if I didn't, he would never believe I loved him enough to marry him, that I was sending him away perhaps to war, and it was perfectly all right in the eyes of God."

The memory of Ralph's deceit was distressing to Evelyn. She was finding it difficult to speak.

"All right, go ahead," her attorney said, encouraging her to continue.

"Well, that was at my home, rather the conversation began when we were sitting in his car out in our driveway, we came into the house and he…reiterated constantly over and over how great his love was for me, and used all kinds of endearing terms, and I remember the feeling that I had, I was just more or less sitting watching him, listening to him, because I was convinced I had never heard of anybody being as much in love as he was, I was as impressed by it, I believed him, I thought he was the most wonderful man I had ever seen, and I was in love with him, and I [told him] I would feel better about it if we would wait until we were married, he said he just wanted that as a proof that I loved him enough to marry him, and he kept on saying that…

"I did allow him to do as he asked and naturally I expected a sacred, beautiful thing that he had discussed and had said it was, and in the eyes of God, and the supreme expression of love…I don't know in all of my life I have never had such a strange feeling of shock and being suddenly grasped in something that there wasn't any release

from, I didn't say so to him at the time, I don't recall, I'm sure I didn't, because for a long time I kept those feelings to myself."

"What were your feelings about it?"

"Well, I was frightened, and I was, well, I hate to say it, I was terribly repelled, it was just a little bit repulsive, because I wasn't prepared for it. He had told me one thing and the reality proved another."

"At that time what was your age?"

"I was seventeen, nearly eighteen," Evelyn said.

Blakely let the jury absorb the fact that Ralph had proposed to Evelyn and then seduced her before she had attained the legal age of adulthood. Then he continued reading Ralph's letters to the jury. Several of the letters expressed his happiness at their physical relationship.

"Now Mr. Jennings stated in his statement to the jury," he said, "that these relations with you had not begun to exist until about 1920, I believe, when you had drifted into them, is that a correct statement?"

"It is not a correct statement, no, sir," Evelyn responded.

"Had they continued from that first time in October 1917 up until this time I am now reading about?"

"Yes, sir."

"July 1918?"

"Yes, sir, when he was at home."

"Did he have intercourse with you [every] time he was home...?"

"Well he did every time, yes, sir," Evelyn said softly. Admitting that she had given into Ralph's demands for sex was painful for her.

Her attorney asked her to speak up because the jury was having difficulty hearing her. "And at those times, what did he say about marrying you?"

"Always we were going to be married...we were going to be married on his second leave, then he explained to me that we couldn't live on a second lieutenant's salary and he said we would be married when he got a captaincy."

"Well now Mr. Jennings has referred to the fact that you continued those relations...will you tell the jury in your own way why you did continue them?"

184

"I didn't have any choice, I felt, I knew well from his importunes and from things he said from time to time...that if I didn't allow him to do as he wanted some times that I would prove to him that I didn't love him, and I didn't want to marry, he would answer I didn't want to marry him. Perhaps I was wrong, I didn't know anything else to do and I believed, of course, we would be married, it was always just a little way in the future, never any great distance in the future, I thought going on was the lesser of two evils."

"What did you believe in your own mind about the result if you refused and did not continue?" Blakely asked.

"I believed he would go off and find someone else, I believe now he would, I know now he would, I know now that he did."

Chapter 20

In Knoxville, Evelyn's supporters and detractors alike read about the first day of the trial on the front page of the *Knoxville Journal* newspaper. In large type, the headline read, "Burning Love Letters to Teacher Read in Hazen-Scharringhaus Suit."

"The courtroom was crowded," the accompanying article said, as Evelyn Hazen took the stand and began to describe how "Scharringhaus reneged on a promise to marry her." But Ralph's attorney refuted that claim, it noted, when he stated that that Evelyn had terminated their long engagement, not Ralph, because she was not a "one-man" woman.

Such a salacious statement would have evoked exactly the response that the publisher wanted: it would have helped to sell newspapers and encourage his readers to clamor for all subsequent articles about the trial. In fact, the *Hazen v. Scharringhaus* case had all of the attributes a newspaperman could have asked for in the 1930s. It involved local celebrities who were attractive, wealthy, and had social standing. It contained sex and the threat of violence. And it involved a young woman who either was very courageous to confront her former boyfriend in a court of law or who had lost her mind.

Publishers and editors across the country fully expected the trial to generate good copy. They figured that at its best, it was likely to be like an opera filled with a colorful combination of comedy, pathos and histrionics presented on a judicial stage. At its worse, it would become a lurid and risqué burlesque show, offering opportunities for a kind of voyeurism that would be enjoyed by destitute victims of the Depression who would wag their fingers at two well-heeled socialites and laugh gleefully as they smeared each other's character with smut. As long as the trial helped to sell newspapers, they were happy to cover it.

Had Evelyn seen the Knoxville Journal article, it is likely she would have been angry and hurt. Although it was fairly even-handed in its coverage, it signaled that she should not expect to receive any

special consideration from the paper, despite the fact that she had worked there during the summer a few years earlier.

When the trial resumed on Feb. 9 for the second day of testimony, Evelyn again took the stand. Rather than return to their chronological account of her relationship with Ralph, she and her attorney called the jury's attention to a comment that Ralph muttered during the first day of the trial.

Blakely asked, "Miss Hazen, when we were reading the letters introduced yesterday, and particularly those in which Mr. Scharringhaus talked about your marriage, did you at that time hear Mr. Scharringhaus make any statement?"

"I did," she answered.

"...What statement did you hear him make, and to whom?"

"I heard him say to his attorney, when the letters were being read, the letters from Camp, in a disgusted tone of voice, 'Oh, that's just kid stuff, I didn't have any intention of marrying her', I heard him distinctly," Evelyn said.

"Any doubt about that at all?"

"No doubt in the world," she replied with conviction.

"Did he make that statement more than once?"

"He repeated that it was kid stuff, the tone of voice was so familiar, that it struck me."

Blakely then offered into evidence more of Ralph's love letters to Evelyn, using Ralph's own words to show the jury that he repeatedly told Evelyn that he loved her and wanted to marry her.

"Now, Mr. Jennings stated to the jury that you were the aggressor in this affair." Blakely said. "[But at] all times Mr. Scharringhaus seems to be complaining about your timidity and backwardness, and that you didn't write him often enough, didn't tell him you loved him often enough, what is the fact about that?"

"He told me always that I didn't tell him enough in my letters or when I was with him, I didn't talk about it constantly, in other words, and whenever I would write him telling him how miserable I

was, I couldn't stand it any longer, he would write and say he thought I didn't love him, that's the way he kept me...."

Blakely interrupted. "What did you tell him you were miserable about?"

"Miserable in the situation I was in, he wouldn't change," she said.

"What did you want him to do?"

"I wanted him to marry me."

"What would he say?"

"...[H]e always said I showed myself inconsiderate of him, and even ungrateful."

"For what?" Blakely asked.

"Because he was working and trying to make it possible to give me a home that I would be proud of, and that I was urging him to take on responsibilities that I knew he couldn't take, that I was being unkind to him, he said it over and over."

"Well had he told you, I am referring to the time now after he left the army, about his financial condition?" Blakely asked, steering her through her testimony carefully.

"He never let me know what his financial condition really was," she said. "I never thought he made at the most over two hundred dollars a month, I know he made forty-eight hundred dollars a year for many years."

Blakely continued, "Was that sufficient for you to marry on?"

"I would have thought so," Evelyn replied.

"...You would marry him now?" Blakely asked.

Ralph's attorneys objected, and the judge sustained their objection. But Evelyn was not silenced.

"Yes, sir," she said, "that's all I ever asked."

Blakely returned to the letters and read excerpts from them aloud to the jurors, focusing on Ralph's own words. One letter written about their sexual relationship in November 1918 prompted a string of objections from Ralph's attorneys. "...[P]lease don't have any regrets," Blakely read into the record, "for I love you with all my heart and only you.

Now, Miss Hazen, to what was he referring when he said, 'please don't have any regrets?'" Blakely asked.

"He was referring to the fact that I did have regrets about what happened," she said. "...[H]e even went so far sometimes as to say, Evelyn, the evil is in your mind, I don't see it that way, you are the one who sees the evil in it."

"He was good and you were bad, is that it?"

"Objection!" Jennings interjected. Judge Bryson sustained it.

"Well, did he ever say there was any evil in his mind?" Blakely asked Evelyn.

"Oh, no, no indeed," Evelyn said, "always sacred."

"What did he say about his mind?" Blakely asked. "What did he say about the state of his mind and soul?"

"He didn't seem to be...."

Jennings objected again and accused Evelyn of being out-of-order by trying to offer a conclusion.

Judge Bryson turned to Evelyn and gave her instructions. "You can say what he said to you."

"He said over and over, hundreds of times in the years, that there was no evil in it, that he loved me and I loved him, and that made it all right," she said.

Blakely asked, "Did you think he was rather sacred about it?"

Jennings objected on the grounds that the question improperly called on Evelyn to state her own opinion, not fact.

Blakely tried to steer Evelyn in an acceptable direction. "Why did you feel so hesitant about even suggesting to this gentleman that he might possibly be wrong about it?"

"Because he always met it with such a convincing argument, and convinced me I was wrong. It was all right in the sight of God...," she explained.

"Did he ever tell you how he had found this out from God or anybody?" Blakely asked.

"No, sir, he never said how...I was supposed to take what he said, and I did for a long time."

"That was his pronunciamiento about it?" Blakely asked.

"Yes, sir."

"...Was Mr. Scharringhaus of a rather pious disposition?"

Ralph's attorneys objected, but were overruled.

"Yes, sir," Evelyn said, answering the question, "extremely so."

"Extremely so? In what way did his piety and holiness demonstrate itself?" Blakely said.

Again Jennings objected, and was overruled.

"He, well he attended church rather regularly with his father and mother, and whole attitude towards things that are sometimes scoffed at in a crude way, he did not, at least he didn't with me, later, however, he began to drink rather heavily and gamble excessively and lost all interest in reading things that were good, as he refers in his early letters. He seemed to like off-color jokes, that was in later years...," Evelyn said.

Jennings moved to exclude Evelyn's response, but he was overruled again.

Blakely pressed on. "In what way did Mr. Scharringhaus's piety or holiness demonstrate itself to you?"

"Objection!" Jennings shouted. The judge allowed Blakely to continue.

"What did he say about it?" Blakely asked, modifying his original question slightly.

"His piety and his holiness, as you term it, demonstrated itself in two ways, by his actions in going to church and affiliating himself with the church, he became a Deacon in the church, and to me personally it was what he said about our relationship, it was holy and pious, and married in the sight of God, and as I have said, he said so often, when I hear his name, I think of those two things, 'It is all right in the sight of God and ten ceremonies could not make me any more bound to you', I have heard that so much."

Blakely introduced more letters into evidence and presented examples of the teasing she had endured from Ralph's friends. Evelyn said she was blamed quite openly for their failing to get married, yet she felt she was incapable of defending herself.

"Well, it just made me frantic sometimes," she said, "I couldn't do anything but sit there and take it, and I got the blame...."

"I want you to tell the jury Miss Hazen why you couldn't open your mouth about it?" Blakely said.

"Objection!" Jennings roared.

"Why, because I couldn't tell it," she said, "I didn't want to."

"Why not?"

"Would anybody want to tell it," Evelyn responded, "not for a minute to tell their friends that they were in the position that I was in, I would rather have taken the blame, as a matter of fact."

"Taken the blame for what?"

"For not marrying him, it was a matter of pride, finally though…I asked him to go to them and tell them, as he had told me, that he was not financially able to be married… [but] he never told them. Time after time I have been disagreeable when a lot of people and especially Mr. [Asbury] Wright, I don't think Asbury would do it now, but he and Mrs. Goforth and some others of our friends, I might say hounded me…I did say on several occasions, why don't you ask him, why do you continually hound me."

"What would Mr. Scharringhaus be doing while you have been hounded in that way?"

"Well, he would sit with a weak, almost simpering look."

"Saintly look?"

"He did simper, because that's the only word I can think of to describe it."

"Let you take the blame?"

"He never opened his mouth, only smile and hang his head."

"Martyr like?"

"Exactly, that's the better word."

"Did he ever on one occasion, any time, come to your rescue?"

"No, sir."

Citing a letter written in February 1919 after Ralph had traveled back to Knoxville from Camp Jackson to visit Evelyn, Blakely asked, "Now, will you tell the jury Miss Hazen to what he referred when he said this, 'I had a wonderful trip and you know why I am happy don't you dear'?"

"He was always happy when he had his way and went away feeling he had convinced me again I should look at it the way he did…," she explained.

By reading Ralph's letters, Blakely established that Ralph had a tendency to say one thing and do another. He used letters from Blowing Rock to illustrate his point.

"...I was pretty much hurt by the fact he went off regularly on vacations," Evelyn said, "telling me that he hated to go and leave me, but he went just the same, and he wanted to go, because he wanted the vacations as he said, and he looked forward to the time when we would go away together, then when I would say [why don't you stay] he would reproach me by saying, 'you don't want me to have a vacation, you are selfish, you have no thought for me.' Always reproaching me, making me feel I was the one that was being unfair, and then he would go on talking as he has written in that letter that he would 'give anything in the world,' to make me stop [being unfair]; he said one thing and did another, and it was pretty maddening and sometimes just from hurt feelings and hurt pride I would say short things, because I couldn't stand some of it, it was terrible to have had someone say one thing and write one thing to you and then just hue to the line of determination of doing the thing you couldn't stop him from."

Reading another letter from Blowing Rock, Blakely said, "'Honey child I feel like a dog being up here where it is so cool and nice when the weather is so unpleasant in Knoxville. I really can't enjoy it when I know that you are uncomfortable.'

"Well," Blakely said, "did he come home then?"

"No, sir," Evelyn answered.

"He stayed on?"

"He stayed on and went back for several years."

In another letter, this time from a train car on the Memphis Special, Ralph wrote, "...I am certainly looking forward to the time when we can have our own little house."

Blakely asked, "Was there any discussion of having your own little home, between Mr. Scharringhaus and you...Had you ever undertaken to pick out a home?"

"He embarrassed me exceedingly in Knoxville once by telling me to select a lot in a subdivision, and it was very pretty, and he pointed it out to some of our friends when we were driving, he certainly never

made any effort to buy the lot, I was embarrassed to death, of course," Evelyn said.

"What about furnishing the home, anything about that said?"

"Well we didn't talk about the actual furnishings, we talked about the home itself and the happiness we would find in it. I think I talked about a family, although I am supposed to have called children, damn brats."

"Did he charge you with that?" Blakely asked.

"I think Mr. Jennings said something of that kind."

"In his opening statement?"

"Yes, sir," Evelyn replied. "Ralph called my school children damn brats."

"Well, what did he say about having children, and what did you say? When you were married?"

"Well I remember distinctly this little bit, late in the spring of 1932, when I thought that after all things were going to work out," she said. "...I asked him if he had lost the vision of a home and perhaps a child, and he didn't have anything to say."

Chapter 21

Evelyn remained on the witness stand for the next three days, answering countless questions from her attorney and chipping away at the impassive and proud exterior of Ralph Scharringhaus. She, Kennerly and Blakely had two primary goals: to demonstrate his studied and heartless treatment of an impressionable and naïve young woman; and to refute the vile accusations that Jennings had thrown at her during his opening arguments. Ralph's own letters continued to provide them with plenty of ammunition.

In one letter sent to Evelyn from training camp, Ralph had referred to himself as "wild." Blakely asked Evelyn what he meant.

"Well, he described himself correctly in his letters when he said he was wild..." she said. "He meant his extreme...."

"Objection!" Jennings thundered. He was becoming exasperated by Evelyn's ability to insert her editorial comments about Ralph into the record.

Judge Bryson said, "...[I]f he did use the word 'wild' to express certain feelings, and you heard it often, you may answer, if you know what that meant between you and him."

"I do know what it meant," Evelyn responded.

"Tell the jury," the judge ordered.

"He said he was wild with love for me, and he certainly showed it, he was wild to the point of extreme brutality. He has left marks on my arms, he would take ahold of me so hard, I asked him not to, he didn't seem to care whether I was there or not, he lost sight of the fact that I was there and had feelings and sensibilities, he was wild, it does express his...."

"You mean when he had sexual intercourse with you?" asked Blakely.

"Yes, and when he led up to it...he hurt me figuratively and literally both."

"All the time?"

"Practically all the time," Evelyn answered. "He didn't seem to realize it even when I told him he didn't pay any attention to me…He was [so] completely abstracted and absorbed with his carnal passions that I don't think he realized how I suffered," Evelyn said.

Blakely asked, "Did you complain about his indifference?"

"Yes, I did," Evelyn replied, becoming distraught at the memory of Ralph's actions.

"I wrote him in 1932," she continued tearfully, "when my father was lying ill and dying, [and] I was fighting desperately to make him do something definite, just to go through the marriage ceremony…even secretly, I made up my mind then if it were humanly possible I would not only submit to it but make him think I didn't mind it, I don't know why, it's probably just an obsession with me, it has been for long, I will never have any peace of mind, no matter how this thing turns out."

Tears streamed down her face as she cried softly.

"Well, what did he say?" Blakely asked.

"I cannot talk right now," she replied.

The reporters in the audience scribbled notes about Evelyn's obvious discomfort as the women in the courtroom sat in sympathetic silence, watching her as she dabbed at her eyes with a handkerchief.

Blakely paused to give the jurors enough time to absorb Evelyn's despair and then read another letter. It ended with "Baby I guess it's a good thing I can't see you tonight because I am so wild that I would simply eat you up and I know you would fuss."

"In all of these letters where he uses this phrase, Miss Hazen, do you understand him to mean the same thing?"

"Yes, just wildly ardent, that's all," she said, slowly regaining her composure.

"Well he says, 'I know you would fuss,' to what does he refer there?"

"…[H]e called everything I said in the way of an objection, pleasant or unpleasant, his father accused me of fussing at him over the telephone…."

Jennings, with obvious irritation, objected and moved to exclude the remark. "We don't want his father to come to the rescue," he added gruffly.

"I don't have to mention his father," Evelyn fired back testily. "[Ralph] accused me of fussing at him."

Evelyn's outburst was a clear indication to Blakely that his witness was in the right frame of mind to respond directly to Jennings's opening statement. He gamely asked her a series of questions designed to strike a blow to the heart of Ralph's defense.

"Now Miss Hazen, up until this time, which was approximately five years after you became engaged to him, did you ever get a letter from him in which he even suggested that you were refusing to marry him?"

"Oh, no, sir."

"Did he ever in all of that period up to this time ever accuse you or charge you with refusing to marry him?"

"No...."

Blakely hesitated a moment as his eyes scanned the faces of the jurors. The time was right, he decided, to ask Evelyn directly about the hateful accusations in Jennings's opening statement. "Before I come to the last letter, which is dated June 1, 1932, I want to go back to something else. Namely, to some parts of Mr. Jennings statement about you. First, Mr. Jennings told the jury that you were the sweetheart of another man 1917, that you refused to see Mr. Scharringhaus, and that you wept on the departure of this other man for training camp, will you tell the jury the facts about that?"

Evelyn described the scene when U.T. football hero Russ Lindsay left for training camp during World War I. "Mr. Scharringhaus was standing by the automobile with Mr. Lindsay, Mr. Lindsay's sister, who was one of my best friends, was with me, we were both crying...."

"Did he ever complain to you...or suggest to you, or ever charge you that you wept because Mr. Lindsay had gone away?"

"No, sir, he didn't mention it...."

"There's another thing I want to ask you about, Mr. Jennings said that you gave as a reason for your refusal to marry Mr.

Scharringhaus, that he had a German name, first, did you ever refuse to marry Mr. Scharringhaus?"

"No, sir."

"Did you ever say anything or have any objection to his German name, if it is a German name?"

"No, sir, he was kidded about it…I wouldn't have gone with him if I had."

"Mr. Jennings also stated that you had told somebody that you were not a one man woman, did you ever make any such statement as that?"

"No, indeed, one man is enough," Evelyn said.

"He also said you were infatuated with a man named Brown, now let's talk about Mr. Brown, first, who is Mr. Brown?"

"Mr. Brown was a reporter and sub-city editor of the Knoxville Journal when I worked there," she said.

"…What was your acquaintance with Mr. Brown?"

"I met Mr. Brown after I had planned to go to the Billy Sunday meetings…I sat next to him in the press box, he had been a reporter on many big daily Chicago papers and western papers, and he gave me some ideas on reporting, the style was different and he helped me write those few little try out stories that I wrote then.…"

"…Let me ask you this direct question, were you ever infatuated with or in love with Mr. Brown?" Blakely asked.

"No, sir, a great many of the girls in Knoxville said he was good looking, just silly talk, laughed about him, we all laughed about it, Ralph did too, and no, sir, he never accused me of being in love with Mr. Brown."

"Did you ever go any place [with him]?"

"Yes, I went with him on assignments."

"Newspaper assignments, where were they?"

"In the summer of 1923, Knoxville had changed from whatever kind of city government they had to the City Manager form of government, and had election of the councilmen, it was in the papers a great deal of heated arguments and bitter feeling in political factions, and all the newspapers were covering those matters. There were

always two reporters sent and very often I was sent with Mr. Brown, if I would refuse to go I would have lost my job."

"There's a young lady reporter in this room right now, isn't there?" Blakely said, turning toward the reporters with a broad gesture, showing there was nothing unusual or improper about a woman reporter covering a news story along with her male colleagues.

Jennings objected and was sustained.

Blakely continued. "I can't remember all of the men that Mr. Jennings said that you were infatuated with, but he said, 'her next love was a man named Bennett', yes, a man named Bennett, now, who was Bennett?"

"Edgar Bennett was one of my students, Edgar was in his teens," Evelyn answered.

"How old was he at that time?"

"I think he was seventeen or eighteen."

"And how old were you at that time?"

"In 1923, I was twenty-three."

"...Was he your next love, or any love? Yes, or no?"

"Why, of course not," she exclaimed.

"He said you called your next love, Bennett, 'angel child', did you?" Blakely asked.

"I didn't call any of my students any such names as that, he was a very nice boy, I shouldn't say he was an angel child...[H]is mother asked me if during the...summer I would coach him in history and mathematics...and he did come to my home in the mornings and I coached him in that."

"With whom were you living at the time?"

"With my parents," she replied.

"Is that all there is?" Blakely asked.

"No, sir, when the boy entered the university that fall...I had promised the boy and his mother I would come down and see that he got started in the university, because I had to certify to the credits he had gotten outside of the high school, so he could enter. So I did come down one day. Mr. Scharringhaus was in a bad humor that morning and was very ugly about it...."

"What did he say?"

"He didn't want me to go down and wait on that brat," Evelyn said, "and I felt responsible for him so I came...."

"Were you ever infatuated with him?" Blakely asked.

"He was a child."

"Mr. Jennings, Judge Jennings, said he laid his head on your breast, did that ever happen?"

"That strikes me as being so ridiculous, no, sir."

"Did he ever lay his head on your breast?"

"No, sir...There's a little bit more to that so if you want me to tell it...."

"Yes," Blakely responded.

"...I heard that some people in town were saying that when Edgar put on his blue cadet uniform that he was very good looking, they said, he is crazy about Miss Hazen, that sort of gossip circulated about, when I heard that I told his mother I was very sorry I did not feel I could go on working with Edgar and put myself in a position to be criticized, I couldn't do it. A fellow teacher at Knoxville called him angel child, and in fun I may have called him angel child, just as a joke, just as she had called him that, but that's the story of Edgar Bennett."

Blakely focused on the next man that Evelyn had allegedly "had," as Jennings had described it in his opening statement. "Now Mr. Jennings told the jury that your next lover was Carl Stafford, first, were you ever in love with Carl Stafford?"

"Never," Evelyn replied.

"Was he so far as you know, ever in love with you?"

"I didn't know it until my father's death."

"Then you heard he had been?"

"He told me he had been, he would do anything in the world he could for me...he was the best friend I had," she said.

"Were you infatuated with him at any time?"

"Not in the least, he was more like a brother."

Blakely stood directly in front of Evelyn and peered at her intently. "Did you ever say to anybody that he was the most soothing person you had ever known?"

"Soothing is not a word I would use...."

"Just answer the question."

"I don't recall, but I can say he was that when my father died, he and Ruth did for me what I will never forget."

"Now, Mr. Jennings told the jury, that you had been up at the mountains with him, and went to his bed room in a night gown."

"That is not true," she exclaimed.

"Is anything like that true?"

"...Why of course not," Evelyn said with disgust.

"He also said that you had visited with him in New York, not indicating where you had been or how you visited, I don't know anything about that, I wish you would tell the jury if there is anything you have to tell."

"Mr. Stafford moved to New York in the fall of 1931...I was in New York that Christmas of 1931 with Miss Mills and Miss Preston and Mr. Stafford came to see me, he came to the apartment regularly, he had complained to Ruth and Miss Preston that he hadn't met anybody in New York, he was very lonesome, he came to the apartment, we introduced him to our mutual friends, who were very nice to him, I did see him a great deal, I was glad to see somebody from home, he seemed to be very glad to meet people in New York."

"...Now, where is Mr. Stafford now?

"In New York, he is married."

"Now the next thing Mr. Jennings said in 1929 you met Jack McKnight and became infatuated with him, did you in 1929 or at any other period become infatuated with Jack McKnight?"

"I did not become infatuated with Mr. McKnight, I met him in 1929." Evelyn explained that she had met McKnight in New York when he was working for the same manufacturing company as Ruth Mills.

"Now Mr. Jennings also said to the jury that you lured Mr. McKnight to Cleveland, did you ever lure Mr. McKnight to Cleveland or any place else?"

"No, sir, I never lured anybody anywhere," Evelyn replied with conviction.

"Did you ever meet Mr. McKnight in Cleveland?"

"Yes, I met Mr. McKnight in Cleveland…In 1930 I took a trip to Europe," Evelyn said. "…I had exchanged letters with him…and told him I was planning a European trip and probably would not be in New York during the summer, and I believe I said, just as a matter of something to say, that I was sailing from Montreal instead of New York. A few weeks after that he wrote back and asked me how I was going to Montreal, if I were coming by way of Cleveland and Buffalo…So the plans were made that I should meet Mr. McKnight and he would drive me in his car to Buffalo [where I could] take a train to Montreal. My father and mother thoroughly approved of it, especially because I had to change trains…Mr. McKnight met me at the train and took me in his own car [to the hotel].

"I went to my room and powdered up a bit for dinner, I met Mr. McKnight in the lobby, later we had dinner and I was very tired, I had come from Knoxville, Tennessee, I had ridden the night before and up until late afternoon that day, and since I was going to drive from Cleveland to Buffalo the next day, I decided to retire comparatively early…so I went to my room, left the dining room and [we] got in the elevator together, he got off the elevator at my floor, went to my door with me, my room happened to be one just beside the woman floor clerk's desk, she said to me…."

Jennings objected once again, but Evelyn cut him off.

"…[T]he room was in front of the floor clerk's desk, like Judge Bryson's desk, and my room was just to the left of it," Evelyn said to him pointedly.

"Well," Blakely asked, "did Mr. McKnight enter the room?"

"Oh, no, he said good-night to me at the door, he stepped just across and pressed the elevator bell, I closed my door then he went on to his own room."

"Mr. Jennings told the jury in his opening statement that Mr. McKnight went with her to a hotel and they registered in a hotel and they spent the night in the hotel, he didn't say you spent it together, but I am asking you that, did you spend the night or any part of the night together?"

"Certainly not," Evelyn exclaimed.

"…Was there anything immoral or improper between you and Mr. McKnight at that time, or any other time?"

"No indeed."

"…Was there ever any secrecy about this trip?" Blakely asked.

"No, sir," Evelyn said, "Mr. Scharringhaus took me to the train the night I left Knoxville, he knew I was going to meet Mr. McKnight in Cleveland, he said he was glad I was not going to change trains by myself, he knew I was a little timid about it. At that time I had not traveled very much, I didn't like the idea of changing trains alone."

"Did Mr. Scharringhaus give you a camera when he told you good-bye?"

"Yes, sir, he gave me one."

"Did he tell you what to do with that camera, if anything?"

"He had given me the camera to take pictures on the trip and that night at the station, before we went down to the station when he gave it to me, he laughed and said, take a picture of Mr. McKnight on the way up, just as a joke, I suppose. I put the camera in my luggage on the train that night and didn't take it out again until I got on board the ship."

"Well, who else knew about you that you were going to meet Mr. McKnight?"

"Miss Gertrude Penland, whom Mr. Scharringhaus took with us to the train that night."

"Miss Gertrude Penland?" Blakely repeated, letting the name register with the jurors.

"Yes, sir," Evelyn confirmed.

"…Mr. Jennings told the jury that you said, he didn't say who you said it to, that you wanted three men, one to give you a thrill, and other to wait on you, be obedient to you, and you wanted money from Scharringhaus, or you wanted Scharringhaus for his money, did you ever make that statement?'

"I did not…Mr. Scharringhaus made a statement, teasingly, like that to me once."

"…What did you say?"

"I said it was absurd," Evelyn answered, "of course, Mr. Scharringhaus never alluded much to money where I was concerned, I thought he didn't have any, he had said he didn't."

"He told you he didn't have any money. Did you ever tell your friends that you had stayed all night with Mr. McKnight?"

"Of course not."

Blakely moved the focus of his questions from McKnight to one of Ralph's best friends. "…There is a man in Knoxville as I understand, named Mr. Clifford Penland?"

"Yes, sir."

"Did you ever tell Mr. Clifford Penland that you didn't love Mr. Scharringhaus?'

"No, sir."

Evelyn said she had discussed Ralph with Clifford Penland once during a trip to New York. Clifford was staying with some friends who had moved from Knoxville to New York City and they had attended the same party on New Year's Eve. After Clifford had been drinking all evening, he asked Evelyn whether she had "ever loved Fish physically."

"I said, Clifford you are drunk and disgusting, I have never loved anybody physically, I added I had never been able to understand the friendship between you and Ralph, you are drunk, I see you both have your minds on the physical, I said, don't speak to me any more, you are drunk."

"You said you had not loved Mr. Scharringhaus physically?" Blakely asked.

"Yes, sir," she responded.

"Did you ever say to Mr. Penland that you loved Mr. McKnight?"

"No, sir, I told him I liked him."

"Now, Mr. Jennings also told the jury, when he was making his speech, that you called Mr. Scharringhaus, I have it here, a son-of-a-bitch, a cad, a skunk and a liar, I just want you to answer the question I ask you, did you ever call him any of those names, just answer my question, did you ever call him those names?"

"I have used the first one that you mentioned."

204

"How about the other, a cad?"

"After he treated me as he did, after my father's death, I said he acted like a cad, I told him so over the phone."

"...Did you ever call him a skunk?"

"So many people have said that about him."

"Objection!" Jennings shouted, trying to stop her from injecting hearsay into the official record and offering a negative characterization of Ralph.

"...How about a liar?" Blakely asked.

"Yes, I have said he was a liar."

"Is he is liar?"

"Yes, sir."

"Objection!" Jennings said. The judge sustained it.

"...[Mr. Jennings] said that you told Mr. Scharringhaus that you couldn't cook or wouldn't cook, or wouldn't sew or couldn't sew, did you ever make any statement as that?"

"No, sir."

"As a matter of fact, can you sew?"

"Yes, I can sew."

"Who made that dress you have on?"

"This isn't sewing, its knitting, I made it."

"You knitted the entire dress?"

"Yes, sir."

"How about your cooking, can you cook?"

"Yes, I can cook."

"What have you done lately about that?"

"Well at Christmas time," she said, "because I didn't have any income...."

Jennings objected with obvious annoyance and was sustained. Blakely was succeeding at attacking his opening statement and his client's character with the speed of a machine gun, and Jennings was becoming increasingly frustrated.

"Did you cook, were you able to cook during your engagement with Mr. Scharringhaus?'

"Yes, the Sunday night suppers we went to in Knoxville, I always made the waffles, it was always my job."

"...Now, Mr. Jennings also said that you had so embarrassed Mr. Scharringhaus that he couldn't go out in society, did you do anything of that sort?" Blakely asked.

"Why of course not, when did he stop going out?" Evelyn said bitterly.

"You mustn't ask any questions," Blakely cautioned her.

"I am sorry."

"Did you do anything to embarrass Mr. Scharringhaus's social activities?"

"I wasn't aware of it, he did plenty to embarrass mine."

Jennings, clearly outraged, nearly screamed his objection. It was sustained.

"What did he do to embarrass yours?" Blakely inquired.

"He left me defenseless, when the people we were with constantly kept asking me why were weren't married, teasing me about it, talking about it, I felt so conspicuous, so self-conscious, I didn't know what to do."

Jennings objected again and again but he was unable to stop the onslaught. Undaunted, Blakely and Evelyn quickly reiterated some key points in her sworn testimony before circling back to Ralph's letters. Then Blakely asked her to tell the jury what had transpired on Friday, May 28th, 1932, the day of her last date with Ralph.

"I hate to have to tell it," she said wearily.

With Blakely prodding her, she explained that she and Ralph had been sitting in Ralph's car in her driveway when they once again began to talk about their marriage.

"...[H]e said, of course, we are going to be married honey, just give me time to get on my feet, when we went in the house I felt very much better...," Evelyn began.

But, she said, they had been in the house for only a short time, when Ralph began to stroke her and kiss her neck. At the time, her father was very ill, and Evelyn was extremely concerned about him. Although she tried to hide her dismay, she said, Ralph could see that she was not interested in having intercourse with him.

"...[H]e said, you haven't changed a bit have you," she testified, "you tell me you love me...and then you turn right around you are

just the same, you won't do what I want you to do, so I did what he wanted me to do, because I [was] just perfectly disgusted, I had to do it, it was necessary to to get that man to give me a marriage ceremony...."

But submitting herself to him was a desperate and ultimately futile act. As Evelyn testified in court, it was during the weekend of May 29-30 that she told Ralph about the damaging gossip being circulated about him and a young married woman. As a result of this conversation, Ralph began to blame her for spreading the story, and she argued with him and his father. With her chances of marrying Ralph rapidly diminishing, she wrote him the long letter of May 31, 1932, and sent it to his store.

"I wrote him in minute detail," she said. "I wrote, I imagine thirty pages of newspaper copy paper, scribbled it, he probably couldn't read it at all...I wrote all of the conversation that took place between his father and me, I wrote him the way his father had acted, his father had shaken his fist in my face, and told me I had denied his son a home and happiness, that I fussed at him all my life...His father said, I told him, that I should go home and get down on my knees and pray about it, I told him I had prayed so much about it I had about given that up...I said I was sorry I had told his father about the sordid, we had been having trouble, because I hadn't meant to tell him what that was....

"I said to him that he must give me security and peace of mind, that's all I hoped for then, I said in the letter that I hoped that we could work out happiness, that wasn't first, peace of mind first and then what would come after, I told him as he knew, as I told him before, I had thought many times of killing myself, but after the way he had talked to me only a few weeks before I realized that would be playing right in his hands, and doing what he wanted, I believe I said in the letter I was not going to, but I had thought of it, page after page of it, naturally, was given up to begging him to come back, I asked him please to call me next week at school or at home and I would call him, I tried to call him and couldn't, that's briefly what I said."

After receiving Evelyn's 30-page letter, Ralph responded in a much shorter letter and terminated their engagement.

"I will read the entire letter," Blakely said. "It's dated June 1, 1932. Special Delivery. Tuesday night.

"Dear Evelyn: I received the letter that was left at the office this morning and have read it carefully. Of course I knew that you were down home last night. I was awake and called Papa when he came upstairs. It was late so we talked only a few minutes and he told me nothing more and in fact not as much as you told me in your letter.

"In writing this letter I know I am laying myself liable to misunderstanding but I sincerely feel it is the best way of trying to express what I think. Nothing I say is meant to be unkind for cruel as you have said some of my other letters were, and I hope you will not take it that way.

"You ask for consideration of your feelings and whether you believe it or not I have always tried to consider your feelings but what consideration have you shown for mine. You have always been ready to believe the worst of me when anyone has come to you with some story. The burden of proof has always fallen on me and I have caught the brunt of your displeasure. You told me you have felt forced to do and say many of the things you have because of the actions of others and I accepted your explanation with reservations. But in the meantime over a period of years you must realize the amount of punishment I have taken, more I believe than any one individual should have to take in a life time.

"And you have not regarded my wishes in matters where my wishes should have controlled. You knew my Mother had had a very serious accident but that did not prevent your writing her a letter that was bound to worry her and then coming down here last night and making her so nervous that she couldn't sleep. And all of this after I had asked you not to bother my family.

"Because of this, the point has simply been reached where mentally and physically I am not able to stand it any longer. It isn't a question of not desiring or not wishing to be considerate and not hurt another's feelings. It is a question of my ability to take further punishment and I don't have that ability.

"There is no solution but to stop. I regret deeply the fact that you are so unhappy now, but I sincerely hope that some day you will find

208

happiness. You have told me many times that I have ruined your life but if that can be said, I feel that you have just as truly ruined mine. You say you have given me the best years of your life but they have also been the best years of my life.

"I am going away tomorrow, I have business that I can try to transact and at the same time perhaps get my nerves back to normal. For weeks you have kept me in such a nervous state that I have been unable to eat sleep or work and at a time above all others when I need all of my faculties to apply to my business.

"When I return is problematical, it may be in two weeks or a month or even longer but it won't be until I am feeling well again. It is useless to try to see me when I get back because nothing would be accomplished or gained. I will feel then just as I feel now. In the meantime I hope you will spare my family further worry by not calling them and by not trying to see them. They are not responsible for the situation and what I am doing is not at their suggestion. However they know I am writing this letter.

"In closing I want to say again that I know I am laying myself liable to misunderstanding by writing, but I have said in this way what I do not believe I could have otherwise expressed and I sincerely hope you will take it in the spirit I am writing it.

"Sincerely, signed Ralph."

Blakely asked Evelyn to describe her reaction to the letter. "...I went so completely to pieces...I was frantic," she said.

That summer, Evelyn said, she decided to sue to him. She testified that she told him about her plan during their conference with Flem in New York.

"...[A]nd he said to me, 'well, you can sue if you want to'...And I said, I regret it Ralph more than I ever regretted anything in my life, but I am not going to let it drop, I cannot...Now I said Ralph, perhaps what I should have done was to have killed you, and I said, I have heard from home that I have been accused of that, [but] that isn't my way of settling things...," she said.

"Miss Hazen, I want to ask you just one more question in order to complete the record, were you at any time before you ever saw Ralph Scharringhaus, during the time you knew him, or afterwards,

guilty of any unchaste act with any man beside Ralph Scharringhaus?" Blakely asked.

"No, indeed," she said.

Blakely turned his witness over to the defense.

Chapter 22

After the first few days of testimony, the news reports about the *Hazen v. Scharringhaus* case had moved from the front page to the middle section of the *Knoxville Journal*. In an article published on Feb. 10 titled "Prefers Vows to Heart Balm," Evelyn was quoted as saying, "'All I want is a ceremony. That is all I have ever asked. I will take it now.'" When Ralph's attorneys protested, her "statement was stricken from the record."

The *Journal* also reported that Evelyn had broken down and cried on the witness stand. "...[H]er calm was shattered at times...Her outburst on readiness to marry Scharringhaus even now was followed by tears as she told of the teasing of friends at failure of her lover to marry her."

The rest of the day's news was dominated by stories about the record-breaking cold that had engulfed the eastern half the United States. The papers reported that temperatures in Michigan had plummeted to a record 51 degrees-below-zero. New York City had reported minus 14 degrees. Americans comforted themselves by remembering that another Evelyn—Adm. Richard Evelyn Byrd—was in Antarctica where the cold was truly unendurable. It was his second trip to the frozen continent and it proved to be his last. Byrd spent five months alone in a hut dug into the ice. Frostbite and carbon monoxide poisoning from his heating stove nearly killed him.

Americans prayed for Byrd, shivered in bread lines, and carefully monitored the growing unrest abroad in the newspapers. In Paris, a crowd estimated at 10,000 had surged through the streets and clashed with police officers during a protest against fascism. In Eastern Europe, Yugoslavia, Greece, Turkey and Romania had formed the Balkan Entente alliance. In Washington, President Roosevelt was focusing on domestic affairs and reducing the size of the federal budget. He had cancelled contracts with air transport companies that had been carrying U.S. mail. Fledgling airline firms feared that the

move would be fatal. One executive lamented, "…this will mean that we're all washed up."

In Covington, Jennings was worrying about the impact of Evelyn's testimony on his case. When the court went back into session on Tuesday, Feb. 13, he rose from his chair at the defendant's table and walked toward the witness box. His eyes bore into Evelyn, probing for vulnerabilities and weaknesses that would show the jury that she was not a wronged woman, but rather a conniving, mean opportunist who was hoping to reap a windfall in court. He approached her like a gathering storm preparing to unleash a furious torrent.

Jennings was intent upon forcing Evelyn to retract some of her earlier statements. He started by asking Evelyn about her age, insinuating that she was one year older than she claimed. If that had been the case, she would have been 18 and at the legal age of consent when Ralph seduced her for the first time. Evelyn ably countered this attack, so he moved on to her early education and her acceptance into the University of Tennessee.

"Did you attend the public schools of the city of Knoxville, or did you attend a private school?" he asked.

"I attended a private school," she replied.

"You never did attend a public school?"

"No, sir."

"…This private school that you attended was an exclusive school for children of those who…paid tuition?" Jennings asked, trying to show that she was a woman of means who did not need nor deserve the financial damages requested in her suit.

"Yes, it was private," she answered coolly.

"Now you graduated from that school, did you?"

"That private school, no, I didn't graduate, the school closed and I found I had enough credits to enter college."

"So that you made enough credits in six years to qualify you to enter the University of Tennessee, in the State of Tennessee?"

"You could say, I [had] been taught at home before that."

"You say I can say it, [but] I desire, Miss Hazen, to have you say it, do you say now that you made enough credits in six years to qualify you for entrance to the University of Tennessee? Answer yes or no," he insisted, sparring with her.

"No, I cannot answer that yes or no."

"I submit, if your Honor please, that she can," Jennings said to Judge Bryson.

"I shall have to say no then, if he wishes it yes or no, I shall have to say no," Evelyn responded.

"Well, as a result of the credits you got in that private school, were you admitted to the University of Tennessee?" Jennings pressed.

"Plus the education I had had in my home."

"...What studies did you pursue in that private school?" Jennings asked.

"So many I have forgotten," Evelyn said.

"Well, tell us those you remember."

"I studied Latin and English, various branches of mathematics, languages."

"What languages?"

"French and...."

"You studied French?" Jennings interrupted.

"And history."

"Did you study physiology and anatomy?"

"I think I had one course in it, I remember learning the names of the bones of the body, that's about all I remember."

"Did you have a book on the human anatomy and physiology the way the body is made up, the number of bones in it, the organs of the body?" he asked.

"Yes, I see your point," Evelyn retorted, "there was nothing about sex."

Judge Bryson cautioned Evelyn. "Now Miss Hazen, it is necessary for you to reply to the best of your ability, to the interrogation given to you by the other side."

"I am trying to do that," she said.

"Just answer the question, and not argue the point," the judge ordered.

But Evelyn was not content to merely answer Jennings's questions. Defiant, she listened to each of the questions very carefully and found plenty of opportunities to point out that he had misstated important facts, as well as minor details, about the case.

"When did you begin to go with Mr. Robert M. Lindsay, commonly known as Russ Lindsay, or Rust?"

"It isn't Rust," she countered.

Jennings brought up the fact that Evelyn had cried when Russ left Knoxville to go to military training camp during World War I and added that she had accepted his fraternity pin.

"Miss Hazen, these fraternity boys, these boys that join little fraternities there at the university, all wear pins, don't they?"

"Yes, sir."

"Every fraternity has a distinct little emblem that they wear, and I will ask you if it also isn't a fact that it's the thing, common occasion there for girl friends of these boys to wear the pins of their friends who happen to belong to a fraternity?"

"It isn't supposed to be customary for them to give their official pins broadcast, they have jewel pins sometimes that they give."

"Well...it isn't a fact that you [had Russ's and Ralph's pins and] wore these two pins, Russ Lindsay's pin and Ralph Scharringhaus's pin for cuff links, or pinned your cuffs with them?"

"I had two pins of Ralph's, this one and a jewel pin, I have them with me now."

"Didn't you tell Mildred Eager that you had Russ Lindsay's pin and also Ralph's pin, and showed them both to her, and if at the time you weren't wearing them as cuff pins?"

Blakely objected, and Jennings modified his question slightly.

"I will ask you if it isn't a fact now that you told Miss Eager that you had both Ralph Scharringhaus's pin and Russ Lindsay's pin?"

"It is not true...I didn't meet Miss Mildred Eager until I had long since ceased to think of fraternity pins."

Next Jennings tried to establish that Mildred, Gertrude Penland, and her brother Clifford Penland had been some of Evelyn's best friends and had shared intimate conversations with her. "Well, you

and Miss Penland have been very intimate friends, have you not?" he asked.

"I considered Miss Penland a friend, until she told me she didn't value my friendship," Evelyn said.

"When did she ever tell you she did not value your friendship?"

"When I caught her protecting Mr. Scharringhaus in a lie."

"This is your answer now to the question I asked you?"

"It is."

"You tell the jury you caught her protecting Mr. Scharringhaus in a lie?"

"Finally I caught her, only by accident."

"How long have you known her brother Clifford Penland?"

"I knew Clifford slightly, I never knew any of those people before I went to the University, they were not my close friends. I think I met Clifford in my freshman year, I met all those S.A.E.'s then, I never knew Clifford very well until I began going with Ralph, he is Ralph's closest friend."

"Do you consider them in your social status, members of the class socially to which you belonged?"

"I am not a snob," she said curtly.

Jennings complained to Judge Bryson that Evelyn was refusing to answer his questions directly, but the judge overruled him.

"I think Miss Penland and her brother could be just as nice as anyone else, individually, not to what they were born," Evelyn asserted.

"You think they were not properly born?" Jennings asked.

"No, sir, I said it's the individual who counts in any class."

"Well, Miss Hazen, as a matter of fact, I will ask you if you did not frequently boast to Ralph Scharringhaus and to his friends, you had given him social standing in Knoxville, and had introduced him into society, by reason of your lineage and aristocracy?"

"I did not, we had a conversation on that subject however, in one of Ralph's angry spells at me, he said, I suppose you think you got me into the men's cotillion club, well, I will have you understand, if I had never seen you I would have just as much social position. I said I cannot understand anybody making a remark like that, since you

mentioned it, I recall to you that my brother-in-law and [a] friend of his did get you invited to the men's cotillion, after you had been black-balled for two years."

"So you did tell him that your brother-in-law got him in to the cotillion, after he had been black-balled for two years?"

"I told him that after he had said to me, 'I suppose you think you gave me my social position in Knoxville, I will have you understand I would have just as much social position here if I have never known you,'" she said.

"...Now I want to ask you, I now hold in my hand Miss Hazen, and am going to pass it to the jury, the ring which you have stated was given you as an engagement ring by Mr. Scharringhaus, and I am going to ask you when it was you came into possession of this ring?"

"...[A]s I said the other day, I cannot swear to the date, some time either during or soon after 1920, I remember that because a sorority sister of mine, who was teaching school with me at the time went along with me to look over a design that I like, that's the only way I have of placing that definitely."

"What month was the ring purchased?'

"I have no idea."

"Well, can you give me the year?"

"I have just said...."

"What year?"

"I have just told you I couldn't swear to the year."

"You cannot swear the year or the month when you say you got the engagement ring?" Jennings asked, focusing on her inability to remember such an important date.

"Oh, it's been so long," she replied. "I was so miserable about that time, I wasn't thinking about it."

"I will ask you if an engagement ring isn't ordinarily a solitaire, a single diamond?"

"Well, sometimes it is, I think probably the girl might have a choice, at least if the man asked her. I chose this type of ring because I wanted it."

"Isn't it a fact ordinarily an engagement ring is a solitaire, that's a single diamond? Is a single stone?" Jennings insisted.

Blakely objected, since Evelyn already had answered the question. An angry exchange ensued between the lawyers. Judge Bryson ruled in Jennings's favor. "I will let you ask her," he said to Jennings.

"I am right about that, ordinarily it's a single stone," Jennings stated.

"I didn't want him to repeat the question," Blakely said heatedly, "she already answered it once, and the record shows she did."

"May I say this," Evelyn interjected, "that since he has given me so much time to think about it, I think of more engagement rings that are not solitaires than are, now that he calls my attention to it."

Jennings exploded. "Have you been informed that an objection would be made to give you time, on this Cross Examination?" he demanded.

"You are the one that's doing all the talking," Evelyn shot back.

The spectators laughed, clearly enjoying the fact that Evelyn refused to be cowed by Jennings and his accusations. The judge shot a stern glance at them, warning them to remain silent.

Jennings continued to pressure Evelyn about the ring, asking if it were true that Ralph had given her $600 "in cold cash" to pay for it and implying that it was never meant to signify an engagement.

"Now, you never wore this ring on your left hand, where girls who are engaged ordinarily wear a ring?" he asked.

"I wore it quite a lot on my left hand, Ralph himself told me to wear it on my right hand."

"I will ask you if he didn't beg you to wear this ring on your left hand and you positively refused?"

"That's not true, he told me to wear it on my right hand, but when we went on a trip, the first trip he insisted on me going with him on, he had a little silver wedding ring that he had me put on my left hand with the engagement ring, he carried this silver wedding ring on his watch, by his watch, in his pocket."

Jennings went back to the subject of money. "Didn't he give you from time to time in lawful money of the United States, two thousand dollars?"

"I will ask you if you did not further state to these two ladies, that when you got there you found that your Jack McKnight had registered for you and for himself, under the name of Mr. and Mrs. Jack McKnight in the hotel, and that he had a suite of rooms engaged?"

"Why, no, sir."

"Further, if you did not state to both of these ladies, that he had a ring and endeavored to get you to marry him, but that you declined?"

"No, sir, Ralph was the one who had a wedding ring," she insisted.

"I will ask you if you didn't further state to Miss Mildred Eager and Miss Penland, that you and McKnight occupied the same room there together in that hotel, as man and wife, for a period of three days?" Jennings demanded.

"I certainly did not."

"...I will ask you if you did not state to Miss Penland and Miss Eager, that after you and McKnight had spent three days and nights together in that hotel, as man and wife, that you said to him, 'Jack, say to me, Evelyn I love you', and that he declined and that then you pressed the matter and finally he did say, 'Evelyn, I love you', and when he did that you flew into a rage, because you had to tell him to say it, and cursed him and called him every vile name that you had at the end of your tongue?"

"I certainly did not, you are teaming up a lot of threats!"

Jennings objected to her response and challenged her again. "I will ask you if you did not also say to Miss Penland, to Miss Eager...that when you got through cursing Jack McKnight, he folded his arms, walked to the window and said, 'this is happiness'?"

"No," she said, "...I said none of that, of course...those two women threatened me," Evelyn shouted.

"...Did you not also say to them that after that his love for you seemed to die?"

"I have said nothing about Jack's love for me. I think he is my friend...."

But Jennings persisted. When Evelyn had finally had enough, she directed a comment to everyone in the courtroom. "I realize that he is trying to trap me," she said.

"I object!" Jennings thundered. "I am not trying to trap anybody, and any person who continually undertakes to inject that into the record, must have consciousness that perhaps they will be trapped. I am just trying to undertake to bring out the facts, as I have a right to do."

Jennings was furious, and the spectators gasped and began whispering to each other at his outburst.

Judge Bryson gaveled them to silence and then turned to Evelyn. "I wouldn't infer things against anyone in this case," he told her, "the only purpose of this trial is to bring out the actual facts, and answer directly the questions that are asked you, and do not infer things, people are trying to trap you, or take advantage of you, you can take care of yourself, you will get an opportunity...."

"I am sorry," Evelyn apologized, "what I meant to say, I realized the attorney is on the opposite side, that I should watch what I say."

Jennings angrily objected to her comment and complained as well about the judge's admonition. He was nearly whining now, and the spectators began to laugh. It was obvious that Evelyn was proving to be a tougher adversary than Jennings had expected.

Judge Bryson ordered the spectators to be quiet. "We are concerned with a very serious matter. I don't see why people want to laugh about the misery and hardships of other people in public, and it['s] not good sportsmanship to even try to make entertainment out of this trial. If you persist in doing it I shall clear the Court room of everyone in it. I cannot sit here and permit you to make fun of these matters, which is indeed a very serious thing, the very next time it happens I will clear the Court room."

Jennings returned to his story about McKnight. "...[A]fter you returned to Knoxville, [did you] not describe to Miss Mildred Eager, a bed room scene that occurred between you and McKnight while you and he were registered there as man and wife?"

"...I did not, because none of that is true, however, she is one of the women who threatened me, after my father's death," Evelyn said.

Jennings objected to her argumentative response and then pressed on. "I will ask you if you did not state after that experience up there with McKnight, to Miss Penland, to Miss Eager and... to a

220

number of other of your friends in Knoxville, that McKnight was the only man who ever gave you a thrill?"

"I have never made such a statement as that to Miss Eager or Miss Penland, or anyone else. I cannot imagine a person telling things of that sort if they were true."

"Did you state to Miss Eager, after your return from your European trip, that when McKnight got up in the morning, and went to the bathroom in the hotel there, went to the bathroom to shave, that he was the cutest thing you ever saw in his pajamas, after he shaved?"

"I made no such ridiculous statement!"

Jennings shifted the topic to Harold Brown, the newspaper reporter. "…[I]sn't it a fact that you continually talked to Miss Penland, Gertrude Penland, about this handsome Mr. Brown, that you told her you were infatuated with him, that it was a pity he married the common woman he had, and he ought to have a wife like you, you could inspire him?"

"No, indeed."

"And didn't she say to you, Miss Hazen, you are 'double crossing Ralph, and not treating his wife right?[']"

"No, indeed, Miss Penland went with Mr. Brown," she exclaimed.

"Didn't you say then, 'what Ralph don't know, won't hurt him?[']"

"No, sir."

"Didn't you also say you could help Brown get rid of his wife?"

"I certainly did not."

"…Isn't it a fact, with reference to this man Brown, you continually bragged about his good looks in the presence of Ralph Scharringhaus and his friends, and called him 'your lamb', called Brown, 'your lamb'?" Jennings repeated for the benefit of the jury.

"No, sir, that's absurd," Evelyn said. "I did say, I will say this, I want to say in addition to that, that anything I had to say about Mr. Brown, I said it in Mr. Scharringhaus's presence, if he wants to exaggerate, that's his privilege."

"…[T]he night Mr. Brown left Knoxville…I will ask you if on that occasion you didn't kiss him twice and he kissed you?"

"I have never kissed that man in my life, [and] he never kissed me."

"Didn't you tell both Miss Penland and Miss Eager that he kissed you goodbye?"

"I did not, that's absurd.

"You deny that?"

"Yes, sir."

"Now, Miss Hazen, I want to ask you a little about this boy, Bennett...You called him your angel child, didn't you?"

"...Miss Eager called him angel child, and I won't swear I never said, just saying it in fun...."

"...Didn't you tell Miss Eager and Miss Penland that he studied with his head on your bosom?"

"I certainly did not, I think that's ridiculous."

"When did you first get acquainted with Carl Stafford?" Jennings asked.

"I met Mr. Carl Stafford I believe in 1927...[he] is one of my best friends...."

"...Did you spend the night down at Miss Eager's home on one occasion after her mother was away from home, and this boy, Carl Stafford was down calling on you...[A]nd you requested Stafford to stay all night and he occupied the elderly Miss Eager's room?"

"No, sir, I don't recall Mr. Stafford staying over night...."

"Maybe I can refresh your recollection, did you not after you had disrobed and put on your night-gown, leave the room where you and Miss Mildred Eager were sleeping, and say to her, 'I am going in to tell Carl good-night', and did you not go in to Carl's room, in your night gown, and stay about three hours?"

"I certainly did not, you are telling me all of this, you cannot recall anything like that to my mind," Evelyn said.

"Do you deny it?"

"I certainly do."

"You have kissed Carl Stafford, haven't you?"

"No, sir, I have not."

After several additional questions, each of which sought to show that Evelyn had been romantically involved with Stafford, Jennings

asked her whether she had driven to Ralph's home with the purpose of killing him.

"I will ask you if you didn't get Miss Mildred Eager to meet you at a certain time and if she didn't sit down in the front seat [of your car] and if she didn't reach back and see that pistol?"

"...I had no pistol at [that] time," Evelyn said.

"...I will ask you if you did not take Miss Eager into your bed room and unlock your dresser drawer, and pull out a pistol, which was wrapped in a kid glove, and didn't say to her, I got this in New York?"

"I did not."

"Did you not tell her that you meant to put on that kid glove, go down to Ralph Scharringhaus's home, hide in the bushes and shoot him from the bushes?".

"No, sir, I'm afraid I'm not that clever."

"...Didn't you tell her, 'I have been told by Stafford where to shoot him, not too low and not too high?[']"

"No, sir...most emphatically I deny it."

Jennings then introduced several letters that he claimed had been written by Evelyn and sent to Mildred from New York in 1932 after her father's death. Most of them begged Mildred for assistance, but one of them, which Evelyn said had been doctored, contained language that implicated her in a murder plot against Ralph.

"I never wrote a letter that way, no, sir," she protested. "I never wrote a letter on paper like that on a typewriter. I did not write that letter. I wrote parts of that letter...."

"This letter bears your signature?"

"It bears a name, but that name has often [been] copied by a certain person, whom we have mentioned," she said, implying that Mildred had written portions of the letter and had forged her name.

Undeterred, Jennings pressed on and read the letter into the record. "...If Flem and any one else who is pretending to help me, fail, Carl can settle them all I think; and the main point is that he has the guts to do it. I am surprised that Flem lacks enough to tell Ralph what's what...I could commit murder when I think of that skunk,

and I may have that [pleasure] before long. At least I have all the necessary equipment that I came up here to get.

"...Write again soon. I'll do something for you to make up for all this. You are a lamb, Mildred. Love, Evelyn."

"That's not my letter," Evelyn repeated to the judge. "I did not sign it, it has my name 'Evelyn' there, [but] I certainly did not write such a letter...."

Judge Bryson stared down at Evelyn. "That's not your letter?" he asked.

"That is not, of course, I didn't [write it]."

Chapter 23

Jennings finished his cross-examination on the sixth day of the trial. Then, just after the lunch break on Wednesday, Feb. 14, Blakely began his re-direct to clear up any misperceptions that Jennings might have been able to place in the jurors' minds.

Under Blakely's questioning, Evelyn explained that it was Mildred Eager who had persuaded her to buy a pistol for her own protection because Ralph's chauffer had begun carrying a gun. Evelyn added that she had not purchased it in New York; she bought the gun in Knoxville.

Evelyn then refuted all of the accusations that Jennings had assaulted her with. She said she never had received any money from Ralph; in fact, she said she had loaned him money. She said she never spent the night at the Eager home with or without Carl Stafford being present. It would have been impossible for Carl to stay all night in Mildred's mother's bedroom, because her mother "never went out of town unless her daughter drove her by automobile."

Evelyn also described the threats that Mildred Eager and the Penlands had made against her. She said that Gertrude Penland threatened her after Evelyn accused her of calling several people in Knoxville and telling "lurid stories about me which were absolutely untrue."

Evelyn said she told Gertrude, "I cannot allow those lies to be circulated about me, the truth is bad enough, but not anything like those lies. [Gertrude] said, all right, if you are determined to embarrass Ralph I will embarrass you just as much as you embarrass him, and she said in order to do that, I will make [up] a story.

"I said that's right Gertrude, you have used the right term, anything you can tell about me you will have to make [up], she was so angry she couldn't control herself...."

Then Blakely asked her about Clifford Penland. "What did Mr. Penland say to you?"

"When Mr. Penland came to Knoxville, he said, he called me one day, no, I saw him on the street, I was driving to my home, and he stopped and said how sorry he was my father had died, he didn't mention Ralph at all, and I said, Cliff, I would like to talk to you, I believe you can help me if you will, and he said all right, he got in the car and rode out to my home with me and I told him a little of the trouble, maybe Gertrude has told you, he said, I would rather not say. I said, now Cliff if I were your sister, what would you do? Well, he shifted [in] his chair and seemed uncomfortable, of course, he explained, I would do something, I would have a settlement. I said, I know what you would do, I know what any red blooded man would do, I know what father would do, he wouldn't have to, Mr. Scharringhaus would grovel. He said, I cannot say Evelyn that I would kill him, I would, if he refused, I would make him marry my sister.

"Cliff, I said, although I am not your sister, you are Ralph's best friend, I hope you are my friend. Of course you haven't always acted like it, I am in distress, before I made a fool of myself, because I was miserable, I felt Cliff was going to try to help me.

"I tell you what you do, [he said,] I will try to talk to Ralph, I don't think I can open the conversation, if he talks to me I will tell him I think he ought to do, I said, well, what is it you think? He said, I think he ought to marry you...you call me tonight, I will get over home about eight....'"

Blakely interrupted, "Now, just at this point, at that time did Mr. Penland invite and request your confidence, or say anything at all?"

"He questioned me about everything that Ralph had said or done, he said, For God sake...."

"Did you tell him everything? Tell him in general?"

"I didn't tell him all I had told Miss Eager, I told him in general," she answered.

"When did he next return?" Blakely asked.

"He told me to call him up, I called him he came to the telephone, he assumed his sister's attitude, I said, regarding Ralph, have you found out anything? He said, listen here, I cannot imitate his voice, he said, I am trying to play bridge with friends, and I would appreciate

226

you letting me alone. I said, you told me to call you. He said, that doesn't make any difference I have been talking to Ralph and he is my friend, and you cannot say things like that, he told me none of that is true, and he said, my friend is a man of honor...'I will stand by him rather than you, because I have known him longer than I have known you.' I said, Cliff, I didn't know the difference between the truth and a lie was measured by the length of acquaintanceship. He said, I am playing bridge, I don't want you to interrupt me...Here he said, 'we', I will tell you what sister told you, (that's Miss Gertrude), 'you will regret this if you make it public, because young lady I can hurt you', and he said, 'Sis and I will both side with Ralph, and you can just know that,' and slammed up the telephone...."

Blakely turned the topic to Mildred Eager. "When did [Miss Eager] make threats, if she made any?"

"Her threat," Evelyn said, "to get even with me, as she put it, didn't come until after she lost her job in high school, that was the latter part of September...1932...Miss Eager returned to high school the first day school opened, and avoided me, her face flushed red when she passed me, and I walked in and sat down by her and in a whisper, at a teachers' meeting, I said, Mildred, why did you do to me what you did? She said, I haven't done anything, I saw the pulse beating in her neck, and her face was fiery red, I said, you act awfully guilty, you might just as well put your cards on the table, I know you sold out on me, that you gave a letter that I sent to you to Ralph, and he had it copied and certified. She said, I don't know he had it copied and certified, I said, I know."

"What letter was that?" Blakely asked.

"That was the letter...[that] had been tampered with...."

Jennings shouted an objection and was sustained.

"What did she say about that?" Blakely continued.

"She denied it, absolutely denied it, said she didn't give him any letter, she hadn't talked to him. I said, Mildred, you wrote me letters in New York [saying] you talked to him, you told me Mrs. Tate said a lot a stuff she didn't say, you told me, you know perfectly well you insisted on going with me on an occasion, on two occasions when I

went with my cousin to see his attorney, when he thought he would have him for his attorney, to handle it...."

Exasperated, Jennings objected again. "This witness is smart," he said, "and she is injecting things into this record, in my opinion, if the Court please, she knows are incompetent...."

Judge Bryson frowned at him. "...I have admonished the witness, and your side objected to the admonishment at the time, I can do nothing more."

Blakely asked Evelyn a more direct question to keep her from adding any more information than was necessary. "Now, Miss Hazen, get right down to the question that I asked you, what threat, if any, did Miss Eager make? I just want the threat."

"...She said to me on the telephone, 'I will get even with you for causing me to lose my job, causing them to fire me, if it's the last thing I do,'" Evelyn said.

"Now, that's the threat," Blakely said to the jury. "Now then, had you caused anybody to discharge Miss Eager, or had you done anything to cause her to lose her job?"

"No, indeed."

Chapter 24

Ralph Scharringhaus was called to testify in own defense on Feb. 16. As he rose from his chair, the spectators craned their necks to see him, this handsome and elegantly dressed businessman whom Evelyn had depicted as a callous, sex-absorbed cad. He climbed into the witness stand, raised his right hand, and took the oath, wearing a confident expression.

Jennings asked him about virtually every topic that had been raised during the trial, including the significance of his giving a fraternity pin to Evelyn. It was not meant to be a symbol of their engagement, he said. Rather, he gave it to her for safekeeping while he was in the Army.

"...She already had [Russ Lindsay's] pin, but I told her I was going away to join the Army, and I would like for her to take my pin and keep it until, if I got back, if I did get back," he said.

"Now, Miss Hazen told the jury that you came home on a leave of absence in the fall of 1917, and that you and she drove down the Court House, you proposed to go in and get a license, and that she agreed to that, to get married, did anything like that occur?" Jennings asked.

"No, sir," Ralph said, "not in 1917."

"She also said she didn't know the difference, as I recall, between a boy and a girl at that time, nothing about sex matters, that you made a very beautiful explanation, used the birds as an illustration, and the pollenation (sic) of flowers, and that you painted such an alluring, captivating picture, and told her it wasn't necessary for a marriage ceremony, you could just be married in the sight of God, by you two indulging in marital acts, did anything like that occur?"

Blakely objected to the question, but Jennings was allowed to continue.

"Did you ever have any such conversation with her?"

"No, sir," Ralph said.

"When did you first hear this story about the pollenation of flowers and the language that she attributes to you, with reference to that alleged occurrence?"

"During the course of this trial."

Jennings asked, "Did you have any improper relations with her in the year 1917?"

"No, sir, I did not," Ralph said.

Ralph said Evelyn was still interested in Russ Lindsay in 1917 and that he saw her just after Christmas that year at the train station when Russ was returning to military camp. Ralph said he, too, was returning to camp on the train, and he spoke with Evelyn and Russ's sister Catherine as they were sitting in the Lindsay family car. "...[T]hey were both weeping," he said.

"Now, did you come back at any time during the year 1918 to Knoxville, on a leave?" Jennings asked.

"I was in Knoxville possibly three or four times...I know I was there Christmas of 1918," he replied.

"Miss Hazen said to the jury, that you and she went down to the Court House in the fall of 1917, with reference to a marriage license...state fully what occurred."

"It was sometime in the year 1918...All during the time that I had been away from her in the Army, after I had gotten my commission, I had been suggesting to Miss Hazen that we get married, and she go back to camp with me," Ralph said.

"Did you mean that?" Jennings asked.

"Of course I meant it."

"Did you love her enough to marry her?"

"Absolutely, that's what I wanted her to do, I didn't get any response to those suggestions, or any encouragement. On that particular occasion in 1918, we were riding in my car one afternoon, and I told her, let's just go down by the Court House and get a marriage license and get married, and you go back to camp with me, to my surprise she said, 'all right', so I headed for the Court House immediately, stopped my car and got out and went in and made inquiry for a license, it was late in the afternoon, possibly five o'clock and the office where they sold the license[s] was closed, and they told

230

me it would be impossible to get one, I made inquiry of some person standing around there.

"I went back out to the car and told Miss Hazen that the office was closed, and she laughed, 'I don't believe you tried to get one', I said, yes, I did try to get one, I said, since we cannot get one this afternoon, let's come down here tomorrow morning and get a license and get married and you go back to camp with me.

"Her manner and treatment of the whole matter, that it was more or less of [a] joke, and she said in substance, if not the exact words, 'no, if you cannot get it now, well, you have lost your chance', and that was the conclusion of that episode, no more was said or thought about it, the whole notion passed out of my mind, I knew the way she had reacted to the whole situation, she had not taken it seriously at all, and I thought that even if I had gotten the license, I would have had it on my hands without anything to do with it."

"Now, did you continue to see her from time to time, while you were in the Army?" Jennings asked.

"Whenever I was home, I saw her just as often as I could, of course, at that time Mr. Lindsay had gone to France, and he wasn't there, so as a rule, I saw her all the time when I was home on these leaves."

Ralph then explained that he left the Army in March 1919, and returned to Knoxville to complete his college degree and join his father at Gillespie, Shields & Co. At first, he said he had a clerical position making only $75.00 a month, which was not enough money to support a home and family. "I was in no position to marry anyone," he said.

"When did yours and Miss Hazen's relations become intimate, Mr. Scharringhaus?" Jennings asked.

"It was sometime in the spring of 1920...I was very much in love in Miss Hazen, had been for a long time, and we were seeing each other a great deal at that time, I know we were seeing each other virtually every night, I was very much in love with her and she seemed to be in love with me, we were very affectionate, there was a great deal of kissing and petting, she would sit in my lap and things went on in that way until we just drifted into it."

"Did you in that connection, undertake to tell her that amounted to a marriage ceremony?"

"Never, never."

"Did you ever tell her in that connection, or at any time, that you were married in the sight of God?"

"I did not."

"When did you first hear that expression used with reference to your relations with her?"

"After this trial started."

"What, if any, method did you and she resort to to prevent conception?" Jennings inquired.

"Well, I used the, I suppose the most common preventive that's known," Ralph answered.

"...State to the Court and jury," Jennings said, "whether or not her participations in those relations was or not voluntary on her part?"

"Absolutely," he said.

"In that connection," Jennings continued, "state whether or not you ever abused her or used any force or violence, anything of that sort?"

"Never, never."

Ralph said that when his salary increased in 1920, he tried again to convince Evelyn to marry him. But "she didn't want to take on the responsibilities of married life, didn't want to settle down, and she thought it would be better to wait for a while, she had various excuses, she had never learned to cook, didn't [know] anything about cooking, and didn't like to cook...she didn't care of domesticity, she didn't want to be tied down that way...and also she said that she did not like children, and did not want to have children. I told her, of course, that my idea of marriage was to have a home and children, and she said she just didn't like them, didn't want to have any children, wasn't going to have any children if she could help it."

"She stated in her Direct Examination, if not then, on Cross Examination, that you referred to the children she taught at the High School, as damn brats, did you every use that expression?" Jennings asked.

"I did not."

"State whether or not she ever used that expression."

"That's her expression in speaking of children, she always referred to her school children as damn brats...She said she didn't want to have any damn brats."

"Did she give any other reason for not wanting to marry?"

"From time to time she did," Ralph said, "various other reasons, one time she conceived the idea she wanted to be away from home for at least a year or perhaps two years...she would like to be out on her own and work at some interesting job, preferably in New York City...."

"Did she advance any other reason, or give any other excuse?"

"Well, from time to time she would bring out other things, one time in particular, when I was under the impression that we were going to be married, she said we couldn't be married because she couldn't have the kind of a trousseau she wanted," Ralph said. "...Finally she did lead me to believe that we would be married in the fall of 1924...[but] in the spring of 1924 she told me that she wanted to put it off until the following spring, she didn't advance any definite reason, other than the fact she just wasn't willing to tie herself down as yet...I told her I was very anxious to go ahead...but there wasn't anything that I could say that...would change her attitude...so that matter just stood that way, went on over until the next spring.

"Then...two months before the spring of 1925, I told her I thought the time had come when we ought to be making some definite arrangement, and that I wanted to speak to Mr. Hazen, her father...very much to my surprise she said, we cannot be married, and wanted to know why not and she said, well, I won[']t be able to have the kind of trousseau that I want, and I said, what kind of trousseau do you want, she said, well, my girl friends that have gotten married, all have had very nice trousseaus, clothes, I wouldn't be satisfied to get married unless I could have one equally as nice as any others. I asked her how much that would cost, she said, around twelve or fifteen hundred dollars, and she said her father was very stingy on matters of that kind and wouldn't give her that much money, and her mother didn't have the money to give her, the only way she could do [it] would

be to continue to teach school until she could save enough money to buy the trousseau she wanted," Ralph said.

"That didn't suit me," he added. "I objected as strenuously as I knew how, but there wasn't anything I could say that would have any effect on her at all. We quarreled about it on quite a few occasions...she said also...if I ever do marry you you've got to change your name. I wouldn't marry anybody with a name like that."

"What [is] wrong with your name?" Jennings asked.

"Well, it's a German name, and she didn't care for it," Ralph said, "she said I would have to change it...I told her that was out of the question...my father was German, my grandfather was German, born in Germany, I was proud of my ancestry, as for changing my name, that was completely out of the question."

Jennings then moved on the allegations about Harold Brown, the reporter. "What, if anything, did Miss Hazen say about this man, Harold Brown?"

"Well, my attention was first called to him by her commenting on how handsome he was...I thought nothing of that, except she kept talking about it until it got on my nerves...it was very embarrassing to me for her to carry on that sort of conversation when other people were present..." Ralph explained.

Then Ralph said that one evening as they were riding, he and Evelyn saw Brown with Gertrude Penland under a street light in Knoxville. "She suggested that we stop and pick them up...she said there's Harold Brown, let's stop and pick him up, I would like to meet him...That was the last thing I wanted to do. I said, no, we are not going to stop, I kept on, [but]...she was so insistent I pulled over to the curb...and asked them if we could pick them up and take them where they were going. They got in, and everyone was introduced...the next I knew about it...she had arranged to sit in the press box with Mr. Brown."

Ralph claimed that based on her infatuation with Brown, Evelyn developed a strong interest in newspapers and worked during the summer of 1923 at the *Knoxville Journal*.

"Did she or not after that become interested in any other man?" Jennings asked.

"The next man that she indicated any interest in was a fellow by the name of Edgar Bennett, a student in high school," Ralph replied. "...I saw very little of him, I wouldn't have known anything about him at all except she talked about him so much...about how sweet he was and how attractive he was, and she would refer to him, her favorite name for him was her 'angel child'."

"Now, Mr. Scharringhaus, she told the jury that all that time her heart was breaking, and that she was constantly urging you to marry her, and have a marriage ceremony, and that you refused, is that a fact?"

"It's absolutely untrue," Ralph said. "I was the one that was trying to get married, I was doing everything I could over that period of time, and I worked at that harder than any job I worked at in my life with less result."

"She filed in evidence here a diamond ring, a ring set with diamonds, I wish you would tell the Court and jury the facts with reference to the purchase of that ring."

"Well, I wanted to give her a ring, that was in the latter part of 1920, and I asked her about it, and she said she would like to have the ring but that she wouldn't accept it as an engagement ring, and I said, all right I want to give you a ring, and I will just give it to you anyway, she said, I don't want anybody to know you have given it to me for fear they might think it was an engagement ring, I said, all right how can you arrange that, and her idea on the thing was that she should go into a jewelry store and make a selection, just like looking over rings and then have a friend of hers go in and actually get the ring, that's the way it worked out."

Jennings introduced the receipt for the ring into evidence and asked Ralph how Evelyn wore the ring.

"She wore it on her right hand," Ralph said, "well, I guess, on her third finger, the third finger of her right hand, as I remember it."

"Did she wear it, or refer to it as an engagement ring?" Jennings said.

"No, sir,"

Jennings asked Ralph about Carl Stafford. "She told the jury...that you suggested that she try to cultivate some other man

than you, go with somebody else, marry somebody else, did you do anything of that sort?"

"No, sir, I did not...I tried to keep her from going with him...it was just a little bit humiliating to me for her to pick this fellow up and start going around with him, [but there] really wasn't anything I could say to deter her...she wasn't going to let me dictate to her, tell her what she could and couldn't do...I had nothing against Mr. Stafford, he was a very nice man, the fact was I didn't want her to go with anybody. She finally said one thing, it would be a good idea to go with him, because we had been going together so long, pretty constantly, it might cause some talk, perhaps it was causing some talk, and it might be better for her if she would go with this other man sometimes instead of going all together with me. I told her if she put it on that basis...and that if she felt that it was wise, I couldn't interpose any objection. I hadn't looked at it in that light...I didn't want to be put in a position where I was asking her to do something that wasn't in her best interest."

Jennings then asked Ralph to describe his trip with Evelyn in 1926 to New York. Ralph said he needed to travel to New York City on a buying trip for Gillespie, Shields & Co., and he told Evelyn that he wished she could go with him. But he did not actually invite her because he thought it was too risky. He thought someone from Knoxville might see them, but Evelyn believed they could get away with it.

"...[W]e went on the same train," Ralph recalled, "when we got there why Miss Hazen went to one hotel, I went to another, I went to the hotel where I always stayed when I went on business, which was the Martinique, Miss Hazen went to the old Waldorf...so that she could establish a New York residence to receive mail from her home and perhaps from other people, and we had planned to stay in separate hotels for one night, and then next day to go to a third hotel and register as man and wife, stay together.

"...[T]hat first day I think we did some sight-seeing, the first night I know we went to the theatre, I took her back to her hotel, I went back to mine. As I went to bed I got to thinking that perhaps I could persuade her to marry me while we were up there in New York,

I got up out of bed, called her up between one and two in the morning, she hadn't been asleep, I told her, I tell you what let's do in the morning, let's go down to the city hall in the morning and get a marriage license and get married, she said she thought it was awfully nice for me to think about it and call her up at that time in the morning, and she didn't think she wanted to do it, I said, why not, the only reason she advanced was her mother never would forgive her if she ran away from home and got married, I insisted and pressed the matter as far as I could, but in a nice way she just refused it and turned it down, that just closed the incident."

Chapter 25

Jennings rubbed his hands together as he moved closer to the witness stand. Clearing his throat, he caught Ralph's eye and seemed to send him a signal that he was preparing to change the subject. It was obvious that he and Ralph had rehearsed this maneuver.

"When you protested to Miss Hazen about her keeping company with Stafford, what, if anything, did she say to you?" he asked.

"Well, she said there wasn't any reason that she shouldn't have other friends, which was perhaps true...On one occasion I recall particularly, she made the remark she guessed she wasn't a one-man woman," Ralph said.

"What else did she say in that connection?" Jennings asked.

"That same time she said that there were three men, if she could, that she would like, for certain reasons, it took three men, in other words...she liked to have in a man certain qualities I have, she was fond of; certain qualities Stafford had she was very fond of, he was very easy to get along with, very congenial and pleasant, and she was very fond of him, he was easy going, do just what she wanted him to; certain qualities in Bennett that she was very fond of, and she once made the remark, if I ever should marry I would certainly want those men to be able to come to see me any time I wanted to see them, virtually have the run of the house, or words to that effect."

"What did you say to that?"

"I said that didn't suit me at all, that isn't my idea of getting married, to have one or two other men, to have my wife sufficiently interested in any other man for her to want them to have the run of the house, so to speak."

Although Evelyn was interested in having other men as lovers, Ralph alleged, there were few people that she liked in general. He said that she made it abundantly clear that she did not like any of his friends, male or female.

"She objected to virtually all the friends I had...she said most of them were very common and ordinary, and she didn't see what I wanted to run around with people like that for, the men, she said, weren't any account, most of them, to use her expression, [were] just a bunch of sots, and she said they weren't honest in their business associations...."

Ralph added that Evelyn was particularly critical of Asbury Wright despite the fact that he had served in France during the war and later had been on the Knoxville City Council as a commissioner. He also said that she did not like Hugh Goforth. "...[S]he called him a gambler, he was sot, didn't amount to anything...."

"...I want to ask you...has there ever been anything improper between you and Mrs. Goforth?" Jennings asked.

"Absolutely not, both Mr. and Mrs. Goforth are good friends of mine," Ralph said.

"Who first made any mention of Hugh Goforth to you and indicated to you that there had ever been anything wrong?"

"Miss Hazen," he answered.

Jennings then embarked on another line of questioning to show the jury that Evelyn could be irrational and that she represented a serious threat to Ralph's life.

"...[S]tate whether [or] not Miss Hazen herself ever threatened you," Jennings instructed.

"She had threatened me prior to June the 1st, 1932," Ralph replied.

"In what way, what had she said to you?"

"At that particular time we were discussing our associations, and she made the statement that if I tried to get loose from her that she would ruin me or kill me, that to my knowledge is the only time that she had threatened me personally."

"Now just state the facts with reference to her chasing you on that occasion," Jennings said.

Ralph said that during the summer of 1932, he and Gertrude Penland were walking down the street near his store to get his car when he noticed that Evelyn was walking up the other side of the street. Since his car was in a parking lot near where Evelyn was

walking and he had heard that she intended to kill him, he went into the Y.M.C.A. on the corner and called a man who worked in his store to ask him to come to the Y.M.C.A., pick up Ralph's car key, and get the car for him. But the employee could not come immediately, and Ralph grew impatient. He decided to take a risk and get the car himself. But when he went back outside, he could see Evelyn sitting in his car.

"…[W]ell, I knew I wasn't going over there to get it then, so I went back down to the Y.M.C.A. waited on this man to come down and get my key, he was longer getting out there than I expected he would be…I went out and walked by the parking lot again, the second time, why, Miss Hazen had left, she wasn't in my car, so I made a dive over and got in my car…pulled out into the street and at the first corner I got caught in traffic…her car came into the intersection…I turned rapidly and went in the other direction…," he explained.

"I was running pretty fast, I thought I would get loose from her that way, the faster I ran the faster she ran, she stayed right behind me, as a matter of fact…she tried to pull up alongside my car, I managed to keep her from doing that, because I would pull over a little…so she couldn't get around. As I got down close to my home…I realized that she was trying to pull in to the right lane between me and the curb, which, of course, would cut me off and prevent me from turning down my driveway…that being the case I pulled over close to the curb to prevent her from doing that…I applied my brake very quickly, then whipped my car right in the driveway and went on up to the porch…I looked out on the [P]ike and I saw Miss Hazen had stopped her car and was getting out, so I suggested to my family we all just go in the house and shut the door, I didn't want to have any trouble.

"…I omitted one thing," Ralph added. "…[W]hen I applied my brakes very slightly to turn in [to the driveway] Miss Hazen's car hit the rear end of my car, her bumper hit my rear bumper, it didn't do any damage."

To support his contention that Evelyn was dangerous and even homicidal, Ralph then said that she was known to go into absolute rages over fairly insignificant issues. For example, he said that she became very angry over a rattle in her car. Since Ralph had helped her

pick out the car, he said she blamed him for the irritating noise and went into a "frenzy" about it.

"...[S]he was pacing the floor, just ringing her hands, cursing about that God damn car, she turned on me, it was all my fault, God damn S.B...I tried to calm her, she was in such a state of mind there I didn't know what to do, I was just speechless, I just stood there and watched her, and she continued to carry on at that rate, pacing up and down the floor, finally she turned on me and tried to hit me, and the only way I could keep her from doing that, I took her hands and held them, and she screamed and raved until she finally exhausted herself and virtually collapsed."

Ralph testified that Evelyn often accused him of things that simply were not true. "...[S]he has always had a very nagging disposition, and found a great deal of fault with virtually everything I did," Ralph said. "...[S]he would accuse me of having used the wrong tone of voice, trying to give offense to her by the way I talked, it eventually got so I didn't say any more than I had to...she seemed to have the idea I was constantly trying to annoy her, doing it intentionally and on purpose, which certainly was not the case, the farthest thing from my mind.

"Another thing," he continued, "I think I, we touched on the fact that she didn't like any of my friends, and when we would go to dances together I was given instructions as to who I could dance with and who I couldn't...I was forbidden to dance with the wives of many of my friends because she didn't like them, she had been told, according to what she said to me, that they didn't like her, that was a very embarrassing situation, I didn't want to tell my friends why I wasn't able to at least be courteous to their wives on social occasions...."

Ralph implied that Evelyn preferred the company of Mildred Eager and Gertrude Penland to his friends, and he described them as her "very close friends" who had been present at some of her angry outbursts.

On the subject of his personal finances, Ralph said he had lost a great deal of money during the Depression. The stock he had owned in Knoxville's three largest banks—the Holstein Union National, the

City National and the East Tennessee National—became worthless when the banks collapsed in 1930. In fact, he said he still owed an assessment on his stock in one bank under the law, but he "didn't have anything to pay it with." Ralph said his real estate holdings and his share of Gillespie, Shields & Co. also lost their value. Gillespie, Shields & Co. had not made a profit since 1926 and was liquidated around 1930.

"...[W]e paid off all the people we owed," Ralph said, "and there wasn't anything left for the common stock holders, of which I was one so I realized nothing at all...I got absolutely nothing out the liquidation of that business."

"Have you been able to get a job?" Jennings asked.

"No, sir, I have not...I haven't had any income since 1931...."

But prior to the economy's collapse, Ralph said he frequently had paid off Evelyn's debts. Jennings introduced several checks into evidence, each of which was marked with an "E" supposedly indicating that Evelyn Hazen had received the money.

"I don't think she realized how far she had gotten herself in debt, she said they were just about to swamp her, she wanted to know if I wouldn't help her," he said.

"Mr. Scharringhaus," Jennings said, "Miss Hazen stated to the jury the other day that in a conversation she had with you in the spring of 1932, when she said that she would sue you if you didn't marry her, that you told her that she could do that if she wanted to, she couldn't make the judgment good if she had one, that you put your money in your father's hand[s] and she couldn't get to it, did you make any such statement as that to her?"

"No, sir, never," Ralph replied.

"Have you [put] any money in your father's hands?"

"No, sir, I have not."

"Have you recited to the jury the facts about your financial situation?"

"I have."

With that, Jennings began to wrap up Ralph's defense. Under his questioning, Ralph insisted again that Evelyn was to blame for their failure to marry during the early years of their relationship. Then,

243

when she began spending time with Carl Stafford, Ralph started to lose interest.

"Well," Ralph told the jury, "during the years 1929, 1930 and 1931...I had been seeing her less and less often. She had been seeing Mr. Stafford more all the time, and I was seeing her less...During that period of time our conversation had largely been confined to impersonal topics, there had been virtually no love making, and there [had] been no talk of marriage, I had not pressed her during that period of time to marry me."

"Why, Mr. Scharringhaus, had you not pressed her any more?" Jennings inquired.

"Well, by that time her interest in other men, against my wishes and over my protest, her abuse and treatment of me when she would have these rages, the fact that I tried a great many years to get her to marry me and failed to do so, and then the attitude she had towards marriage, expressed by the fact she didn't want to have any children, she didn't want to cook, didn't want to do housework...just the things she said about marriage, and married life, made me realize that our ideas were so different, widely different on the subject it would be impossible for us to live together pleasantly and peacefully if we were married, I didn't press her any further."

"Did she during any time ever suggest to you the idea of marriage?"

"No, sir, as I said, our conversation and association during this time was largely impersonal...shortly after the new year of 1932, I was with Miss Hazen one evening, I happened to be in an Auburn automobile, a new car, the man who sold Auburns, one of the salesmen for the Auburn Company at that time was a very good friend of mine, and on various occasions he had tried to get me to buy an Auburn, at that particular time he was pressing me again, I told him very frankly I wasn't in the market for an automobile, didn't have any money to buy an automobile with...[but] he wanted me to drive this car, and on this particular occasion I was in the car when I went and had a date with Miss Hazen on that night. We took a ride, we went, I should say to [Maryville], Tennessee, sixteen miles from

244

Knoxville, and probably six or seven miles beyond that, and then back to her home.

"During the course of that ride Miss Hazen said [there was] something she wanted to ask me, and I said, all right, and she asked me the point blank question, if I were in love with her, and I said, no, I am not, and I said, I want to tell you why I am not, I hope we can discuss it quietly and pleasantly and not either one of us get worked up about it...

"[T]hen I went back and reviewed with her our entire associations, I told her she knew that if a man had ever been in love with a girl, that I had been in love with her, for years, dating back to the time I was in the Army, and she knew I had tried repeatedly to get her to marry me, and I mentioned again all the excuses she had given me from time to time as to why she didn't want to get married, the fact that she wanted to go away for a year or two, and spend that period of time in some other city; the fact one time she wouldn't get married because she couldn't have the kind of trousseau, didn't have money to get the trousseau she wanted, the fact that she didn't want to give up any of her other men friends, the fact that she didn't want to have any children, the fact she hated cooking, housework, and all those things that go to make up a marriage.

"I reminded her of all those things she told me and I went back and told her about how badly she made me feel in connection with Mr. Brown, back in 1923, and then following that there was Mr. Bennett; and following that was Mr. Stafford; and then I reminded her of all the times when she had abused and found fault with me about little things, the spying she had done, petty things, and I told her by reason of all these things, just an accumulation of them, over a period of years, I told her she had killed my love, that was the reason I didn't love her any more, wasn't in love with her. I told her, I said, if you had made an effort to do it, set out deliberately, to kill my love, you couldn't have done a more complete job, over a period of years, it wasn't any all at one time, it wasn't any one instance that did it, but just a gradual proposition and every thing adding a little bit to it, just cutting off a little bit at a time.

"I told her…I was just virtually your slave, I would do anything you wanted to do, laid my heart at your feet and you just kicked it around, you didn't want it, and I said, I am going into details, because I am not mad, not vindictive, I don't have any animosity towards you at all, not blaming you for it, just telling you why…I am not in love with you any more…[S]he said then that I was exactly right, she admitted the truth of everything I said, she said she was sorry, she said in connection with the other men, when I raised an objection about her going with them, she just thought I was mad about it, that my pride was hurt, she didn't realize I felt as badly as I did…

"[S]he said about her rages and jealousy, she regretted that very deeply, sometime[s] she just seemed, she just couldn't control herself, one of these moods would come on her, she knew what she was saying, and even at the time didn't want to say it, [but] it just came out, she couldn't help herself.

"About the other things, she said that she hadn't felt the way she said she felt about married life, she said that as a matter of fact, that she thought married life was fine, and hadn't meant it when she said she didn't want to have any children, she summed the whole thing up by saying for ten years possibly she had been playing a part, that person she had shown herself to be to me was not the real person at all, another person, and when she made this explanation and told she did love me, and that she had been playing this part, why, then she felt that everything should immediately be all right with me, and I should be in love with her again.

"I told her I accepted her explanation at its face value, just what she said, but that loving a person or not loving a person is something that you cannot control, no amount of voluntary effort can make you love a person or not love a person, she had simply just killed something in me, and in asking me if I wouldn't be in love with her again she was asking me something that I had no control over whatsoever.

"Then she said she felt one reason we had drifted apart, and one reason I didn't, wasn't in love with her was because our relations sexually had ceased for a long time, and I told her she was wrong about that entirely, that that had nothing whatever to do with it, the

246

only reason that I had ever wanted that relation was because I had been in love with her at the time and the fact that it had ceased had nothing whatever to do with my love for her, and if that really were renewed, it would have no effect on making me be in love with her again. She was positive it would, she said she knew that was one reason we had drifted apart, and she made the suggestion, what I would like to do is to go away together some week end, like we used to do a good many years ago, we can arrange it all right so that we can get away, if you will do that, why, I will make the week end so perfect and so pleasant that I know you will be in love with me again.

"She always said that when school was out in the summer or spring of 1932, that she was going to New York and she would like for me to go to New York with her and stay up there, I told her that I didn't think I could go to New York, as far as a week end trip was concerned, I was very busy at the time and just couldn't arrange to go, [but] my real reason for saying that was the fact that I didn't want to go, she had killed my love, and that was just the way I felt at the time.

"She asked me, however, she said, won't you continue to go with me, and I told her I hope that we will always be able to be good friends and go together, because there are times when you want to be, no one I have ever known can be nicer and more pleasant, more attractive and better company than you are, and when we are getting along pleasantly, I would rather be with you, spend an evening with you, associate with you, than anybody I know of. That's exactly what she wanted to do, so that was the burden of the conversation on that particular ride."

"Did she at any time say to you in that conversation, 'I want you to give me a ceremony, I want you to marry me'?" Jennings asked.

"No, sir," Ralph said, "she did not, there was no discussion of that kind…the discussion was just what I have told you it was."

"Well, did you have any further conversation with her from that time on, during the year 1932?"

"From that time on she also told me, she said Mr. Stafford is in New York, and I will have a great deal of time on my hands, I wish

you would see more, see me more often than you have seen me, finally I told her I would see her just as often as I could."

"Now, she stated as I recall her testimony, that you had sexual relations with her on or about the 28th of May 1932, is that true or untrue?"

"That's untrue," Ralph said.

"Did you have any relations with her of that kind in the early part of 1932?" Jennings asked.

"I did, early in the spring of 1932...nearly every time we were together she was very anxious to make me fall in love with her again, and time and again she would refer to what she had said previously about sexual relations, if they were resumed she knew I would be in love with her again, and I told her that was absolutely wrong, but as a result of that, we were intimate one or perhaps two times, early...."

"About when was the last time?" Jennings asked.

"The last time, I would say fully thirty days, around the first of May, or before the first of May."

"There has been a letter introduced here in evidence, I believe dated June the first, in which you stated in substance to Miss Hazen the reason, explained why you couldn't continue going with her, what was the last conversation you had with her before you wrote that letter?" Jennings probed.

"The last conversation I had with Miss Hazen was, I don't recall the exact date, on, I think a Monday night, the letter was written possibly either a day or two days after that telephone conversation."

"Just tell the Court and jury the nature of that conversation, what you said to her what she said to you, where you were and where she professed to be?"

"...[A]long the latter part of May 1932. I called her this evening and it was probably about eight or eight-thirty, just a social call...just called to get in touch with her...In the course of our conversation she wanted to know if I loved her, was beginning to love her again, or loved her more than I did to start with. I just told her, no, I didn't, and with that why, she just flew into this rage and began to reproach me and curse me."

"Tell the jury what she said," Jennings instructed.

248

"Well, she called me a God damn skunk, and a cad and a cur, she called me [a] God damn S.B...she was screaming so loudly I had to hold the receiver away from my ear while she was talking...talking so loudly that her voice became practically unintelligible, she shouted over the telephone, I held the telephone there until I heard someone speak to her at the other end of the line...I heard...a click at the other end of the line, indicating that the receiver had been hung up."

"She told the jury in her testimony, you cursed her."

"No, I never cursed her or any other woman in all my life," Ralph said.

"After that now did she come down to your house that night?"

"Yes, she did...I had been feeling badly for several days and about half sick...and I just had about all I could stand, and I just took the receiver off of the telephone and just left it hanging up so she wouldn't be able to get the connection again. I was worn out, I intended to go to bed, which I did, I went on upstairs and went to bed...

"Possibly an hour later, I had been asleep, the door bell rang and awakened me, my father went down to answer the door, he was partly undressed himself, he and my mother were in their room getting ready to go to bed, he had his collar off and had his coat off, but he went down to the door. In just a moment he came back up, my room was upstairs, he came back up to my room and said that Evelyn was down at the door wanting to see me, was asking for me and he said she seemed to be very much worked up, and he said what's the matter anyhow?

"I said, well, we had a rather unpleasant telephone conversation and I expect that's what's the matter, he said, well, are you going down and I said, I would rather not...I wish you would tell her that I have gone to bed and that I will get in touch with her later. So he went down the stairs and I didn't see her that evening."

"Could you see your father and Miss Hazen down there?"

"I couldn't see Miss Hazen, I could see him, I did see him. I walked to the entrance of my room at the top of the steps, I could see him, he was standing inside of the door-way and she was standing on the front porch, right outside of the screen door."

"She has stated to the jury that your father on that occasion shook his fist in her face, did he do that?"

"I didn't see any such thing as that, I stood at the head of the steps during a good part of the conversation, I was standing there because I wanted to hear what was said, if possible, but they were talking in such a low tone of voice that even though it wasn't a great distance, I wasn't able to distinguish what was being said."

Ralph said his parents left Knoxville the next morning to travel to his father's sister's home in Erlanger, Ky. That evening, he said he retired to his room fairly early and was reading when he heard a car pull into the driveway around nine or nine-thirty. Ralph told the jury that although there was dense shrubbery all around the house and the garage, he was able to see the car.

"...[T]he light reflected back from the house on to the car and I could recognize the car, I [could] see just the top from my window."

"Whose car was it?"

"Miss Hazen's."

"Was that the same car in which she later chased you down the [P]ike?" Jennings asked, trying to establish that Evelyn represented a serious physical threat to Ralph.

"Yes, sir," he said. Then to emphasize the fact that he had reason to be afraid of her, he added, "I left Knoxville following that, the day following the night when I saw her car down home."

Ralph testified that he went to Erlanger because he felt it was not safe to remain in Knoxville. He returned home only after Evelyn had gone to New York City that summer. Later, although he felt no obligation to marry her, he agreed to meet with her in New York to end the unpleasantness between them. Ralph's version of the July Fourth conversation bore little resemblance to Evelyn's sworn testimony.

"...[S]he went over the fact that we had been intimate, and that after all of these years it was a very mean and low down despicable trick to write her a letter and terminate our associations, and she said I simply couldn't get away with it...and she said, you have got to marry me and support me, that's just my due, that's coming to me, and that's what you have got to do, and I am going to see that you do it or else

you can take the consequences…She went on to say, if I didn't marry her that she would broadcast to the world the fact that we had been intimate, with the idea of ruining me, and that she would bring suit against me, and would prosecute me criminally," Ralph said.

"Miss Hazen told the jury that while she was talking you looked out the window and twisted your neck-tie, did you do either?" Jennings asked.

"No, sir, I did not, I kept my eyes on her all the time, I heard repeatedly that she had threatened to kill me and I was watching her all the time, I wasn't looking out any window."

"How did the interview terminate?" Jennings asked.

"After Miss Hazen had said what she was going to do…she wanted to know what my decision was, I told her I would not marry her. At that time Flem spoke up and said Ralph, why don't you think about this thing a little while, instead of making your decision right now, I didn't know what he had in his mind but I followed his suggestion, because I assumed that's what he wanted, and so I said, all right, that may be a very good suggestion, I will do that and I will get in touch with you…I got up and got my hat and was starting out the door, [when] Miss Hazen said, Flem, I would like to see Ralph alone for about fifteen minutes. I said, no, I won't agree to that…and Flem agreed with me, he said, I don't think that would be wise, you understand, he and I had agreed he was to be present…I got my hat and left…."

At the very end of Ralph's testimony, Jennings asked Ralph once again about his financial situation. "Have you been able to obtain employment, get work, since you have been [in Kentucky]?" he asked.

"No, sir, I have not," Ralph replied.

"Have you any income?"

"No, sir, I have not."

"Any property?"

"Absolutely not."

Chapter 26

By the time that Jennings finished his line of questioning, Ralph had been on the stand testifying in his own defense for nearly three days, and had portrayed himself as a reasonable, mild-mannered, well-bred gentleman who had been repeatedly berated and abused by an unreasonable, rude, and emotionally out-of-control woman. But Ralph's depiction of Evelyn and their relationship began to crumble when Blakely began his cross-examination.

"Now, I understood you to say that in, you did say in 1929, 1930 and 1931, your conversation and associations during that time were impersonal, that is with Miss Hazen, and you tried to make it so," Blakely said. Then referring one of the letters that had been introduced into evidence, he said, "I want you to look at Exhibit A-148, February 22, 1929, during which year you say your relations were largely impersonal. You wrote that letter, didn't you?"

"Yes, sir," Ralph answered.

"Did you write the word, 'Dearest'?"

"Yes, sir."

"Did you consider that very impersonal, did you consider that a very impersonal word?"

"I wouldn't say it could be called impersonal, I had been writing Miss Hazen a great many years...."

"Is that an impersonal word?" Blakely said, scowling at him.

"I shouldn't think it would be called that, no, sir," Ralph replied.

"What did you mean by it?"

"Just what it says."

"What was that?" Blakely asked.

"Dearest."

"What idea did you intend to convey by that word?" Blakely demanded.

"I didn't intend to convey any idea at all, that's the way I started all of my letters to her," Ralph in a matter-of-fact tone of voice.

"Why did you write it?"

"Because I had written that way in the past, I continued," Ralph said.

"You wrote this whole letter, and you wrote the word 'Dearest', you told the jury you didn't intend to convey any idea at all by it," Blakely saied.

"No, sir," Ralph said, "I didn't intend to convey any idea."

"Were you telling the truth then when you said 'Dearest'?"

"I didn't stop to think of any meaning at all, I had been starting all of my letters that way," Ralph said.

"What did you mean when you said, 'I send you my love'?" Blakely said.

"I meant just what I said, I did send her my love."

"You meant to send her your love then, did you not?"

"Yes, sir."

"Did you mean that when you said, 'Dearest'?"

"I suppose I did, Mr. Blakely."

"Well, were you telling the truth then?" Blakely asked.

"I suppose I was, yes, sir," Ralph said.

"Was that an impersonal relationship in 1929 then?" Blakely said, narrowing his gaze.

"The relationship, I think if you will go back, I said was largely impersonal."

"How largely impersonal was it?" Blakely said.

"Well, I don't believe I can tell you the exact degree, but it was largely impersonal, as compared to our relationship prior to that time," Ralph replied.

"And you tried to keep it impersonal, did you?" Blakely asked accusingly.

"Yes, sir...."

Blakely next noted that several letters written in 1929 ended with similar expressions of affection. "'All my love.' Did you mean that?" Blakely demanded. "You said that?"

"Yes, I meant that," Ralph responded.

"Well, you meant 'All my love,' but you didn't mean anything by 'Dearest'?"

254

"I attached no importance to it when I wrote that letter," Ralph said.

"Did it strike you that somebody, Miss Hazen in particular, might attach some importance to it?"

"No, sir, it did not."

"Did you mean exactly what you said when you wrote that you were lonesome for your sweet baby?"

"Yes, I did," Ralph said. He shifted his weight in the chair. His formerly placid and controlled expression was showing signs of fading. Still, he stuck to his story.

"Who was your 'sweet baby'?" Blakely asked.

"I was referring to Miss Hazen," Ralph replied.

"And then what did you mean when you said, 'I want to be loved by you and nobody else but you'?"

"Just what I said."

"You really meant that?"

"Yes, sir."

"Getting back to 'Dearest', did you mean that?"

"I placed no emphasis on that at all," Ralph said. Beads of sweat were breaking out on his brow.

"Did you mean it?" Blakely demanded.

"Yes, sir," Ralph finally admitted.

"Did you mean the 'Dearest' in the other letters too?" Blakely said.

"Yes, sir," Ralph answered.

"Your statement now is that you did mean it?" Blakely hissed at him.

Jennings objected, so Blakely moved to another phrase that Ralph had written in a letter to Evelyn.

"'I want to put my arms around you and feel yours around me and to kiss those sweet red lips.' Was that impersonal?" Blakely asked.

"I wouldn't judge that it was," Ralph said.

Blakely continued to drill Ralph about his letters, moving from 1929 into 1930 when he closed some of his letters with "remember I love you."

"There were times when I loved her then, yes, sir," Ralph explained.

"You were loving her at that time? July 1930?" Blakely said, leaning toward him with a menacing look on his face.

"When that letter was written," Ralph said.

"In between times, did you fall out of love?"

"Sometimes when she would curse me and abuse me I would, yes, sir."

"You would fall in and out of love, is that correct?"

"I don't know exactly how you would express it," Ralph said.

"I want to know, how many times you would fall in and out of love in a year?"

"I have no idea."

"As often as five or six times a year?" Blakely said with a sweep of his arm.

"It might have been, might have been more than that."

"Can you say how much more?"

"No, sir, I couldn't."

Referring to another letter, Blakely asked, "You spoke about a dream that you had the other night, 'It seems that I was along on the trip and we were in England or France. I came into your bedroom...and there were several people visiting there. You were sitting on the bed dressed in a most alluring nightie and seemed to be enjoying yourself thoroughly.' Did you consider that a very impersonal letter?"

"No, sir," Ralph replied.

"That was a rather personal letter, wasn't it?" Blakely said.

"Yes, sir."

"'In the crowd was some man whom you invited over to the bed for a kiss,'" Blakely read. "Was that impersonal or personal?"

"I would consider that personal," Ralph said.

"'When he responded I naturally objected.' Now, was that the way you felt about it? About any other man kissing her?" Blakely asked, turning his back on Ralph and looking at the jury.

"In the dream, I was recounting a dream," Ralph tried to explain.

"How about when you weren't dreaming, would you object to anybody kissing her?"

"I don't know that I thought about it, Mr. Blakely."

"Well, think about it now," Blakely ordered, swiveling around to face Ralph.

"I wouldn't object now."

"Why did you object to anybody else kissing her?"

"I said I objected in the dream."

"Are you out of the dream now?" Blakely said scornfully.

Blakely turned to another letter, this one written in July 1930. "'Mama and Papa are going to Jamestown on Friday and as the cook will have her vacation I will be all alone. Wish you were here.' What did you mean by that?"

"I meant by that my family was going away, I would be more lonesome than usual, very often when they were gone, Miss Hazen and I would go down home and play the radio, sit around there in the evening."

"Is that what you wanted her to come home for, to play the radio?" Blakely asked him. "...[A]ren't you saying this, well, your father and mother are away, the cook is away, and come on down, let's play?"

"Not necessarily."

"Isn't that what you meant...I will ask you if you didn't...right up to the last moment, write to her in terms of affection and endearment?" Blakely insisted.

"During what period?"

"To 1932."

"I did," Ralph finally admitted.

Although Blakely had inflicted a major blow to Ralph's defense, he wasn't finished yet. He walked to the plaintiff's table, picked up Ralph's written reply to Evelyn's suit, and proceeded to pick it apart.

"Did you deny...the following, 'The defendant denies that plaintiff was for many years or at any time employed as a teacher in the public schools in the City of Knoxville, Tennessee'?" Blakely asked.

"I denied that as a part of the rest of that."

"You did swear in this, did you not, 'that plaintiff was guilty of lewd and lascivious conduct, such as showed her to be unchaste and unfit for a wife, of which the defendant had no knowledge at the time specified in the petition'?"

257

"Yes, sir."

"Did you refer to any conduct with you?" Blakely asked.

"No, sir," Ralph said.

"Did you refer, to whom did you refer as having had lewd and lascivious relations with Miss Hazen?"

"I referred to Mr. McKnight and also to Mr. Stafford," Ralph answered.

Blakely gazed at Ralph with a disgusted look and turned the witness back over to Jennings.

Jennings asked the judge to excuse Ralph from the witness stand and called Clifford Penland into the courtroom in an apparent attempt to bolster Ralph's story. As soon as Cliff was sworn in, Jennings homed in on the conversation that he had had with Evelyn at a restaurant in New York during the 1931 Christmas holiday.

"What did she say to you about Ralph?" Jennings probed.

"Well, the talk that I heard principally was about another man, I didn't get very much news of Ralph, except she said she did not love him and never had loved him," Cliff answered.

"What did she say about, what other man was it she was talking to you about?"

"Mr. McKnight, known as Jack McKnight…she wanted to enlist my services while in New York in finding out as much as I could about Mr. McKnight, and to cultivate him, so to speak, see if I could advance her position with him."

"…What did she say about that? Just tell what she said."

"Well, she told me that she did love him…and that he interested her more in many ways than Ralph ever had, or than any other man ever had."

With that statement included in the record, Jennings turned Cliff over to Blakely and sat down at the defense table.

Blakely wasted no time in discrediting Cliff. He strode confidently to the witness stand and dispatched his prey with haste.

"How long have you been here, Mr. Penland, awaiting this opportunity to testify?" Blakely demanded.

"Objection!" Jennings shrieked, seeking to prevent the question from being answered.

Judge Bryson allowed limited information to be entered into the record. "The witness would testify, if permitted to answer," Bryson said, "and his testimony would be true, 'I have been here approximately five days.'"

"Who is paying your expenses and your hotel bill?" Blakely shouted at him.

"Mr. Scharringhaus," Cliff replied under oath.

Chapter 27

Mildred Eager was the next witness to be sworn in for the defense. The prim, middle-aged schoolteacher seemed self-conscious and slightly fearful initially, but as soon as she was sworn in, it became clear that she intended to do as much damage as possible to Evelyn's case. Mildred immediately accused Evelyn of subjecting Ralph to "mental cruelty" and went into great detail about her infatuations with other men.

"...[D]id you know a man by the name of Harold Brown, in Knoxville in 1923?" Jennings asked her. "Did Miss Hazen ever talk to you about Harold Brown and how she felt towards him?"

"Yes, sir, she admired him very much...she said she thought he was very handsome, he had a very brilliant mind, he was very companionable to her, she got a great deal out of talking to him, and she liked to work with him at the Knoxville Journal, she went on assignments with him and that they were thoroughly congenial," Mildred said.

"Did she ever make any statement to you about Brown's wife?" Jennings asked. "What did she say about Brown's wife?"

"She said she was inferior to Mr. Brown," Mildred asserted.

"What kind of a wife did she say Brown really ought to have?"

"One who could really give him some inspiration," she said.

"...What, if anything, did she say on that subject, whether or not she knew any woman she thought would inspire Mr. Brown?"

"She told me that she and Mr. Brown had decided that she would be a great inspiration to him."

"...Now, did you know a boy in high school named Edgar Bennett?"

"I did," Mildred confirmed. She said that Evelyn had tutored the boy in her home. On one occasion, she said, she had seen him at Evelyn's home on a Saturday morning, and that Evelyn had made a

caramel layer cake for him. Mildred said Evelyn had called him "angel child."

"Did she ever give the details of any unusual position or attitude this young man assumed when pursuing his studies under her tutoring?" Jennings asked.

"Well, she told me that he studied with his head on her breast."

"I want to ask you about this man named Carl Stafford...Did you ever hear she and Stafford discuss Scharringhaus and if so what did they say about him?"

"They discussed ways in which Stafford could put things over Scharringhaus and get dates away from Scharringhaus."

"What have you heard Miss Hazen say, if anything, what her feelings were towards Stafford?"

"She told me that Stafford was the one man who had come nearer to doing everything she wanted him to do of any man she had ever known, and she thought he was the most comfortable person she had ever been around."

"Did you ever see any actions or marks of affection bestowed on Stafford by Miss Hazen?"

"Yes, sir."

"Tell the jury what you have seen now of their conduct and relationship."

"Well, I have seen her take his face between her hands and kiss him," she claimed smugly.

Mildred then proceeded to tell the jury that Evelyn and Carl had stayed one evening in her home when her mother was out of town. "He went upstairs and went in to his room, which was the middle bed room, Miss Hazen and I went in the back bed room, which was my bed room, we undressed, she put on my negligee, and asked me if I thought it would be all right if she went in to tell Carl good night, and I told her yes, I was tired and I fell asleep and when Miss Hazen returned to my room, she awakened me and I looked at my watch and it was in the neighborhood of two o'clock."

"Did you ever hear of Jack McKnight?" Jennings asked. "Just tell the jury now what she told you about this man McKnight."

"She told me she met the one man in her life, the most ideal and the most perfect man, and the one person who would make her life complete," Mildred said.

"...Did she or not tell you anything about seeing McKnight in Cleveland, Ohio, on the occasion when she stopped there on her way to Europe?"

"Yes, sir...she told me before she left Knoxville that she was going to meet Mr. McKnight in Cleveland and that I shouldn't tell it, because she didn't want Ralph to know it, and I didn't tell it, she went on to Cleveland, met Mr. McKnight and wrote me a letter to the effect that she had met him, and that she spent the night in Cleveland."

"Do you know whether or not, did Miss Hazen ever make any statement to you about whether she ever gave McKnight any presents?"

"Oh, yes, I went with her to buy one."

"What was it she bought him?"

"A ring...She told me she bought him a watch in Europe."

"...[W]hat else did she tell you about her associations with McKnight in 1930...as to whether or not she saw him at any other time during that trip?"

"She saw him on her return from Europe, she saw him first in New York...She told me they took a week end trip to Buffalo."

"Just tell the jury now what she told you on the subject of that week end with McKnight in Buffalo," Jennings said, pulling as much damaging testimony out of her as possible.

"Well at three different times she told me three different stories about it. The first time she told me, she said she met Mr. McKnight in Buffalo, and they went to the Statler Hotel where he had a suite of rooms and where he had registered as Mr. and Mrs. J.F. McKnight, they had planned to get married but it was late and that they didn't, but that nothing wrong occurred at all, they had twin beds, he slept in one and she slept in the other."

"In the same room?"

"In the same room, he held her in his arms for a period of hours, but nothing out of the way occurred at all, that was the first story. In the summer of 1931, when we were in New York, she brought the

263

subject up again and told me she hadn't told me all about the Buffalo trip, that something had occurred, that it had been the most perfect experience, the most perfect thrill she would ever experience in the world, and asked my advice about what to do about it, she and Mr. McKnight were not getting along so well together at that time."

"State whether or not she had sexual relations with Mr. McKnight," Jennings said, turning toward the jury for effect.

"She said she had."

"And then asked your advice about what?"

"What she should do about it, about getting Mr. McKnight back," Mildred replied.

"Did she give any reason as to why there had been any interruption in their relations?"

"She said the situation was so unusual, that it got on her nerves...that she lost her temper and called him every name in the category, she did not designate the names."

"Did she say anything about the effect, of what she said to McKnight had on him?"

"She said he walked over to the window, folded his arms and said, 'well, Evelyn, this doesn't speak of love.'"

"...What did she say to you on the subject of Mr. Scharringhaus after these McKnight and Stafford episodes?"

"She came to me and told me that she had decided that Ralph was the best proposition and the nicest man she had known, and she was going to marry him."

"That was the spring of 1932?" Jennings proffered.

"Yes, sir...Then later on she told me he seemed to be rather indifferent...then next she told me that he had told her he didn't love her, and again she asked me for advice."

"...What did you say to her in response to that?"

"I told her that I thought she could get him back if she would show him that she really loved him, and she said, no, I wouldn't do that, I always get more by raising hell, and that was what she was going to do."

Jennings then introduced letters into evidence that Evelyn had written during the summer of 1932 because some of the language

264

seemed to support the allegation that Evelyn had threatened Ralph as well as his father.

From a letter postmarked June 20, 1932, while Evelyn was staying with Ruth Mills in New York City, Jennings read, "Dearest Mildred: I am down at Ruth's office; otherwise I do not believe I could write anything. I am still terribly nervous, and the sight of a pen makes me wild. I cannot explain it, but when my mind begins to try to concentrate on writing with pen and ink, my arm begins to ache and I feel as if I could fly.

"I do not know how long I am going to be up here. Flem called me Friday night and said I should stay until he called again. I think he plans to come up here when that skunk Ralph does, if his business will permit. Please do not tell him I told you this if you should happen to see him. I am leaving everything to him, poor thing, for I am at a total loss to do anything for myself any longer. What the outcome will be now for eventually I do not know and I simply do not think about it. New York, with Carl here doing more than most six people would do, is a real hiding place; somehow I feel far away and more secure from the fiends that have been making my life so miserable for so long. Every time I think about that devil Mr. S. I could slay him. I am afraid Flem has not told Ralph what that old thing said to me, and I think he should, for you know how R. thinks his father is so perfect. I'll tell him that and several more things in no uncertain terms if I ever see him again.

"Mildred, you are a real friend, of which creatures there are too few, and I certainly do appreciate it. I have just written Mama and told her that I going to try to collect a little on that insurance policy and that I am going to ask you to go out and help her find the papers. If you don't want to do it, please don't feel that you have to. I thought Dr. Lynn could sign it and date his first prescription May 30, the date he gave me the nerve medicine and again June 4, the date he came out to see me. God knows I was sick enough that last week of school and have been practically in bed ever since both here and at home. That makes three weeks in all; the first one the last week of the hellish school and the next two from June 6 to 20. I should have had Ruth's doctor here several times, but I simply did not have five dollars to

invest in each visit, so [I] struggled along without anything more than what Dr. Lynn gave me. If you go out, you will find the policy and the papers in the middle drawer of my bureau I think; if not, then look in the little top one on the right. Don't fail to see that all drawers are locked again. The key is in my purple sewing box in front of Carl's picture on the little old-fashioned sewing table. I didn't tell Mama where the key is; I forgot it. Put it back and tell her not to let any one get into my things.

"Today I am trying a new occupation, much against my better judgment, but coming down to Ruth's office to help her. Her assistant was in a terrible automobile accident yesterday, so can't be back for some time. She asked me if I wanted to try it, and since it amounts to nothing, I thought I would if I find I can stay up all day. She is out now, but there is no business, so I am trying to keep myself from flying out of the window by writing on this machine. As I told you, I simply cannot write with pen. I venture to say there will be little salary connected with this 'job,' but even fifteen or twenty dollars a week will be of value…

"I wish you could be here, but that apartment is hardly big enough for two people, not to suggest three. The one I looked at Saturday at the Hotel Irving on Gramercy Park, when I was considering moving, is nice and very reasonable, too. As I said, I do not know how long I'll be here. Sometimes I think I'll just stay all the time and wash my hands of that damnable place and people forever. If Carl had a bigger salary and a little more on the side, I'd be tempted to do it, for he certainly is the most agreeable, soothing human being I've ever seen. He has been a life-saver to me.

"I have not seen Jack and have no desire to do so; however I may write him a note and ask him to have dinner with Carl and me sometime. I seriously doubt whether [he] would want to; I am really sorry I told him so much that probably made him miserable for a few weeks. I am sure he is not capable of feeling anything very much longer than that.

"Write me again soon, and do what you can about the insurance. I'll surely appreciate it, for I need all the money I can get. I do not feel that I am 'gyping' the company, for I have been ill if any

one ever was; in bed, too. Give my love to your mother and tell my mother that I miss her and am thinking about her every day even if I am bad about writing. Mildred, you are an angel to go out to see her, and some day, if I ever am myself again, I'll do something for you if I can. You know how I feel about what you have done for me anyway, don't you?

"Write soon. Devotedly, Signed, Evelyn."

Having established that Mildred had been a confidant, Jennings then asked her a long string of questions about comments that Evelyn had made over the past several years.

Mildred said it was true that Evelyn did not like children and called them "damn brats." It was true that she called Ralph's friends "skunks and sots." It was true that Evelyn had cursed her Dodge Six car and blamed Ralph for selecting a poor car for her. Furthermore, Mildred claimed that Evelyn had said she wanted to become an actress and was quite good at pretending to faint.

Changing the subject, Jennings asked, "Did she ever make any statement to you, or in your presence as to whether or not she would be satisfied with just one man?"

"Oh, she told me on several occasions that she thought that out of the whole world of men she ought to be allowed to have three, she only wanted three."

"Did she designate any particular three men that she thought might fill the bill?"

"She did."

"Who did she say they were and why did she want that particular three?"

"Ralph Scharringhaus, Carl Stafford and Jack McKnight...Ralph had a good back-ground, made money, very dependable; Carl was very pleasing to have around, very soothing, did the things she wanted him to do, and Jack gave her the biggest thrill."

But Mildred said, by the late spring of 1932, Ralph no longer wanted to marry her, despite the fact that he and Evelyn had been intimate for several years. It was then that Evelyn decided to kill Ralph and invited Mildred to become a co-conspirator. She testified that Evelyn called her one evening and asked her to go with her to a

dressmaker's home in Park City. When Mildred got into the car, she sat down on something hard and discovered a pistol lying on the seat.

Mildred described the trip to Ralph's home. "Well, she said, we are going to look for Ralph, she was going to kill him," she claimed. She said Evelyn drove down the Scharringhauses' drive, saying that that was the location where she planned to shoot him. But it appeared that no one was home, so she drove to the Goforths' and the Wrights' to look for him. Mildred said she asked Evelyn to take her home and that ended the murder attempt that night.

Jennings then asked Mildred where Evelyn kept the pistol and she testified that Evelyn bought the gun in New York and kept it in a dresser drawer.

"...[I]t was wrapped in a brown kid glove, and [she] showed it to me, and she said, this is going to do the work, and she said, this one won't fail me, and she said, I am going to wear this glove on my right hand so there will be no fingerprints, she put the pistol next to her skin and she said, I love the feel of cold steel."

"...[W]hat else did she say about this New York pistol?"

"She told me that she received instructions how to use it."

"From whom?"

"From Carl Stafford...That she must have it perfectly level, must not shoot too high or too low, because if she did, her shot would go wild...She told me she was going to wait, stand in the shrubbery to the right [of] the driveway, as you go into the garage, and when he came into the garage, that she would get him."

Jennings said, "...She told the jury the other day, you offered to drive her down there while she killed Scharringhaus, you suggested she ought to do it, that you said no, and you offered to take her."

"I did not," Mildred countered. "[S]he asked me if I would drive her down there in my car and wait across the [P]ike until she killed him, killed Mr. Scharringhaus, I told her that I wouldn't be a party to a murder and serve a penitentiary sentence for anybody...I also told her it would ridiculous to go down in my car, because it was a red roadster, a very conspicuous car, couldn't possibly go down in my car if she was going down, and you cannot go in my car, you will have to get another car, but I did not offer to get a car."

268

Mildred said her friendship with Evelyn ended during the first week of school in September 1932, at a teachers' meeting. "...Miss Hazen came in and sat beside me there and she opened the conversation by saying, God damn you, she said, you double crossed me, and Ralph's double crossed you, but, she said, I will give you one opportunity to straighten this out or else you lose your position. I have framed you with the Board of Education."

Blakely had watched the jury closely, monitoring their facial expressions for the impact of Mildred's testimony. He decided that he should not attack her immediately. So when he rose to his feet to cross-examine her, he began cautiously in a non-threatening manner by asking her about her age and her address. Instinct told him he needed to start slowly and wait for just the right moment to pounce. He was respectful toward the former schoolteacher until she began to get comfortable with him and less defensive. Then he launched into a series of questions designed to prove that she had double-crossed Evelyn.

"Well, for many years you and Miss Hazen were good friends, weren't you?" Blakely asked.

"Yes, sir," Mildred replied.

"...Now you did have, Miss Hazen did have your confidence and you had hers, didn't you?"

"Oh, yes."

Blakely read two letters into evidence that showed Evelyn had turned to Mildred and asked her to help bring about a reconciliation with Ralph. A June 9, 1932, letter, written just after Evelyn had left Knoxville following her father's death, pleaded with Mildred for assistance.

"Mildred," Evelyn wrote, "I can't stand this torment and waiting much longer. Don't let them let him put them off with promises, for he'll get away. It must be settled now the way it should be settled. Don't let them let him give them the slip. He & the old demon are that kind. Nothing can be done with the old one there."

In another letter, written on June 14, 1932, Evelyn reported that she was "more desperate" than ever. "Please help me, Mildred, and make them realize that R. will have to be made to face the issue…This thing has got to be settled, and you know my family won't help me."

"Were you on her side in this controversy?" Blakely asked Mildred.

Jennings objected, and Blakely reworded the question.

"Well, you were taking her part, weren't you?"

Jennings objected again and was sustained. Still, Blakely was able to make his point.

"You were acting for her, as her friend, weren't you?"

"I was," Mildred said.

"…Now, Miss Eager, did you ever tell Miss Hazen that you thought she was right in this, in this controversy, or whatever you want to call it?"

"Right in what way?"

"She was right in her claims, whatever they were?"

"I don't recall that I did, perhaps I did."

"I show you a letter dated Washington, D.C. August 2, 1932, and addressed to Miss Evelyn Hazen, and I ask you if you wrote that letter?"

Mildred examined the letter. "I did," she said.

Blakely began to read. "Dear Evelyn…I want you to know that I sincerely wish for you, a happy settlement of this most unfortunate affair. And I do wish for your own sake the stubbornness could be removed from Ralph and any feeling of revenge that you might have had. Unless these two things happen I don't see how things can be satisfactorily settled. You have gone through more than any girl should ever be asked to stand.

"But Evelyn you couldn't be your father's daughter & inherit your mother's courage without making the final issue one that will benefit you.

"Don't ever think that I don't understand and sympathize with you…

"Love, (Signed) Mildred."

Blakely asked Mildred what she meant by writing the letter, and whether she sincerely hoped to help Evelyn reach a settlement that would make her happy, a settlement in which Ralph would marry her.

Mildred responded that she just wanted Evelyn to be happy with or without a marriage. "Well, everything was in an uproar," she said, "bound to be settled in some way, I had hoped whatever way it was settled it would be for her happiness."

But Blakely showed the jury that Evelyn's happiness was not foremost in Mildred's mind despite her words to the contrary. "Now, as Miss Hazen's friend and confidant, did you go with her to a lawyer's office in Knoxville?"

"Yes, sir," Mildred said.

"...And you did tell what took place there, didn't you?"

Jennings objected, but the judge ordered Mildred to answer the question.

"Yes, sir," she said, squirming slightly.

"To whom did you tell that?" Blakely asked.

"Judge Jennings," she replied, glancing at Ralph's defense team.

"...Now, you didn't tell Miss Hazen at that time that you were going to tell on her, did you?" Blakely demanded.

"I did not." Mildred had to admit.

Blakely then asked her about the day that she and Evelyn were fired from their teaching positions. Over and over again, despite loud and angry objections from Jennings, he asked Mildred whether she blamed Evelyn for her termination. Time after time Mildred refused to answer the question directly. Blakely could see in the faces of the jurors that he had made his point. "All right, if you would prefer not to answer it, I cannot force you to," he said. He turned the witness over to Jennings again.

Jennings immediately shifted the focus from Mildred's apparent betrayal back to Evelyn. "With reference to this statement that Miss Hazen made to you about her meeting Jack McKnight in Buffalo, New York, spending the week end with him in the summer of 1930,"

Jennings asked her, "I wish you would state how she prepared...herself for that meeting or subsequent happenings in the bedroom."

"She told me of a very handsome blue satin negligee that she had borrowed to take up there, and how well it looked, and when McKnight saw her in that negligee, he was simply breathless," she said.

"What, if anything, did she say she did before putting on that beautiful blue negligee, which she had borrowed for the occasion?"

"She had let her hair down."

"And...what did McKnight do or say, what did she say he did or said, when she came in on him and took his breath away?"

"She told me that he said, Evelyn, I never dreamed that anyone could be so beautiful."

Moving on to Evelyn's meeting with Ralph in New York, Jennings asked, "Did Miss Hazen say anything to you with reference to that conference she had in New York City, when her first cousin, Flem Hazen, was present, when she talked to Mr. Scharringhaus in July 1932...What statement did she make as to what preparation she had made for that conference?"

"She told me that she had a new permanent and she bought an entire new outfit."

"Did she make any statement about wanting to see Ralph alone on that occasion?"

"Yes, sir."

"...For what purpose, did she say?"

"She said she could get him back if she could just see him alone for fifteen minutes."

"Did she say how she expected to get him back?"

"Yes, sir."

"What did she say about that?"

"She said that if she could see him alone for fifteen minutes she would pull the sex act on him and have him back," Mildred said.

Jennings, nearly gloating, handed the witness back to Blakely.

Rising to his feet, Blakely fired a single lethal question at her. "Now, Miss Eager, who is paying your expenses here?"

"Mr. Scharringhaus," she replied.

272

Chapter 28

The next witness for the defense was Gertrude Penland. At 47, Gertrude was an unmarried career woman who had spent much of her professional life working as a reporter.

Under Jennings's questioning, Gertrude said that Evelyn never intended to get married, would have preferred to work in New York for a few years, and did not want any "damn brats." She also stated that Evelyn was very interested in Harold Brown, and that he had kissed her before he left Knoxville in the fall of 1923. Gertrude testified that she told Evelyn it wasn't "quite right" for Brown to be interested in her because he was married and had two children.

"What did she say about Ralph?" Jennings asked.

"Well," she responded, "she said, what he didn't know, wouldn't hurt him."

"…Well, did you know a high school young man and a foot ball player, named Bennett?"

"Yes, I knew him slightly, I met him with Evelyn in the car with them one day, I think [that was] the only contact I ever had with him."

"What, if anything, had you heard Miss Hazen say about Bennett?"

"Well, he was a wonderful pupil, the best pupil in the high school, and she was very much…"

Blakely interrupted and objected strenuously to Gertrude's response.

"Well, she called him her…" she started again.

"Angel child!" Blakely blurted out from the plaintiff's table.

Surprised by his outburst, everyone in the courtroom gasped. Judge Bryson glowered at Blakely.

Jennings scowled as he and Smith objected. Then refusing to have his line of questioning interrupted, he returned to Gertrude. "Did

she say anything about what particular attitude he was in, when he was being coached by her at her house?"

""Yes, she said he kept his head on her shoulder, or her bosom."

"Which one?" Blakely shouted.

Jennings was outraged and bellowed an objection.

The judge admonished Blakely. "The defendant's witnesses should be allowed to testify without interruption," Judge Bryson said testily, glaring at Blakely.

Jennings pressed on. "Tell us what [Miss Hazen] said about the time she spent with McKnight there in that bed room in Buffalo, New York?"

"Well, she said the first evening after she came, she went in and changed her traveling clothes into a negligee, and he put on his dressing gown, they had dinner there in the suite and spent the evening in the hotel, and she, of course, occupied one bed and him another."

"In the same room?" Jennings asked.

"In the same room, that's right."

"What else did she say on that subject?"

"Well, she said that it was a very happy occasion, that Jack was delighted to have her, he had told her, she said, she was more beautiful than he had known it was possible for her to be."

Gertrude testified that although Evelyn appreciated Ralph's qualities because he was "worthwhile, and could possibly give her more in a material way than any man she had known," she wanted to be with McKnight because he could "entertain her."

"What, if anything, have you heard her say, as to whether or not she wanted more than one man?" Jennings asked.

"I have heard her say that," Gertrude replied with a slight smile, confirming the earlier testimony.

She also said that she had tried to dissuade Evelyn from bringing suit against Ralph. "…I said, Evelyn, the fact that you are bringing the suit, and the fact you are making the connection now, won't help any…if you bring that thing to the Court, you will put your friends, as well as yourself, in a very difficult position, when it[']s in the Court, the information you have is no longer yours, if you tell the

274

truth about things; and I said, when you come to Court you must tell the whole truth…and your friends…will have to tell the whole truth, and I asked her not to bring it to Court, and she said, yes, she was going to do it, and I said, well, I am very sorry, and I hope you will think about it a long, long time before you take such a step, and she said, well, I have already thought it over, and she said, I won't talk with you again about it, I said, very well, I hope whatever you will do will be for the best, that's the last time we discussed the Court matter or the McKnight matter."

Jennings, who was finished with his witness, sat down at the defense table.

Blakely was disgusted and angry when rose to cross-examine Gertrude. He quickly drove a spike into the heart of her testimony.

"Miss Penland, have you discussed with Miss Eager the details of the story that you have told about the night at the hotel in Buffalo?" he demanded.

"We talked about it some time ago, yes, sir, she was the only person that I had discussed it with until after the suit was brought," Gertrude answered.

"You went over it together?" he said.

"I don't know what I said—I told her my story, she told me hers, we often referred to it," Gertrude said, becoming defensive.

"Did she tell you this story that you have now told?"

"Well, the details were practically the same…I said we discussed it."

"…[D]id you ever discuss your testimony with Mr. Scharringhaus?" Blakely said.

"Not until after the suit was brought, several months after."

"And you came here from Knoxville?"

"I did."

"Are you here at Mr. Scharringhaus's expense?"

"Yes," Gertrude said, "I assume he will pay the expenses. May I say, in connection with your question that about my friendship with Evelyn, I would like to explain that it[']s most regrettable to have to appear in the role in which I appear here, nothing would have induced

me to give confidences or discuss personal matters with someone else, except that I felt as a matter of justice, but when she forced the issue, Ralph's mutual friends and hers had to take sides, I felt, in order to see justice done, I felt I should tell what I knew about the affair."

"In as much as you have made that statement, isn't it also a fact that nothing on earth could have forced you to come here unless you wanted to?" Blakely said, emphasizing the fact that Gertrude had just admitted to being biased in the case.

"Nothing could have forced me to come, unless I wanted to, nothing, except the sense of justice."

"Then in that case, you didn't want to come?" Blakely asked.

"I certainly did," Gertrude volunteered, "after the issue was drawn and made."

Blakely allowed her final comment to hang in the air.

Chapter 29

The defense rested its case on Wednesday, Feb. 21, 1934, and Blakely recalled Evelyn to the witness stand. He painstakingly asked her about each of the allegations that Ralph and his witnesses had made against her.

As the trial neared completion, tempers were at the boiling point. Jennings and Smith, Ralph's attorneys, objected to nearly every question.

"Miss Hazen, did you ever refuse to marry Mr. Scharringhaus, after you became engaged to him?"

"Objection!" Jennings shouted.

"Answer yes or no," Judge Bryson ordered Evelyn.

"No, indeed," she said vehemently, "I never refused, he knows I never refused."

"Did you tell Mr. Scharringhaus in 1925, or at any other time, that you would not marry him, because you did not have the money to buy your trousseau?"

"Objection!" Jennings thundered.

"I did not say anything about a trousseau, he mentioned the trousseau," Evelyn said. "He said for me to give that as an excuse for our not being married, that it would do as good as any other, and I did, fool that I was."

"…[D]id you ever tell Ralph Scharringhaus that when you were married to him, you would want Bennett and Stafford to come to your house and see you, and have the run of the house…Or did you ever say that you wanted three men, Scharringhaus, Bennett and Stafford, or Scharringhaus, Stafford and McKnight?"

"No, I was having no success with one. I never made any such statement," she said bitterly.

"…Did you ever abuse or curse Mr. Scharringhaus, or go into a tirade about the purchase of your machine?"

"I did not."

"Now, Miss Mildred Eager also testified that after your return from Europe you told her that you had spent three days with McKnight at Buffalo, and had registered as man and wife at the Statler Hotel, did you tell Miss Eager any such story?"

"I certainly did not, that's the most fantastic and ruthless story I ever had to listen to." Evelyn, who was nearly shaking with emotion, began to cry.

Again Jennings objected and the end of Evelyn's answer was excluded.

"Miss Eager also testified you told her, out of the whole world there were three men you wanted, Mr. Scharringhaus for his money and back ground; Mr. Stafford because he was pleasing; and Mr. McKnight because he was the biggest thrill of them all, did you tell Miss Eager anything of that sort?"

"No, indeed," she said tearfully.

Blakely turned to Evelyn's alleged plot to kill Ralph. "Miss Mildred Eager also testified that you tried to get her to help you kill the defendant, Mr. Scharringhaus, and escape from the scene, did you ever do anything of that sort?"

Jennings objected and was sustained.

"Did you ever show Miss Eager a pistol?" Blakely asked.

"No," Evelyn said, "I never owned a pistol until August of 1932."

"You didn't?" Judge Bryson asked.

"No, I did not," she stated.

"...Did you ever try to get Miss Eager dismissed as a teacher in the school?"

"No, indeed, I was too miserable that summer to think about anything but my own troubles, I wasn't thinking about her."

"...Now, Miss Mildred Eager further testifies that you told her while you were in Buffalo with McKnight, you wore a blue satin negligee, and when he saw you in it, it knocked him breathless, and that when you came in to his presence wearing that negligee, you let your hair down, and he said to you, that he didn't know that anything could be so beautiful, did you tell Miss Eager that?"

"No, I was not there, and I had bobbed hair, anyway."

Judge Bryson turned to Evelyn, "You didn't tell Miss Eager that?"

"No, sir," she replied.

"Miss Eager testified that you had before your interview in New York, bought a new outfit, and that you wanted to be alone in that room with Mr. Scharringhaus for fifteen minutes, so, as Miss Eager expresses it, you could pull the sex act on him and get him back, did you tell Miss Eager any such thing?"

"None of that is true, I had no new clothes—that's just impossible."

"...Now then, did you tell Miss Penland that in speaking about Mr. Brown, that what Mr. Scharringhaus didn't know, wouldn't hurt him?"

"I certainly did not."

"...Was Mr. Brown known as 'Lamb' to anybody in that office?"

"Yes, sir."

"To whom?"

"He was called 'Gertie's lamb'."

"Who was Gertie?"

"Miss Gertrude Penland."

"...Did you ever refer to Edgar Bennett, in speaking to Miss Penland, as your 'angel child'?"

"No, sir."

"Miss Penland also testified that you told her that when Mr. Bennett was studying, he studied with his head on your shoulder or bosom, did you tell her that?"

"I certainly did not."

The moment that Blakely and Evelyn finished their rebuttal, Jennings and Smith asked for the case to be dismissed because "of misconduct of the Plaintiff, in repeatedly injecting into the record statements over the objection of counsel for the Defendant, and not in response to questions by her own counsel, and irrelevant and incompetent matter." They were overruled.

Closing arguments began early the next day, Friday, Feb. 23. Before a packed courtroom, the opposing attorneys squared off, firing venomous words at each other. Their arguments were "bitter," one reporter wrote. An observer said they acted like "a pack of wolves just ready to devour their prey."

At the plaintiff's table, Evelyn had to sit silently and watch as Blakely and Kennerly defended her honor. Her future, her very life, was buoyed upward by their supportive remarks, only to be crushed by Jennings's and Smith's accusations.

Ralph, too, suffered wounds during the heated exchange. Evelyn's legal team called him a "debaucher and coward." General Kennerly, finally taking center stage in the trial, said Ralph courted "Evelyn from 1916 until the spring of 1932, and as the years rolled by he grew tired of her, sought to dump her off on others." He likened Mildred Eager's and Gertrude Penland's performances on the witness stand to "the witch scene from Macbeth."

"If, on her return from New York, she had killed [Ralph] in the streets of Knoxville, no jury of 12 men would have convicted her after hearing her story," Kennerly asserted.

Ralph's attorneys implored the jurors to examine Evelyn's flawed character. They called her a "wildcat" who had seduced several men. They also accused her of trying to win the sympathies of the jury by pretending to be vulnerable and helpless. Smith pointed to her overly sympathetic performance on the witness stand. She tried to "cry a verdict from the jury," he claimed.

Blakely countered by accusing Smith of pouring "out all of the vindictiveness and vituperation that was in him" upon Evelyn. Then he exhorted the jury "to at least give [Evelyn] vindication" by finding in her favor.

The case went to the jury at 4:20 p.m. As Judge Bryson explained in his instructions to jury, at least nine of the 12 jurors had to reach an agreement in order to return a verdict. If less than all 12 concurred, those who were in agreement were required to sign the verdict. He also told them that under the law, they were not allowed

to award more than $100,000, which was the amount specified in Evelyn's petition. He reminded them that she had asked for $50,000 for breach of promise to marry and another $50,000 for damages.

With the case in the hands of the jury, Evelyn and her legal team left the courtroom. There was nothing left to do but wait.

For two years, she had been preparing for this moment in hopes of salvaging her reputation and making Ralph take responsibility for the way he had treated her. Now, her fate rested with 12 strangers who had been empowered either to reject her case as the ravings of a hysterical woman or give her a victory over the accusations of Ralph and his subsidized witnesses.

The jury deliberated less than two hours. Evelyn and her attorneys hurried back to the courtroom to hear the verdict.

The next morning the headline on the front page of *The Kentucky Post* in Covington trumpeted the news: "Teacher Wins $80,000 in Love Verdict."

"She threw up her hands and cried, 'It's vindication. I wanted it and I got it,'" *The Post* reported. "She murmured this sentence over and over again after the verdict had been read and as she shook hands with each of the jurors."

The women who had attended every day of the trial crowded around Evelyn "and congratulated her, many of them weeping with her," *The Post* reported.

"[T]he pretty southern school teacher [was] alternately sobbing and laughing," *United Press* reported.

Eleven of the 12 jurors had found in Evelyn's favor and had signed the verdict.

Chapter 30

The $80,000 award was the largest ever in Kentucky and among the largest in the United States. Yet, the *Knoxville Journal*, which had published articles about the trial almost on a daily basis, did not publish a story about the verdict. The residents of Knoxville had to search for news of Evelyn's victory in other publications.

They did not have to look very far. The verdict generated news stories throughout the country, prompting at least two men to send letters to Evelyn in hopes of meeting her. Money appeared to be their motive.

"Congratulations!" Lyle L. Willis wrote from Stone Gap, Va. "I've just read in today's paper, where the jury gave you a verdict for $80,000. Right now while you are thinking of many things you are going to do, you will undoubtedly be in need of the services of a man like me."

Theodore Halversen of Madison, Wisc., took a decidedly more direct and familiar approach. "I have a very definite reason in writing you, namely to form your acquaintance," he wrote in an ink-splotched letter. "I've never been in Knoxville or elsewhere in the Southland. I surmise that you were born and reared in Dixie. I'd like to be there now. I would like very much to receive immediate reply. Would please me and give genuine satisfaction. I'll be waitin' for Dixie breezes to 'blow' from you Evelyn. Tell me all about Knoxville."

Evelyn also received several letters from women who had been in the courtroom every day to watch to the proceedings. "Everyone of us was happy at the verdict," Flora Kirchner wrote. "Did you see the man who so closely resembled Ralph Scharringhaus? He told me that for a week he had to stay away from the court house because people were so bitter."

Evelyn also heard from college friends who had read about the case in their local newspapers. From Jacksonville, Fla., Mrs. E.H. Ramsey wrote, "I have just been reading what you have been through

and want you to know how glad I am that the termination was as it was. I hope it helps in some small way to know that ones and friends stand by—and I do—even tho its been years since we've even seen each other."

Strangers from other parts of the country sent Evelyn letters as well. L.M. Shaw from Hanford, Calif., congratulated her on her victory and said, "More power to you. I admire your spunk."

But spunk was not a word that Evelyn's friends would have used to describe her single-minded drive for vindication. Ralph's deceit, her father's death, and her imprisonment in the mental hospital had taken a toll on her health and her state of mind. Sworn depositions completed just before the trial began described the impact on Evelyn's appearance and demeanor.

Carl Stafford said there had been "quite a decided change" in Evelyn when he saw her in New York in the summer of 1932. He described her as depressed and worried, not at all like the person she had been prior to her father's death and the end of her engagement to Ralph. As he put it, Evelyn had been "very pleasant, a person whom you would enjoy associating with and talking to," but by mid-1932 she had become "very morose."

Ruth Mills, who was a fashion and merchandising manager for No Mend Hosiery Mills at a branch office in the Empire State Building, said it was "great shock" to see Evelyn when she arrived in New York that summer.

"It was the most distressing experience I have ever had," Ruth said. "Evelyn came up here and came to see me looking like an old woman. She had circles under her eyes and wrinkles half-way down her cheeks, and her head sat down in her shoulders like this—like she could hardly hold it up. She was in a pitiable condition, both as to her appearance and her general condition. You would not have known it was the same person."

Ruth also said in her deposition that Evelyn had asked her to be her maid-of-honor at the wedding that had been set for the fall of 1925. She and Evelyn had "planned the wedding in detail even to the

costumes and refreshments," and Ruth had purchased her gown. "Miss Hazen was accumulating her trousseau at that time and continued to," she stated.

In his deposition, Flem Hazen described his efforts to convince Ralph to marry Evelyn. Flem said he met with Ralph on the mezzanine of his store, in drug stores and at an orange juice stand on Knoxville's Gay Street. At the conclusion of each meeting, Ralph "just continued to say he didn't see anything could be gained [by marrying Evelyn], but he would think about it and discuss it with his father."

Flem also confirmed Evelyn's version of the conference they had with Ralph in New York, adding that he told Ralph "it was his duty to marry her."

Ralph replied by saying, "I will reconsider and when I get back to Knoxville go over the matter with my father and let you know what I decide to do."

A week later, Flem said he met with Ralph in Knoxville and he said after talking with his father, "he would refuse to marry her."

"I have known her ever since she—ever since a few days after she was born," Flem said about Evelyn. "I remember distinctly my mother took me out to her home and seeing her when she was little baby in the crib...I always thought Evelyn was one of the sweetest, nicest girls I have ever known. I do not say that because she is my cousin, but just because she was."

"What kind of disposition did she have?" Kennerly asked during the deposition.

"A very sweet and lovable disposition."

"How did that become during the last year or two...?"

"Well, I think she had sort of lost her sunny disposition and didn't seem to be interested in things and seemed to have more or less of an unhappy attitude, and rarely came around to parties and social functions like she had always done in the past," Flem answered.

In another deposition, Miss Clara Bewley, who was the head of the English Department at the Knoxville High School, said she was shocked when she read about Evelyn's lawsuit in the local newspaper. Bewley said she had seen how Evelyn had conducted herself in her high school classes and called her reputation and ability as a teacher

"the very best." She added that as an educator who had worked with young girls for several years, she understood how easily young women could be influenced by men.

"I have thought about it great deal, more than any one would suspect," Bewley said, "for I held Miss Hazen in such high esteem that it led me to study a great deal about that, and then my knowledge of young girls has led me to think a great deal and I have come to this conclusion, that as I understand this, that began when she was still in the teens. We all know there is nothing that is so easily led astray as a young girl. If she trusts a person I am of the opinion that a young girl, trusting a young man whom she loved, could be led into doing things she ought not to do, to do just what happened and since that happened, as I understand from what was published in the Knoxville papers, that's all I know, but it is my opinion that if a young girl still in the teens should be led to commit that mistake and still be under the influence of that man's power, I can see the possibility of this conduct being continued and keeping her life under a shadow and under a cloud till she would do things that under no circumstances would she contemplate and, knowing her as I do, I still am of the opinion that Miss Evelyn Hazen is a woman of good character, regardless of the fact that what you said has taken place."

Knoxville City Superintendent of Schools Dr. Harry Clark agreed with Bewley and said that it was not unusual for a young woman to submit to her boyfriend's sexual desires during World War I. "If it did happen in the war period you must remember the psychology of girls at that time was very different from today and there were many war babies at that time that really came from a pure love relationship. Girls thought that they would never see their lovers again."

Still, he said, he was required to dismiss Evelyn from her teaching position because of the rumors about her "immoral" relationship with Ralph. "We require not only moral people [as teachers] but people that there isn't serious talk about; this was a case of serious talk about one," he explained.

Several other deposed witnesses, including Dannie Mellen Payne, vouched for Evelyn's strong moral character. Under oath they stated that they had never heard her use vile or profane language, drink

alcohol or smoke, and they described her as a very modest and proper young woman. She was ladylike and charming, they said, quiet and reserved rather than bold or forward. One co-worker said Evelyn was as "well bred as any one I have ever known."

Stung by their defeat, Ralph's legal team filed an appeal and requested a new trial. Three years later, the Court of Appeals returned its decision in what was then called the Scharringhaus v. Hazen case. In an opinion dated June 25, 1937, the judges said that Ralph's attorneys had failed to prove that Evelyn had engaged in affairs with other men, and that Ralph's own testimony was refuted by his love letters to her.

The judges stated that Ralph repeatedly "proclaimed an ardent love, expressed his loneliness and pictured the prospects of an early marriage and the beauty of a home with [Evelyn]…These confirm the plaintiff as to the existing situation, and especially her distress…If it were his word against hers, the conflict in evidence might create some doubt as to the true story, but his letters, as we have stated, support plaintiff's version throughout. Thus he admits that in all his letters he had never made any complaint or reference to her receiving the friendly attentions of those with whom he was now charging her with having improper relationships."

The Court of Appeals had harsh words for Mildred Eager and Clifford and Gertrude Penland. The judges wrote that Mildred had played the role of a double-agent, promising to help Evelyn while at the same time betraying her confidences to Ralph. As they put it, she "had drunk from the same cup and then betrayed her friend. The impeachment was self-evident…[Likewise] a cloud of suspicious bias rests upon [Gertrude Penland]. The same is true as to her brother, whose evidence, however is much less incriminatory."

Furthermore, the judges rejected Jennings's claim that Evelyn was able to influence the jury's verdict against Ralph by improperly interjecting conclusions into the record. Although the Court agreed that Evelyn had been a "voluble" witness, it wrote that her comments

against Ralph during the trial could by no means "be regarded as prejudicial to the defendant's substantial rights."

About Evelyn, the Court determined, "There is displayed the picture of a young woman of refinement, culture, and high social standing. There is unfolded the story of grievous wrong with tragic consequences, of lost employment, of a vanished profession, of intense mortification, or wounded pride, of a broken spirit, of wrecked hopes, of despoiled honor, or degraded reputation, of lost social standing. She has been robbed of the priceless jewel of chastity and branded with a mark as indelible as the mark of Cain. The doors of real love and matrimony have doubtless been closed against her. If she is to be believed, the defendant possessed this girl, body and soul, during the charm of youth and until the blossomed maturity of womanhood. For fifteen years he played with the tender chords of a woman's heart and when he became tired crushed them as he would an inanimate thing."

The Court of Appeals rejected Ralph's request for a new trial and ruled that Evelyn had been "justly entitled to receive the award of $80,000."

The ruling generated another round of public interest in Evelyn's case. The *New York Times* published a small story, and *Life* magazine, in a gossip column called "Private Lives," published a photograph of Evelyn taken during the trial and reported that she had won a "heart balm" from Ralph Scharringhaus. *Life* called Ralph "an ardent wooer but a laggard groom."

The "laggard groom" apparently found a way to avoid paying his debt to Evelyn. It is believed that she never got the money.

Chapter 31

In the aftermath of the trial, Evelyn had little or nothing to show for her victory in court. No money, no husband, and very few friends. Most of Knoxville's society considered her a pariah. For them, it was improper to associate with someone who had spoken out so publicly about her personal affairs.

Ralph, on the other hand, returned to Knoxville and took up residence with his parents. Despite testifying that he had no job or money, Ralph and his family continued to live in their large, stately home on Kingston Pike near the country club where he played golf and tennis on a regular basis. He also continued his relationship with Elizabeth Goforth.

At the time of the trial, Evelyn and her attorneys did not have a shred of hard evidence linking Ralph with Elizabeth. Their suspicions were based on gossip, hearsay, and vague reports about Ralph's car being seen near the Goforth's home whenever her husband Hugh was traveling on business.

But a few months after the trial ended, the gossip was confirmed. Evelyn obtained scores of letters that Ralph had written to Elizabeth Goforth while he was on the run and attempting to avoid the trial.

"[T]he 'varmint' wrote to Mrs. Hugh Goforth," Evelyn wrote, "after he left Knoxville (ran away wildly!) to escape General Kennerly, who was demanding retraction of the slander he and his co-workers were trying to spread about me, beginning (believe it or not) the day after my father died! Some of these letters even prove that the varmint is the father of Mrs. Goforth's child (now grown and not living in Knoxville)! How I got them is classic!"

Evelyn told a few acquaintances that she had purchased the letters from a man who called her from a dry cleaning shop, claiming he had found them in the bottom of a box filled with clothes. But it

was rumored that she obtained them from the nurse that Elizabeth had hired to care for the baby.

"Evelyn knew the Goforths were looking for a maid. She heard it at the country club. So she sent them one. She paid the maid, and so did the Goforths, and she got the letters," a Hazen family friend reported. "Mrs. Goforth never would have suspected any thing like that."

Many years after the trial, Evelyn said she was prepared to use the letters to quiet the gossip that was still circulating about her. In a statement resembling a news release, she wrote:

> If it were not for the fact that many people may still wonder about the testimony introduced against me by the defendant and his witnesses during the trial of the lawsuit in 1934, and the manner in which some of the recent news accounts have been handled, I should have no statement to make now.

> Under the existing circumstances, however, I should like those persons who are interested to know that I have access to and am ready to produce at any time, if necessary, nearly 100 letters in Mr. Scharringhaus's handwriting, dated from 1932 to 1934 when he returned to Knoxville, to prove that for several years, both before and during the time of the litigation, he has been involved in an affair with a certain well known married woman of Knoxville. The letters are addressed to her.

> These letters were not shown to me until several months after the trial of the lawsuit.

> He wrote to her in detail of a meeting he had with two of his women witnesses in a certain Kentucky town prior to the trial, at which time, the letters state, they planned the stories intended to besmirch me.

> Many of the letters indicate that the defendant and the young woman intended to have their "future together", and that they would let "no obstacle stand in their way."

They show conclusively that she met him *outside of the State of Tennessee several times* and wrote to him constantly, concurring in his ideas as to how he should conduct his part of the lawsuit. In some, the fear is expressed that her husband "might have doubts about" them; the defendant wrote that his long distance telephone calls and his letters to her would be timed to reach her when the husband would not be at home.

These letters show, also, that the defendant and this young woman scored and criticized many persons in Knoxville whom they had called friend, not excluding one of his attorneys, and the woman's husband; and every effort made to injure me, even to "get rid of" me, was discussed fully in their correspondence.

The extremes to which these long letters go in personal matters between them not referred to in this statement are almost incredible and have to be read to be appreciated fully.

I am not trying to be vindictive, but I feel that nearly six years is more than enough time to contend with deliberate misrepresentation, and I am trying only to protect myself with the proof I have had put before me and let the people who read something of the testimony against me know something now of the real truth.

This documentary evidence is available to prove every statement in this article and more; and while I am not seeking further publicity, if those affected by this article are not satisfied with the statement I have made to vindicate myself before my friends, I am ready and willing to publish this proof in full and make known the names of all parties and the facts concerned in it.

Ralph's letters to Elizabeth Goforth track his travels from Knoxville to Berea, Ky., the day after Evelyn was released from Lyons View asylum, on to Erlanger, later to Florida with his parents, and finally back to Erlanger again. In them, Ralph professes his ardent love for Elizabeth Goforth, whom he frequently called Lib, and for her

new baby. Ralph also describes his efforts to avoid Evelyn and her lawsuit by staying out of the State of Tennessee.

At the end of December 1932, after he had been on-the-run for about six weeks, Ralph wrote to Elizabeth about how he had planned to avoid capture:

> It is essential that the suit (if any) should be delayed beyond the May term of court and if suit is really filed I may go to the mountains as I told you and defer it beyond the September term of court. In the meantime I am hoping that she will fall out with Flem and Kennerly. She won't be running true to form unless she does.
>
> Darling I am pretty low as I guess you know from this letter. It is terrible, being an exile and particularly when it's so indefinite. I can't tell you how much I miss you and how lonesome I am for you. Write me as often as you can, Honey because your letters mean so much to me. I love you.

On January 3, 1933, a letter postmarked in Cincinnati, Ohio, Ralph thanks Elizabeth for a letter that she wrote to him from the hairdresser's:

> Honey I can't tell you what a comfort you and your letters are to me and how tremendously much you mean to me. Just a few lines from you especially when you tell me that you love me makes a new man of me. I really need you Darling and you are the only one I have ever felt that way about.
>
> Your optimism about the suit was most encouraging. I rely more on your hunches than I do on other folks' judgment. I hope you are right but [I] am afraid to expect anything good. I have been disappointed so often. About Carl, according to the Sunshine story, he should have considerable influence but unfortunately he is a "yes" man. That is the reason they have gotten along so well. I hope he believes her story and is in love with her and persuades her to fly to New York with him and establish a little love nest

there. That would be too perfect. There is one thing to consider. If she wants him she may not want to have the ugly mess of a suit quite so much. You see I can still build hope on a very flimsy foundation.

Of course by now suit may already be filed, today being Jan. 3rd [1933]. If so I will hear about it tomorrow. I hope the New Years Eve party was jolly. Cannot imagine it's being so with Krutch and Bascom. That perhaps is only prejudice on my part. I know Hugh is very fond of Bascom or Hortense as I believe Carl calls him. I like him myself and after all, who the hell am I to be critical of any one. I love you Sweetheart and as long as you love me, the world doesn't seem such a bad place.

During his trip to Florida with this parents in early 1933, Ralph continued to write to Elizabeth nearly every day, discussing the controversy he left behind in Knoxville, and providing a glimpse into the impact of the bank failures. On March 4, 1933, he wrote:

About Evelyn, we have heard nothing further. I too hope she and Kennerly are stalling but am afraid to count on it. Another thing about her getting judgment either by default or otherwise, I understand that bankruptcy will not relieve you from such a judgment. I am not allowing myself to think that I may not be able to come home when [I] leave Florida. I don't see how I am going to stand being away from you that long. It gets worse and worse all the time. The only relief is your letters and the fact that I can think about you and talk to you as I walk along the street and ride in my car. You would be surprised if you knew of the long conversations I have with you. Of course I have to do the talking for both of us and undoubtedly have gotten some of your replies wrong. Still it helps an awful lot and makes me feel that you are really with me.

...I truly feel that you are my wife and the only I will ever have. I want you more than I knew it was possible for one person to want another and I intend to have you, that is

if you want me. It would be heaven if I knew that we could always be together for the rest of our lives. I wouldn't want to be separated even one day.

Sweetheart your letter written Thursday came today and I wonder if you knew how sweet it was. I love every word in it and I am so glad you told me what you wore to the dance. Also the fact that you don't like to dress up for any one but me. I always admire you and I think you are beautiful. I mean that. I wouldn't have a thing about you changed. And Honey don't ever think that I am unaware of your clothes. I always notice them and like them too. There is one exception I seem to remember some sort of a pea green outfit that I didn't care for a great deal.

About Mr. Shields, I am glad you told me what you heard. I haven't worried about it. If he chooses to believe her instead of me, I will simply check him off my list of supposed friends and let it go at that. You would be surprised perhaps to know how nonessential every one I know is to me except you. From now on I expect to let "all men count with me but none too much." I always have been pretty much that way. If I can have you then I can check out the rest. What I have been through has made me sort of cold blooded with every one but you. With us it has had just the reverse effect. I feel closer to you than toward any one I have ever known and you are the only person in the world that has the power to hurt me.

I knew about the bank holiday in Tenn from the paper. Now the Miami paper announces a holiday here and I see it has spread to 42 states and that the N.Y. Stock Exchange has closed. Well, there is no telling what will happen next and I have given up forecasting. By the way there is an article in Harpers for March "If Roosevelt fails." Read it if you have a chance and let me know what you think of it.

Honey, tell me about the baby. You surely realize that I don't say half what I want to say in my letters. However I will take a chance and say that I am as crazy about her as

you are and next to you I think she is the sweetest thing in the world. I love you more each day that I live.

Although Ralph frequently expressed concern that his letters might miscarry and land in Evelyn's hands, he continued to write quite openly of his love for Elizabeth. In the letter postmarked in Miami on March 25, 1933, he hints that Elizabeth has written to Ralph about having another baby, apparently with Ralph as the father.

My Precious Sweetheart –

I was so glad to hear from you today and weight is off my mind too. It was the letter you wrote Tuesday and mailed Wednesday. When I didn't get a letter yesterday I began to worry like you that my last Friday & Saturday's letters had fallen into the hands of the enemy and it was a real relief to know that they finally reached you. I cannot understand the delay. I mailed them at the airport near here on Sunday, ordinarily they would have been delivered Monday afternoon. I must be terribly nervous because I live in constant dread that something will go wrong with our letters and at the same time I don't see how anything could. You be sure to watch for the postman. I really think that is important.

Now listen. I want you to get that "new girl" idea out of your mind. If you don't hear from me for two or three days there will be a good reason but it will not be because I do not love you or because I have a new girl. Any more talk like that and I will spank you when I get back to Knoxville. I am so glad that your happiness depends on me Darling because mine depends on you. I hope you will always feel the same way. I want to make you happy and some day I hope that I can. We could both be tremendously happy if we had half a chance. Of that I am firmly convinced. I want you more all the time and Sweetness I am not only in love with you but I also love you, if you know what I mean. If you don't I'll tell you when I see you.

We went to a see a movie last night here in the Grove and it was not only bawdy but vulgar. I enjoyed it thoroughly. I like Wheeler & Woolsey although I am sure you do not. They played in "So This Is Africa." It was extremely amusing but was so bad that I became a little nervous myself as to what they might do or say next. If you want an evenings diversion, I would suggest that you see it. I will see "42nd St." when I have the opportunity. From what you say I know I will like it. I think I told you we saw "Cavalcade." At any rate, don't miss it. I think you will agree that it is a wonderful picture.

Did you tell me that Martha Hazen had been very sick. Charlie Wait told me but I can't remember whether you mentioned it or not. I wonder if Evelyn's sojourn there had any connection with it. If you have heard, let me know.

Sweetness, from what you say I imagine the baby is almost too big for you to manage. I wish I could see her sitting up. How soon will she be walking? *Your other remark was sweet and you know there is nothing I would like better but I will say one thing, you certainly are a glutton for punishment* (italics added). You are my Precious Darling and I adore you Honey. There aren't words to tell you how sweet I think you are but I hope some day to have a chance to show you how much I do love you and how much you do mean to me. You are the only girl in the world as far as I am concerned and it will always be that way. I love you to death Darling.

Chapter 32

Evelyn Hazen was never able to escape the notoriety of her suit and to return to the life she had known prior to her love affair with Ralph Scharringhaus. After the trial, she went back to Mabry Hill and lived out the remainder of her life in her family's antebellum home.

With no income, Evelyn had to find a job. Eventually she went to work at the University of Tennessee, where she served as a secretary in the English Department. Those who knew her claimed that she virtually ran the department and was largely responsible for its solid reputation. Evelyn, too, said that her duties were more than secretarial. She claimed that she had worked as a substitute teacher at the university on occasion, and that she had written the Harbrace English textbook, which has been used widely in secondary schools throughout the country for many years. The writing project had been assigned to the department's dean, but she claimed that she did all of the work.

From time to time long after the trial, Evelyn continued to receive anonymous letters about Elizabeth Goforth and Ralph Scharringhaus. One letter on plain paper and printed in block letters advised her, "Check on GoForth afternoon date's. They think that you are through and have forgotten. You have friends that you do not realize are your friends." Another letter written in the same hand advised, "Do not let any grass grow under your feet. Check carefully on everything at party in cottage at Topoco Lodge during this entire week. Your friends are more numerous and are changing where you lest expect."

In addition to working at the university, Evelyn spent several years caring for her elderly mother and her uncle Churchwell Mabry. Sometime after the trial, her mother suffered an injury that is common to many older women. She broke a hip and never walked again. She became bedridden and stayed in her upstairs bedroom, never coming downstairs or leaving the home for the remainder of

her life. She was completely dependent on Evelyn for her meals, hygiene, and companionship until her death in 1953.

Evelyn's Uncle Churchwell, the one of her mother's brothers who apparently had not conspired against her, also became an invalid and moved into the first floor bedroom in the old manse. Taking care of two elderly, bedridden people proved to be very difficult, so in 1951 Evelyn placed an ad in the newspaper to hire an aide to look after Uncle Churchwell. Sarah Jane Grabeel responded to the ad and moved into the Mabry-Hazen house to serve as his full-time nurse. Uncle Churchwell died a few weeks later.

Evelyn never told her mother about Uncle Churchwell's death. When her mother would ask, "How is my dear brother today?" Evelyn would respond, "He's not very well." Her mother, who died of old age at 97, went to her grave believing that her brother was still alive.

After Churchwell's death, Evelyn invited Grabeel to stay in her home. She continued to live in the Mabry-Hazen house for 36 years, until she was quite elderly and no longer could care for herself.

During all of the years that Grabeel lived in Evelyn's family's home, she said that Evelyn never had a suitor. "[She] had male friends…[she] would have friends over…[she] would have big suppers, but [there were] no boyfriends."

Grabeel also said that Evelyn refused to sleep in her own bedroom because she believed that it was haunted by a ghost that had a disturbing resemblance to Jack McKnight.

"Miss Hazen said she had been sitting in bed reading, and she said his head came right between her and that book. He smiled at her and then went on by. The next night, he appeared at the foot of her bed. He was full length. He had a coat on," she said. "We always figured that's when he died."

In middle-age, Evelyn became a shrewd businesswoman. She invested wisely, amassed a small fortune in stocks and bonds, and purchased numerous apartments and houses as rental properties. But as the years passed, she began to succumb to the foibles and failings of old age. She became less diligent about monitoring the condition of her rental units and her home and was slow to make adequate repairs. The white exterior of the Mabry-Hazen house became weathered and

gray. The untended bushes grew into thickets that were nearly impenetrable.

During the last few years of her long life, Evelyn was in ill health. Surgery for a stomach problem and a chronic hip or leg ailment made it difficult to manage day-to-day living. Evelyn became dependent on a handful of people. Lucille LaBonte, some of her renters, and a couple of handymen tried to help her care for her house and rental units, brought her food, and fed her pets. A self-described animal lover, Evelyn kept number of cats and one dog inside her home. Several others dogs roamed the hillside or lived in the pens that had been built near the front porch.

One night in the early 1980s, intruders bent on terror and mayhem opened the dogs' cages and slit their throats. Before they left the grisly scene, they hung a noose over Evelyn's front door.

Evelyn was horrified. She spent the final months of her life carrying a pistol with her constantly, even when she was just walking from room-to-room in her own home.

As she neared the end of her long life, Evelyn suffered from severe mood swings that occasionally would transform her from her usual entertaining and congenial bearing to an irrational, belligerent menace. Those who witnessed these outbursts reported that her face would become distorted and her eyes would glow an intense green with her fury. Sulerner Hampton, who rented one of Hazen's houses, wondered aloud whether the Evelyn might have been possessed.

On Friday morning, June 14, 1987, Evelyn fell on the stairs of her home. A renter who was accustomed to taking breakfast to her heard her cries for help as he approached her front door. He summoned the police, who forced their way inside.

They found her lying on the landing of the massive, curving staircase. In attempt to get up on her feet, she had pulled a small table down on top of herself. Within a few minutes, an ambulance arrived and emergency medical technicians carried her down the stairs on a stretcher.

"She told me to take care of the house and be sure to take care of her pets. That's the last words she said to me, that I heard her say," the renter recalled.

Evelyn did not appear to be seriously injured. But later that afternoon, just as hospital officials were preparing to release her and send her home, she suffered a massive stroke. She lingered for two days and died on Sunday, June 16.

Epilogue

Evelyn Montgomery Hazen was buried near her father and mother in the Old Gray Cemetery in Knoxville. The newspapers that had covered the trial in the 1930s scarcely noticed her passing. The *Knoxville News-Sentinel* published a short obituary that included no mention of the precedent-setting court case.

Lucille, Judge Bozeman, Sulerner Hampton and two or three other renters attended a brief graveside service just before her body was interred. Each remembered her fondly as a smart and often generous woman who spoke near-perfect English, and who toward the end seemed to prefer speaking in fluent French. They recalled the woman who until a few years before her death was one of the most beautiful women they had ever seen.

Lucille, who was named as a trustee of Evelyn's estate, was determined to comply with her Last Will and Testament and save the *Mabry-Hazen House* and its contents as a museum. But the estate contained very little cash, so she called upon the good will of friends, business acquaintances, and family members to help her. With their assistance, Lucille worked for several years to establish the museum, and in doing so, to honor Evelyn's memory.

Cleaning up the property and cataloging Evelyn's belongings for the museum was a huge task. Lucille began by placing the *Mabry-Hazen House* on the national registry of historical places. Then she located an empty bank building where she stored Evelyn's numerous antiques and her personal effects in a vault for safekeeping while the house was being repaired.

But with very little money at her disposal, Lucille could not figure out how to pay for the necessary structural and cosmetic improvements. Then, in a stroke of genius, she asked the warden of a nearby prison to send inmates to work on the house. He agreed to help her, and as armed guards watched, the prisoners replaced the roof, shored up the porch, and painted the rooms and the worn

siding. Lucille took sandwiches and lemonade to them as they toiled in the hot summer sun.

In time, the *Mabry-Hazen House* began to return to its former glory as one of the loveliest homes in Knoxville. Local contractors removed the overgrown bushes and weeds and restored the lawn to its original beauty, and a paving company volunteered to rebuild the circular driveway and construct a parking area for visitors at no charge.

Today the *Mabry-Hazen House* is owned and operated by The Hazen Museum Foundation in accord with Evelyn's will. With its wide front porch and floor-to-ceiling windows, the house stands proudly on Mabry Hill as a monument to a Southern culture and a lifestyle that passed away long ago.

Although her house is intact, the memory of Evelyn's celebrated court case is rapidly fading away. Everyone associated with her suit is gone.

Ralph Porter Scharringhaus, who continued to live with his parents after the trial, never married Elizabeth Goforth. After the trial, he got a job selling cars and eventually married a woman who reportedly had been hired as a nurse for his mother. He died in 1971.

His father Edward H. Scharringhaus died in 1954. In his obituary, he was remembered for his beautiful gardens and as a "stalwart force" in his local church.

Long-time Knoxville residents say that Elizabeth Goforth lived with her husband Hugh until she reportedly had him institutionalized. According to the Knoxville rumor mill, she eventually moved to Alabama where she married a wealthy businessman.

Aside from her home and museum, Evelyn Hazen's legacy, her landmark court case, is all but forgotten. Changing social conditions and the government actions that have improved economic opportunities for women have nearly negated the utility of breach of promise to marry lawsuits. Evelyn's contribution to American jurisprudence has become a relic from another time, a piece of antiquity that no longer has relevance in a society where men and women are judged to be equal.

Acknowledgments

Evelyn Hazen's story would have been lost without the foresight and tireless efforts of Lucille LaBonte and several members of the LaBonte and Holt families in East Tennessee. Those to whom I owe a personal debt of gratitude include Lucille's granddaughters Lucia Spears and Beth LaBonte, who spent hours copying and assembling the documents that Lucille sent to me; the individuals who provided information or agreed to be interviewed including Judge C. Howard Bozeman, Bill Cardwell, John Coker, Lisa Dohling, Laura Harrell Douglas, Jim Dykes, Mary Gill, Sarah Jane Grabeel, John Green, Sulerner Hampton, Martin Hunt, Pleas Lindsay, Dannie Mellen Payne, Archie Russ, Dorothy Standifer, Mamie Winstead, and others whom I might have forgotten and neglected to mention; Douglas Robinson, the attorney who located an important legal document that helped me find the court records of the *Scharringhaus v. Hazen* case; Tamee Hayes and Mark Stone at the Kentucky Department of Libraries and Archives, who located the 2,000-page transcript of the case and arranged to have it copied and sent to me; Kelly Quinn, who typed a large portion of the initial draft; Jean and Juanita Holt, who accompanied me while I researched the locations of the Scharringhaus residence and other pertinent sites; Julie Jilinski and Zuraidah Hoffman, who read the manuscript and offered suggestions; my parents Paul and Clarice Davis who introduced me as a young child to Knoxville and the Smoky Mountains, thus beginning a love affair of the heart with East Tennessee; and my husband David Banks, who wanted to marry me despite my single-minded determination to complete my research and write this book.

The *Seduction of Miss Evelyn Hazen* is dedicated to the late Lucille LaBonte, whose perseverance and commitment led to the establishment of The Hazen Foundation Museum in Knoxville, Tenn. Miss Hazen, as Lucille unfailingly called her, had entrusted Lucille

with restoring her rundown and rotting pre-Civil War home to its earlier glory. She knew that Lucille was the ideal person for the job. Determined and optimistic, Lucille had a knack for looking beyond the obvious and seeing the possibilities. In dealing with people, for example, she did not just look at an individual; rather, she saw into them, deep into their sinews and synapses, where she often found and encouraged their innate goodness and strength of character. Under her powerful influence, young and old alike tended to work harder and to do the right thing. Lucille was a preacher and a politician, the embodiment of compassion and wisdom, and my personal mentor.

It was Lucille who convinced me to write a book about Evelyn Hazen. To assist me, she conducted research at the Knox County Courthouse, photographed gravestones at the Old Gray Cemetery, scheduled interviews, and shared her remembrances of her conversations with Miss Hazen. About two years after we began the process of producing a book, Lucille suffered a serious head injury in a fall at the home of a business acquaintance. She lay in a coma for several days. When she emerged from the coma, she had difficulty in remembering the names of commonplace items. A few years later, the sudden death of her only child Joe LaBonte exacerbated the lingering effects of the injury.

Lucille LaBonte

I last visited Lucille at a nursing home east of Knoxville. The nursing staff said she was experiencing dementia. I do not think that she remembered who I was.

Lucille LaBonte died in August 2003. The world became a poorer place with her passing.

Selected Bibliography

Associated Press, "Abuse Charged to Miss Hazen," *The Knoxville Journal*, February 18, 1934, p. 5-A.

Associated Press, "Brutal Love Letters Read," *The Knoxville Journal*, February 11, 1934, p. 5-A.

Associated Press, "Burning Love Letters to Teacher Read in Hazen – Scharringhaus Suit," *The Knoxville Journal*, February 9, 1934, pp. 1-8.

Associated Press, "Court Hears 'Other Man'," *The Knoxville Journal*, February 15, 1934, p. 5.

Associated Press, "Counts Denied by Miss Hazen," *The Knoxville Journal*, February 14, 1034, p. 5.

Associated Press, "Evelyn Hazen Planned Death," *The Knoxville Journal*, February 13, 1934, p. 10.

Associated Press, "Ex-Teacher Here Asks $100,000 Heart Balm from Scharringhaus," *The Knoxville Journal*, March 25, 1933, p. 1-4.

Associated Press, "Hazen Hearing Jury Completed," *The Knoxville Journal*, February 8, 1934, p. 1.

Associated Press, "Hazen Hearing May End Today," *The Knoxville Journal*, February 23, 1934, p. 8-B.

Associated Press, "Icy Blasts Sweep Down on Country," *The Knoxville Journal*, February 21, 1934, pp. 1-2.

Associated Press, "Jury Ponders Hazen Verdict," *The Knoxville Journal*, February 24, 1934, p. 5.

Associated Press, "Miss Hazen's Tale Refuted," *The Knoxville Journal*, February 20, 1934, p. 3.

Associated Press, "Prefers Vows to Heart Balm," *The Knoxville Journal*, February 10, 1934, p. 5.

Associated Press, "Threats Laid to Miss Hazen," *The Knoxville Journal*, February 17, 1934, p. 5.

Associated Press, "Wins $80,000 Verdict," *The New York Times*, June 26, 1937, p. 19.

Bryan, Jack, "The Half Century of a Wholesale Grocer," *The Knoxville News-Sentinel*, November 2, 1930, p. C-7.

Burnside, Gen. Ambrose, "Report of the Knoxville Campaign," O.R –Series I – Vol. XXXI/1 [S# 54] 1863.

Green, John W., "W.T. Kennerly 1877-1944," *Bench and Bar*, (Knoxville, Tenn., Archer & Smith, 1947) pp. 219-225.

Hazen, Evelyn M., "The Chronological Account" (Knoxville, Tenn., Unpublished, 1932-33).

————, "Chief Justice Robert Stephens – A Tribute," *The Advocate*, July 2002.

Miller, Ernest I., "A Battle of East Tennessee in the Civil War," The Cincinnati Civil War Round Table, 1996, pp. 1-10.

Rule, William S., *Standard History of Knoxville, Tennessee* (Chicago, Ill., The Lewis Publishing Company, 1900).

————, "Business Man To Take Stand," *The Kentucky Post*, February 16, 1934, p. 1.

————, "Crowd Listens to Depositions," *The Kentucky Post*, February 15, 1934, p. 1.

————, "Death Takes Judge R.C. Bryson, 81," *The Kentucky Post*, August 23, 1968, pp. 1.

————, "Defense Puts Questions in Balm Hearing," *The Kentucky Post*, February 14, 1934, p. 1.

————, "E.H. Scharringhaus Dies At Hospital At 85," *The Knoxville Journal*, February 12, 1954, p. 24.

————, "End of Heart Balm Case Near," *Kentucky Post*, February 23, 1934, pg. 1.

————, "Friend Called in Balm Suit," *The Kentucky Post*, February 20, 1934, p. 1.

Hazen v. Scharringhaus (Transcript), Kenton County Circuit Court, February 8-23, 1934.

————, "Hazen, Miss Evelyn Montgomery," *The Knoxville News-Sentinel*, June 16, 1987.

————, *Heart of the Valley* (Knoxville, Tenn., The East Tennessee Historical Society, 1976).

————, *History of Tennessee Illustrated Knox County* (Chicago, Ill., The Godspeed Publishing Co., 1887).

McWilliams, Peter, "Prohibition: A Lesson in the Futility (and Danger) of Prohibiting," *Ain't Nobody's Business If You Do: The Absurdity of Consensual Crimes in Our Free Country* (World Wide Web, McWilliams & Prelude Press, 1996).

————, "Miss Hazen Wins Balm Suit Appeal," *The Knoxville News-Sentinel*, June 25, 1937, p. 1.

_____, "Name Pallbearers for Judge Bryson," *The Kentucky Post*, August 24, 1968, p. 10K.

_____, "Passes Away: Rush S. Hazen Succumbs Suddenly At Santarium," *The Knoxville News-Sentinel*, June 1932, pp. 1-A-7.

_____, "Private Lives," *Life*, July 12, 1937, p. _.

_____, "Retired Knox Industrialist Dies," *The Knoxville News-Sentinel*, February 11, 1954, p. _.

_____, "Sawyer A. Smith, Top-Notch Defender," *The Kentucky Post*, November 3, 1969, p. 3.

_____, "Scharringhaus Rites Wednesday," *The Knoxville Journal*, April 13, 1971.

Scharringhaus v. Hazen, Court of Appeals of Kentucky, June 25, 1937 (107 S.W. (2d)), pp. 329-338.

_____, "Scharringhaus Still on Stand," *The Kentucky Post*, February 17, 1934.

Stephens, Robert L., *Gilbert v. Barkes*, Supreme Court of Kentucky, 97-SC-463-DG, 1997.

_____, "Stephens L. Blakely Dies at Age of 80," *The Kentucky Post*, February 24, 1959, pp. 1-3.

Tate, James A., "The Church and the Liquor Traffic," *Centennial Convention Report* (Cincinnati, Ohio, Standard Publishing Company, 1910), pp. 235-239.

_____, "Teacher's Love Story To Be Given Acid Test," *The Kentucky Post*, February 12, 1934, p. 1.

_____, "Teacher Wins $80,000 in Love Verdict," *The Kentucky Post*, February 24, 1934, p. 1.

_____, "Testimony of Defense Witnesses Denied by Plaintiff in Rebuttal," *The Kentucky Post*, February 22, 1934, p. 1.

Thornton, Mark, "Policy Analysis: Alcohol Prohibition Was a Failure," Cato Policy Analysis No. 157, The Cato Institute, Washington, D.C., 1991.

Twain, Mark, *Life on the Mississippi* (World Wide Web, New York City, N.Y., Harper, 1901), chap. 40.

United Press, "$80,000 Given to Jilted Teacher," *Charleston Daily Mail*, February 25, 1934.

About the Author

Jane Van Ryan is an award-winning broadcast journalist and communications professional. Early in her career, she served as a talk show host, anchor and reporter at television stations in Charleston, S.C., Peoria, Ill., and Louisville, Ky., before spending several years at a major network affiliate in Washington, D.C.

Since 1987, Van Ryan has managed communications programs for trade associations, a large corporation specializing in research and engineering, and one of America's oldest and most respected research universities.

Van Ryan is a graduate of Hanover College in Hanover, Indiana. She and her husband, who reside in Maryland, have four grown children and several grandchildren.